1982

Creative Techniques in Nature Photography

Creative Techniques in Nature Photography

Arnold Wilson

J. B. Lippincott Company
Philadelphia and New York

Acknowledgment

Very few books are the work of one man alone, and this is no exception. Many of my science colleagues at Beckett Park have helped me both directly and indirectly and I must thank Dr Allan Calder, who particularly encouraged me during those periods when I was beginning to wane and who also gave helpful advice on the chapter dealing with micro-organisms. I am also indebted to Mr John Ericson, who willingly gave of his time and expertise in the development of the mechanical and electronic equipment discussed in Chapter 2. Mr Bill Wrest and Mrs Jennifer Dods, our laboratory technicians, rendered valuable service by looking after much of the equipment and caring for many of the animals and plants which were used in the various chapters. The Department of Animal Sciences, Leeds University, supplied some of the insects used in Chapter 8 and also gave helpful advice on several occasions.

I am indebted to the British Museum (Natural History Section) for permission to use Figs. 11.1a and 11.1b, and to Mr Thomas McGinley for providing Fig. 12.3. Throughout the preparation of the text I myself have referred constantly to that fine book *Nature Photography: Its Art and Technique* by H. Angel; Heather Angel's photographs in the book and in the press have been a constant source of pleasure and inspiration to me.

I also wish to thank Mrs Aileen Edwards, who transformed, without delay or fuss, my much altered handwritten notes into a beautifully presented typescript.

Finally, I wish to express my special thanks to my wife, who accepted, without ever complaining, my increasing pre-occupation with plants, animals and cameras, particularly during the latter months, when I spent most evenings in the laboratory or the darkroom.

A.W.

U.S. Library of Congress Cataloguing in Publication Data

Wilson, Arnold,
 Creative techniques in nature photography.

 Bibliography: p.
 Includes index.
 1. Nature photography. I. Title.
TR721.W54 778.9'3 78-26226
ISBN–0–397–01354–X

Contents _____

Introduction_____

This book has been written with two groups of people in mind: first, the amateur and semi-professional photographer who has mastered the basic techniques of photography and who is developing an interest in natural history, and second, the person who is basically a naturalist and who would like to start taking photographs of plants and animals in the field. The former will have no difficulty in understanding the photographic terminology used in this book, whereas the latter may first have to read some introductory text on basic photographic principles.

I have attempted to cover most of the main animal and plant groups, including selected microorganisms, to make the book as all-embracing as possible. In each chapter suggestions are made for photographic work, and these are then discussed and illustrated. Each chapter also undertakes a discussion on the availability of materials from both natural sources and specialist suppliers and includes (where appropriate) notes on the housing and care of organisms.

The discussions and photographic techniques are related both to the natural history approach, and to the aesthetic approach. The latter should be useful to those photographers who are more interested in line, shape and texture than in pure natural history, and who strive to produce pictures which, although not entirely devoid of biological information, base their appeal mainly on aesthetic criteria such as light and shade, tone distribution and line composition. Both approaches are valid and merely reflect the interest of the photographer and the purpose for which the photograph is being taken.

1 Choice of Camera_____

BASIC REQUIREMENTS

What does a nature photographer require of his camera if it is to be a useful and effective instrument? The following is a list of the most important requirements.

A The quality of the finished product, be it print or transparency, should be of a very high standard, so that fine detail is clearly resolved and colour accurately rendered. A highly corrected multi-element lens will be needed to meet this requirement.

B The camera should be capable of recording natural environments, such as sea-shore, moor-land, freshwater, under varying lighting conditions, and therefore a fairly fast lens will be essential.

C The camera should be able to record moving organisms successfully, both large and small. This requires a relatively high shutter speed of $1/500$ sec or $1/1000$ sec to completely, or at least partially, 'freeze' the movement, so the shape and position of the appendages can be studied.

D It should be capable of close-up work with a reproduction scale from approximately $1:20$ to $1:1$ (i.e. image to object ratio). This requires a very accurate viewing system and the use of a close-up lens, or extension rings or bellows.

E The camera must be capable of photomicrography, using a standard microscope, covering magnifications ranging from $10:1$ to $1,000:1$. For good results a camera with interchangeable lenses is required.

F It must be reasonably compact and readily portable. All 35 mm and most 6×6 cm ($2\frac{1}{4} \times 2\frac{1}{4}$ in) cameras satisfy this requirement.

G The camera must be fairly cheap to operate. This implies that either 35 mm film or 120 roll-film must be used, sheet film being much too expensive.

H The camera must be reasonably priced. Cost is relative, and whereas a camera costing £500 (UK) might be considered inexpensive by the wealthy enthusiast, it would be very expensive to the average nature photographer. Based on current (1978) prices, approximately £50 (UK) must be spent to obtain a satisfactory secondhand camera and a minimum of £90 (UK) for a new one.

RANGE OF CAMERAS AVAILABLE

There are six main types of camera presently on the market, and they each differ in their suitability for nature photography.

1 Box
2 Rangefinder
3 Stand (technical)
4 Polaroid Land
5 Twin-lens reflex (TLR)
6 Single-lens reflex (SLR)

Box cameras

Today's box camera does not resemble the box camera of yesteryear, but behind the sleek modern exterior is found the same simple interior. The lens is a simple meniscus type (sometimes made of plastic), has a fixed focus and cannot therefore be used closer than about 2.5 metres (8 ft), and is relatively slow (f8–f11), so that it can be used only when the sun shines. It usually has one speed of approximately $1/25$ sec, often referred to as instantaneous, although in some models the shutter blades can be kept open to give a time exposure.

The film is usually 35 mm, or a 126 cartridge, and during processing enlargements (enprints) are automatically produced. A recent innovation has been the synchronisation of the shutter for flash bulbs and the use of the four-flash cube. This greatly extends the use of the camera and enables it

to operate successfully in artificial light. However, as a camera for the nature photographer, it will not:

1 Produce accurate colour rendering or record fine detail (requirement A)
2 Photograph fast-moving objects (requirement C)
3 Cope with close-up work and photomacrography (requirement D)
4 Tackle photomicrography to anything but a very limited degree (requirement E)

The modern box camera is, therefore, not a satisfactory instrument for the nature photographer.

Rangefinder cameras

Many camera models come under this heading, but one feature they all have in common is a built-in rangefinder. The simplest would cost only a few pounds, whereas the precision-built Leica is currently priced in the region of £600 (UK). The type of film used spans the whole field from cut film down to 120 roll-film and 35 mm film. The quality of the lenses varies greatly, ranging from, for example, a modest three-element f2.8 Color–Agnar to the brilliant seven-element f1.4 Summilux. The rangefinder can be either 'uncoupled' or 'coupled'. In the former case it is used to measure the distance from the subject to the camera and this distance is then transferred to the focusing scale on the lens mount. The sole advantage over a separate rangefinder is the convenience of having it always ready and available when using the camera. The viewfinder eyepiece is often quite separate from that of the rangefinder.

The coupled rangefinder is, as the name suggests, coupled to the lens-focusing mechanism so that when the lens mount is rotated it automatically operates the rangefinder. Also the viewfinder and rangefinder are combined so that the picture limits are as seen in the viewfinder, an accurate and convenient arrangement. Many such cameras also have a built-in exposure meter. Again there is the uncoupled meter where the reading is taken and the information used to set the lens aperture/shutter-speed combination, and the coupled exposure meter, which is automatically coupled to the lens aperture and in some cameras to both the aperture and the shutter mechanism.

The best of these cameras are really fine instruments and fulfil most of the requirements of the nature photographer. The main difficulties are the related problems of parallax and close-up work. Parallax is the difference between the view seen in the viewfinder and that which is actually photographed by the camera lens. Parallax errors are present in all types of camera except the single-lens reflex, where the picture is viewed through the camera lens. The problem of parallax is illustrated in Fig. 1.1.

If the horizontal axis of the viewfinder is parallel to that of the taking lens, and, say, 7.5 cm (3 in) higher, the viewfinder will include 7.5 cm (3 in) more at the top of the picture and 7.5 cm (3 in) less at the bottom than would the camera lens. For distant objects this disparity is negligible, but it becomes much greater at point B, 3 metres (10 ft) away, and excessive at point C, 5 cm (2 in) away,

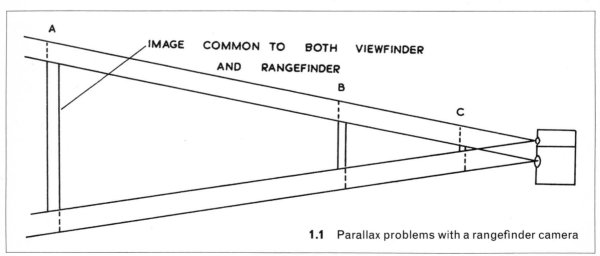

1.1 Parallax problems with a rangefinder camera

where the viewfinder and camera lens are actually registering totally different views.

Methods have been devised to correct this (eg by an automatic tilting down of the viewfinder for near objects) but, as long as the viewpoints of the taking lens and the viewfinder are separate, parallax must exist. This therefore presents a grave problem for the photographer interested in close-up work, photomacrography, and all but the simplest photomicrography. There is really no satisfactory solution to this problem (except for Leica users who can purchase a Visoflex reflex housing) and, as a large proportion of the nature photographer's work is done at close distances, a rangefinder camera is not the ideal instrument.

Stand (technical) cameras

These cameras tend to be heavy and bulky and, as the name implies, are intended for use on a tripod or stand. They cannot be operated quickly because the image has to be focused on a ground-glass screen located in the film plane at the back of the camera. After focusing, the screen is removed and replaced by a plate or piece of sheet film. This type of camera is almost incapable of photographing moving objects but is ideal for static structures such as buildings. It usually has a swing back so that the plate can be kept in the vertical position when the camera is tilted upwards to include the tops of buildings. This avoids convergence of vertical lines, which would occur if a fixed back camera were used. Many of these cameras have a rising front which controls the amount of foreground on the negative.

Finally, stand cameras use rather large plates, 12×10 cm (5×4 in) or larger, which are very expensive. Although close-up work and photomicrography are quite possible, bulk, cost of materials and slowness of operation weigh too heavily against them for stand cameras to be considered an ideal tool for the nature photographer.

Polaroid Land cameras

This system was developed by Dr Edwin H. Land, of Polaroid filter fame, in Boston, USA, and the first model became available in 1948. It enables black and white prints to be produced 15 seconds, and colour prints 60 seconds after pressing the shutter-release button. The secret lies in the special developer–fixer agent which is attached, in the form of a gelatin capsule, to the positive paper inside the camera. After the negative has been exposed, it is drawn face-to-face with the positive paper through rollers which break the capsule and spread the developer–fixer into the negative–positive sandwich. A positive image is formed on the positive paper and the negative is then stripped away from the face of the print.

Several film sizes are available, including Type 107 (black and white) and Type 108 (colour), both producing eight pictures measuring 8×10 cm ($3\frac{1}{4} \times 4\frac{1}{4}$ in), Type 47 and 48 roll film producing eight 8×10 cm ($3\frac{1}{4} \times 4\frac{1}{4}$ in) black and white pictures and six similar-sized colour pictures respectively. Several models have built-in coupled rangefinders, and all have some form of automatic exposure control. Unfortunately they all suffer the disadvantages associated with rangefinder cameras and these limitations, coupled to the very high price of the film, do not make this camera an ideal instrument for the naturalist.

A few years ago Dr Land introduced a very unusual SLR camera called the SX 70. Its novelty lay in the unconventional viewing system and in the unusual route taken by the light as it passed from the lens to the film. However, it is a genuine SLR camera, with fully automatic exposure and processing systems, and it can produce high-quality prints within a minute or so of making the exposure. It can be of interest to the nature photographer for certain purposes, although it does have a fixed lens (ie not interchangeable), and Polaroid film is still rather expensive to buy.

Also in the realm of Polaroid equipment are the CU-5 camera, which has been specially designed for close-up work, and the MP-4 multipurpose camera, which is a versatile instrument combining the characteristics of a stand camera with the automatic processing of the Polaroid system. Neither of these cameras, however, possess all the characteristics required by the nature photographer, although they are both first-class instruments in their own field.

Twin-lens reflex cameras

When one thinks of these cameras, Rolleiflex always comes to mind. Over the years since the first Rolleiflex was produced in Braunschweig in 1928 by Franke and Heidecke, this type of camera has become a firm favourite with both amateurs and professionals alike. But is it the best type of camera for the nature photographer?

The twin-lens reflex (TLR) consists of two distinct parts (Fig. 1.2). The upper is the reflex section, where light passes through the viewing

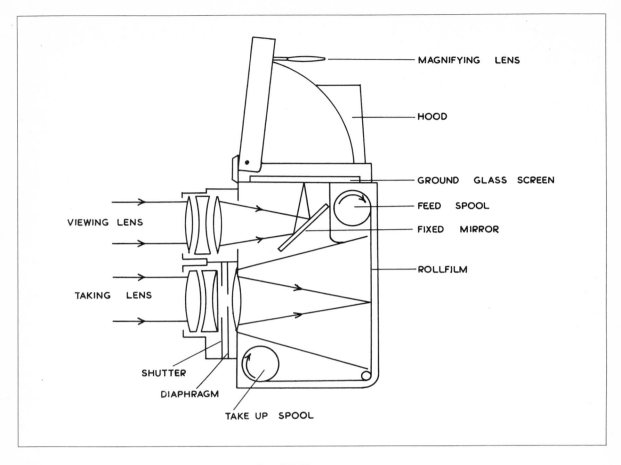

MAGNIFYING LENS

HOOD

GROUND GLASS SCREEN

FEED SPOOL

FIXED MIRROR

ROLLFILM

VIEWING LENS

TAKING LENS

SHUTTER

DIAPHRAGM

TAKE UP SPOOL

1.2 The basic principles of the twin-lens reflex (TLR) camera

lens, is reflected from the surface of a 45° inclined mirror and is viewed on a piece of ground glass fixed horizontally in the top of the reflex area. To facilitate focusing, much of the extraneous light is eliminated by the self-erecting hood which surrounds the focusing screen. The lower part of the camera is the taking area, consisting of the lens, shutter mechanism and film, and is completely isolated from the upper viewing section. However, the viewing and taking lenses are mounted on a common panel, so that focusing on the ground-glass screen will automatically focus the light through the taking lens onto the film. The taking lens is set to the required aperture but the viewing lens is always fully open, thus producing a very bright image for ease of focusing. However, there is no visible indication on the focusing screen of the depth of field being produced by the taking lens when set at different apertures.

The film used is 120 (or the double length 220) producing twelve 6×6 cm ($2\frac{1}{4} \times 2\frac{1}{4}$ in) exposures, although models are available using 127 film giving twelve 4×4 cm ($1\frac{1}{2} \times 1\frac{1}{2}$ in) exposures. Many models now have built-in coupled exposure meters, removable hoods, pentaprism viewing systems, and fresnel focusing screens with split image or microprism rangefinders. All models, except the Mamiyaflex, have fixed lenses (ie not interchangeable), although telephoto and wide-angle attachments are available for some of them.

The best of these cameras are manufactured to extremely high standards of reliability, and fulfil most of the requirements of the nature photographer. However, once again we are confronted with the problem of parallax (Fig. 1.3). There are two aspects of this problem which need discussing and the first concerns the framing of the picture. As the camera approaches the subject, so the

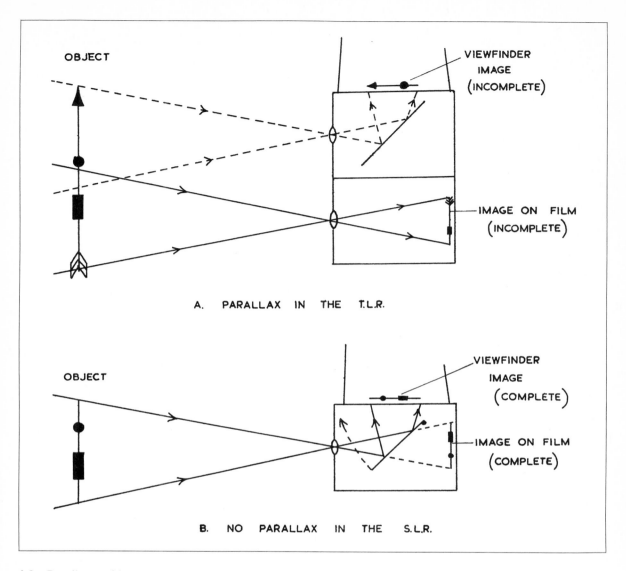

OBJECT

VIEWFINDER IMAGE (INCOMPLETE)

IMAGE ON FILM (INCOMPLETE)

A. PARALLAX IN THE T.L.R.

OBJECT

VIEWFINDER IMAGE (COMPLETE)

IMAGE ON FILM (COMPLETE)

B. NO PARALLAX IN THE S.L.R.

1.3 Parallax problems

disparity between what is seen by the taking and viewing lenses increases enormously. This is partially solved in the more expensive TLRs by the presence of movable metal strips at the top and bottom of the focusing screen. As the camera is focused on near objects the two metal strips move slightly down the screen to bring the picture area more into line with that 'seen' by the taking lens.

Most TLRs will focus down to about 1 metre (3 ft) although the Mamiyaflex extends down to 20 cm (8 in) because of the extra long bellows, but, to work any closer, supplementary lenses are

required. These must be produced in pairs, one for the taking lens and the other for the viewing lens; the viewing supplementary lens incorporates a parallax compensating wedge to 'bend' the light so that the field of the viewing lens corresponds to that of the taking lens.

The second part of the parallax problem is almost impossible to solve because the viewing system will always see a slightly different picture from that seen by the taking system, since they are separated spatially. In extreme close-ups, the taking system may be looking horizontally at the

subject, whereas the viewing system would be looking down on top of it. An attempt to solve this aspect of the parallax problem has been made by the manufacturers of the Mamiyaflex. The camera is focused for close-ups in the normal way, but, before making the exposure, the camera is raised to bring the taking lens into the position formerly occupied by the viewing lens. Thus the picture taken is exactly as seen in the viewfinder screen and this method works well for non-moving subjects. The device is called a paramender.

In view of the problems of parallax which make close-up work and photomacrography very difficult, the twin-lens reflex camera is not considered to be the ideal instrument for the naturalist.

Single-lens reflex (SLR) cameras

As the name suggests, this camera is of the reflex type (ie light is reflected from the surface of a 45° inclined mirror) and contains one lens only, which functions both as the viewing lens and the taking lens (Fig. 1.4). This principle has been used in

1.4 The basic principles of the single-lens reflex (SLR) camera (35 mm)

camera design for very many years and whereas the early cameras such as the Thornton Pickard Ruby Reflex were bulky and used plates, the modern equivalents are more compact and use, in the main, 35 mm film.

The German firm of Ihagee was the first to apply this principle to the 35 mm camera and this type of camera today enjoys a well earned popularity probably never envisaged by its founder in 1936. The first 35 mm SLR cameras consisted of the basic components required to operate this system, ie a taking/viewing lens, a hinged 45° mirror, and a ground-glass screen surrounded by a viewing hood. The subject was focused, usually at full aperture for extra brightness, on the ground-glass screen and the lens was then stopped down to the working aperture. The shutter-release button was pressed, releasing the mirror which swung upwards, thus allowing the light to fall on the film as the focal-plane shutter blinds moved across the film plane. Therefore, at the moment of exposure, the image was no longer visible in the viewing screen, because the hinged mirror had swung up towards the screen, and there it remained until the film was wound on, when it returned to the 45° position.

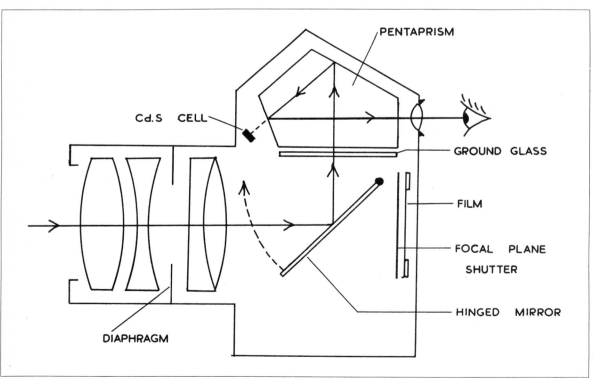

PENTAPRISM

Cd.S CELL

GROUND GLASS

FILM

FOCAL PLANE SHUTTER

HINGED MIRROR

DIAPHRAGM

From this simple beginning a number of developments and refinements have taken place so that today this type of camera is a very sophisticated, precision built, piece of equipment. The manual diaphragm was replaced firstly with a semi-automatic, and then a fully automatic diaphragm (referred to as FAD). This allows the focusing to be done at full aperture but, on pressing the shutter-release button, the lens 'stops down' to the set aperture and opens up again after the exposure has been made. Thus critical full aperture focusing can take place right up to the moment of exposure and this is extremely useful, particularly if the lens is set on a very small aperture.

The viewing system was then made more efficient and easier to use by the addition of a pentaprism and eyepiece on top of the ground-glass screen. This produces a 'large as life' image, the right way up and correct for right-left, and is a tremendous improvement on the waist-level reflex finder (as the basic system is called). On the debit side the pentaprism has increased the weight, bulk and price of the camera. The ground-glass screen has also changed over the years. First, the 'fresnel' lens principle was applied, thus allowing one side of the screen to act as a convex lens to collect light and give a brighter image. Accuracy in focusing was then increased by incorporating a twin-wedge, split-image rangefinder in the centre of the screen; this however has been largely replaced by the microprism centre, which makes the focusing operation not only very accurate but extremely rapid.

The hinged mirror has also been modified and today it is referred to as the 'instant return' mirror. When the shutter-release button is pressed, the mirror rises just long enough for the exposure to be made and then returns to its $45°$ position. This allows continuous viewing of the subject, except for a very short break at the moment of exposure.

The ease and accuracy of determining the exposure has also received considerable attention. The selenium barrier cell, which converts light falling on it into electrical energy, has largely been replaced by the cadmium sulphide cell, which undergoes a change in its electrical resistance when the light falls upon it. This system requires a small battery to produce the circuit current, which is read off on a microammeter. The advantage of the cadmium sulphide meter is that it can be readily manufactured to have a sensitivity at least one hundred times greater than that of the similar-sized selenium barrier cell. Originally the exposure meter was simply built into the camera but not coupled to it; then the coupled meter was developed, but the real breakthrough came when through the lens (TTL) metering was introduced. In this system the exposure meter is located behind the lens and therefore only the light passing through the taking lens is measured so that exposures can be extremely accurate. The meter is coupled to both the diaphragm and the shutter mechanism.

Close-up work is straightforward, since there are no parallax problems with which to cope; whatever is seen in the viewfinder will appear on the negative. When extension rings or bellows are used to get close to the subject being photographed, an increase in exposure is required. This can be calculated, but with TTL metering a direct exposure reading is given, no correction being necessary.

Another advantage of the SLR camera is that the standard lens can be replaced by a large selection of other lenses. These range from wide-angle lenses with an acceptance angle of $75°$ for a 28 mm lens, and $63°$ for a 35 mm lens, to telephoto lenses with an acceptance angle of $18°$ for a 135 mm lens and $12°$ for a 200 mm lens.

It is worth remembering that the use of the Pentax/Praktica screw thread is very widespread and all lens manufacturers (as distinct from camera manufacturers) tend to make this thread the basic fitting. There are, therefore, numerous makes of lenses available with this screw fitting. Manufacturers such as Nikon, Canon, Minolta, Miranda, and Petriflex have their own special fitting and therefore the choice of telephoto and wide-angle lenses for these cameras is much more restricted. However, adaptors are available to convert from the Pentax thread to other fittings, although they are fairly costly, and are not available for all fully automatic lenses. Even the Pentax thread can now no longer be looked upon as the popular basic thread because the current range of Pentax cameras are using a newly developed bayonet fitting.

The preceding paragraphs referred to 35 mm cameras and most photographers are content to work with 35 mm × 24 mm ($1\frac{3}{8}$ × 1 in) negatives. These cameras cost more than equivalent range-finder cameras because of the rather expensive pentaprism and the complex, and therefore expensive, mechanism required to operate the mirror and the fully automatic diaphragm.

A small but increasing number of people prefer to use a larger negative, and for them the 6 × 6 cm ($2\frac{1}{4} \times 2\frac{1}{4}$ in) SLR camera is available (Fig. 1.5). A few years ago this choice was limited to the very expensive Rollei S.L.66, the Bronica S2 and the Hasselblad 500 C, or the medium-priced Pentacon Six. Two new models then made their appearance, the Japanese Kowa Six and the Russian Zenith 80. These cameras, although costing little more than half the price of the Hasselblad, received favourable comment in the photographic press. At the moment the market for the larger formal camera, 6 × 4.5 cm ($2\frac{1}{4} \times 1\frac{3}{4}$ in) to 6 × 7 cm ($2\frac{1}{4} \times 2\frac{3}{4}$ in) seems to be expanding rapidly and a fairly large number of models are now available.

In the popular 6 × 6 cm ($2\frac{1}{4} \times 2\frac{1}{4}$ in) format there are the Hasselblad 500 CM and 500 ELM, the Rollei SL 66, the Bronica S2A and EC, and the Kowa Super 66. The Hasselblad is regarded by many photographers as the ultimate in 6 × 6 cm ($2\frac{1}{4} \times 2\frac{1}{4}$ in) cameras. It is equipped with a superb Planar lens, an in-built leaf-blade shutter (ideal for flash photography) and it is compact and very versatile. Unfortunately its high price, and the very expensive additional lenses put it beyond the reach of many photographers.

The Rollei SL 66 has been in production for

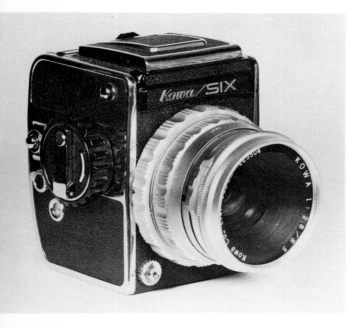

1.5 The Kowa Six, a high-quality 6 × 6 SLR camera giving 12 exposures on a 120 film, or 24 on a 220 film

over ten years and although the standard of workmanship is beyond reproach, the price has always seemed to be rather high when compared with other cameras in this field. However, it does possess the excellent Zeiss Planar lens, which focuses down to about 18 cm (7 in), and a lens panel which can be tilted 8° upwards and downwards.

The Bronica S2A has become well established and is very popular with many photographers. The price has always been reasonable, whilst the Nikkor lens is regarded as one of the best in the field. The S2A model has a standard mechanically controlled focal-plane shutter, whereas the EC model has an electronically operated shutter.

The Kowa camera has been in production for over eight years and started life as a medium-priced camera with a leaf-blade shutter. It was regarded by many photographers as the poor man's Hasselblad! The latest model, the Super 66, has an interchangeable magazine back and retains the very useful leaf-blade shutter.

There are two variations on the 6 × 6 cm ($2\frac{1}{4} \times 2\frac{1}{4}$ in) format: the slightly larger 6 × 7 cm ($2\frac{1}{4} \times 2\frac{3}{4}$ in) and the smaller 6 × 4.5 cm ($2\frac{1}{4} \times 1\frac{3}{4}$ in). The former, introduced several years ago, was heralded as the ideal format. However, it never really established itself and at the moment there are only two models available, the Pentax 6 × 7 and the Mamiya RB67 Pro.S. The Pentax is a large version of a typical 35 mm SLR camera and comes complete with a superb Takumar lens, a replaceable pentaprism, but no interchangeable back. The Mamiya is a very large heavy camera, reminiscent of the old Thornton Pickard Ruby Reflex, and comes complete with a revolving back (as did the TP Reflex) and a leaf-blade shutter. Both the Pentax and the Mamiya are expensive cameras but very versatile and capable of producing excellent results.

The 6 × 4.5 cm ($2\frac{1}{4} \times 1\frac{3}{4}$ in) format has recently been re-introduced on the market and at the moment two models are available. The first to be marketed was the prize-winning Mamiya M645 and this was followed a few months later by the Bronica ETR. Both have received excellent reports in the photographic press but it is too early to say whether this 'new' rectangular format will replace the well established 6 × 6 format.

All the above cameras take both 120 and 220 film and have fully automatic lenses except the Zenith 80 which has a semi-automatic lens. Pentaprism viewing systems (or the cheaper mirror system),

TTL metering, extension tubes and bellows, and a range of lenses, are available for these cameras and they can therefore become as versatile as the 35 mm SLR camera, if one is prepared to pay the high prices involved.

Several obsolete 6 × 6 cm ($2\frac{1}{4} \times 2\frac{1}{4}$ in) cameras are still available, and although they have either manual or pre-set lenses and non-interchangeable backs, they do represent very good value for money. Such cameras include the Agiflex II and III, Corfield 66, Praktisix I and II, Kalimar 66 and its predecessor the Fujuita 66.

The SLR camera is the ideal instrument for the naturalist. It will cope admirably with distant views, close-ups and photomicrography; it is fairly compact, easily portable, cheap to operate and reasonably priced. It will, in fact, fulfil all the requirements listed earlier from A to H. One could begin with a humble secondhand camera and add to it as, and when, finance permits, or a substantial sum of money might be invested initially in buying a complete outfit.

My own equipment consists of a 35 mm Canon FT camera with stop-down TTL metering, a 135 mm f2.5 Canon FL telephoto lens, a Komura Telemore 95 converter, a 300 mm f5.6 pre-set Tele-Kilar Kilfitt lens and a set of automatic extension tubes. This outfit can cope with almost anything which the nature photographer is likely to encounter in his travels. I also have a Kowa Six (original model) which produces colour transparencies for publication (Fig. 1.5). All the equipment was purchased secondhand, and has performed faultlessly over a number of years.

BUYING A SECONDHAND CAMERA

Is buying a secondhand camera a viable proposition? In the author's experience, the answer is an unqualified 'yes', if the following points are borne in mind.

1 When buying secondhand equipment from a photographic dealer make sure that the guarantee is worthwhile. If the camera has not been fully checked, ask to have it done immediately because a small percentage of all such cameras are faulty.

2 Equipment belonging to a full-time professional photographer will probably have been used every day and therefore when sold is likely to be nearing the end of its useful life (mechanically if not optically).

3 When buying privately, ask to have the camera on a few days' approval against cash and check the following points:

A Examine the general condition of the bodywork because this reflects the care taken by the owner. If the bodywork is dented or damaged think the worst and act accordingly.

B Examine carefully every visible screwhead. Burr marks indicate that a screw has probably been removed by an amateur 'repairer' and these superficial marks could indicate a deep-seated and expensive fault.

C Examine the surface of the lens for slight abrasions and deeper scratches. These could affect the performance of the lens if only by reducing the contrast of the image. Check for any indications, such as burred edges or absence of paint, that the lens elements have been removed. If so question the owner about it. Try the focusing mechanism and note the amount of 'backlash' present – a large amount indicates that the camera has had a lot of use.

D Although shutter speeds can only be accurately checked by electronic means, make sure the mechanism works smoothly at all speeds. A faltering blind is easily detected if the camera is held, with the back open, up to the light.

E Check that the winding mechanism works smoothly. This not only winds on the film but also sets the shutter and operates the exposure counter. A fault in this direction could prove to be quite expensive to rectify.

F Examine the pressure plate, and if it looks 'as new', then the camera has probably had little use. A pressure plate has only to show a small amount of wear to indicate that the camera has had a very large number of films through it.

G If the camera has a coupled rangefinder or a reflex focusing mechanism, check, by focusing at infinity and at several measured distances, that the focused distances agree with the distance scale on the lens mount.

H Expose at least one film using a range of shutter speeds and lens settings. The lens performance can be tested by photographing one of the special lens testing charts, or simply by photographing a double sheet of newspaper, when covering power, edge definition, contrast and astigmatism can all be studied.

If, after the above checks have been carried out, the camera is worth buying, then a fair price can be reached, based on similar equipment offered in the 'for sale' columns of current photographic magazines.

2 Additional Equipment

In addition to the camera, the nature photographer needs to purchase particular items of equipment, some of which are fairly obvious accessories, such as flash units and tripods, and some of which are less well known, such as the macrolight and dark activated switch. Some of the items are essential and are used frequently, whilst others have a more specialised application and will be used rather less often.

1 A portable macrolight
2 A sequence-analysis attachment
3 Remote-release systems
4 Flash units
5 Camera supports

1 A PORTABLE MACROLIGHT

The macrolight is a portable ringflash unit which can be used both indoors and in the field. It produces a softer, more diffused, light than direct flash and is particularly effective when working only a few centimetres (or inches) from the specimen. A commercially manufactured ringflash is very expensive to purchase, whereas this unit can be constructed by the photographer very cheaply, because it makes use of a normal compact electronic flash unit as its light source. (The design of this unit is based in part on the Studio Flash Unit which I described in *Amateur Photographer*, 21 May 1975, but mainly on a macrolamp unit described by D. M. Gibson in *Amateur Photographer*, 9 July 1975.)

The main component of the unit is the reflector, for which one could use a metal canister (such as a sweet tin), measuring approximately 14 cm ($5\frac{1}{2}$ in) in diameter and 7 cm ($2\frac{3}{4}$ in) deep. Inside the reflector, four miniature screw (MES) bulb holders (the type used in dolls' houses) are wired in parallel, using any insulated flex capable of carrying 4 amps. The light is produced by four 6

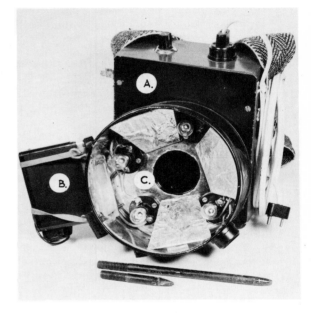

2.1 A portable macrolight unit powered by a 6-volt motor-cycle battery *A*. The flash unit *B* is secured to the side of the reflector *C*. The latter can be either hand-held or screwed onto the camera lens mount

volt MES 950 motor-cycle bulbs rated at 5 watts each, and together they function as the modelling light. Two apertures are cut in the reflector: a central hole of 44 mm ($1\frac{3}{4}$ in) diameter for the attachment of a filter holder, and a 5 cm × 3 cm ($2 \times 1\frac{1}{8}$ in) rectangular hole in the side to admit light from the flash gun. A 48 mm ($1\frac{7}{8}$ in) filter holder (the size required for the camera lens) is glued to the back of the reflector, which allows the latter to be screwed onto the camera lens in the manner of a conventional lens hood. A piece of ground glass is glued to the inside of the reflector

over the rectangular hole, in order to diffuse and reduce the light from the electronic flash unit.

Two rubber bands are used to hold the flash unit in position and, although this method looks rather inelegant, the system does work well and also allows different shapes and sizes of flash unit to be accommodated. The flash is reflected from the inside surfaces of the container, but in order to concentrate the light a little more, three extra reflectors should be fixed at 45° to the main axis. They consist of pieces of card covered with crumpled aluminium foil (to soften the light), held in position with cellophane tape.

The macrolight is normally attached to the front of the camera as shown in the photograph (Fig. 2.2) but it can also be used away from the camera when oblique lighting is required. Using a medium-powered flash unit and 125 ASA film, exposures for close-up photographs between 0.5 and 1 metre ($1\frac{1}{2}$ and 3 ft) are usually in the f16–22 region.

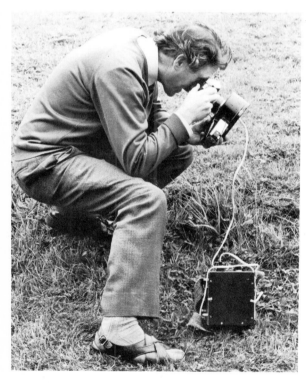

2.2 The macrolight in use on a steeply sloping bankside. The spike screwed into the base of the battery box allows the latter to be firmly located on the steep slope

In order to make the macrolight completely portable, add a separate power pack: as dry batteries are rather expensive to keep replacing, use a lead-acid battery instead. A 12-volt system might seem the obvious choice, but even the smallest 12-volt battery will be much too heavy to carry on field trips. A 6-volt, motor-cycle battery is smaller and lighter, and one with a capacity of 11 amp hours will give good service. The four 5-watt bulbs would take 3.3 amps (20 watts ÷ 6 volts) thus giving the battery a life of just over three hours between charges. This battery should be mounted in a suitable container, with an on/off switch fitted (as shown in the photograph).

It is essential to ensure that the side of the battery which will be in contact with the photographer is smooth and uncluttered for ease in carrying, although the other three sides could well be used to support various accessories. In the example shown, one side housed the cable linking the battery to the reflector, whilst on the opposite side two spikes were clipped. These were used to solve the difficult problem of stabilising the battery when it was standing on uneven ground – a frequent occurrence when working in the field. One of the spikes is screwed into the base of the battery box and the whole unit is then pressed firmly into the ground. This works extremely well, and no matter how steep the working gradient, the battery box can always be fixed in a vertical position (Fig. 2.2). The short spike is used for hard level ground and the long one for soft uneven surfaces. The front of the battery box is used as a support for the reflector, and this is held in position by two spring clips. The unit, which is completed by fitting a shoulder strap, performs extremely well both indoors and in the field.

2 SEQUENCE ANALYSIS USING A MULTIVISION LENS

In recent years many interesting optical accessories have been produced which attempt to make the final image just a little different and more interesting than the normal 'straight' photograph. These accessories include split-field, cross-screen, star-six, variocross, colour-burst, soft-spot and multivision lenses or filters. The multivision lens is of considerable interest to the nature photographer in the analysis of animal movement, and its use in photographing liquid-impact sequences was described by D. C. Emmony in 1975 ('Simple Sequence Photography', D. C. Emmony, *Amateur Photographer*, 16 July 1975).

Briefly, this technique brings together two quite separate characteristics: the three images produced by a three-parallel-face supplementary lens, and the travelling time of a horizontally running focal-plane shutter. The three-face lens which I use is one of the Hoya range, which screws into the lens mount in the same way as a normal filter (Fig. 2.3). It produces three separate images with an overlap area around each image. As the focal-plane shutter moves across the film plane in the back of the camera, the three images are exposed sequentially. The length of exposure given to each image will depend solely on the camera-shutter setting, and for fast-moving structures such as an insect's wings, a 1/1000 sec exposure would normally be used.

The time interval between the three images is dependent on the length of each exposure and the speed at which the focal plane shutter moves across the negative area. The brightness of the three images is proportional to the amount of light coming through each of the three sections of the supplementary lens and, in the lens which I use, the plane glass central strip has an area approximately 20 per cent larger than each side prism. This gives a brighter centre image, but this brightness can be reduced by sticking a small rectangular piece of black paper to both the top and bottom of the central strip.

It is also fairly obvious that the camera lens must be used at or near full aperture, as any stopping down immediately reduces the size of the two side prisms. This multi-image lens is of single-element non-achromatic construction and therefore suffers from the usual optical aberrations. The central image is very acceptable, although the two side images are rather poorly defined.

Figure 2.4 is a schematic diagram showing the

2.3 SLR camera with the three-parallel-face supplementary lens in position

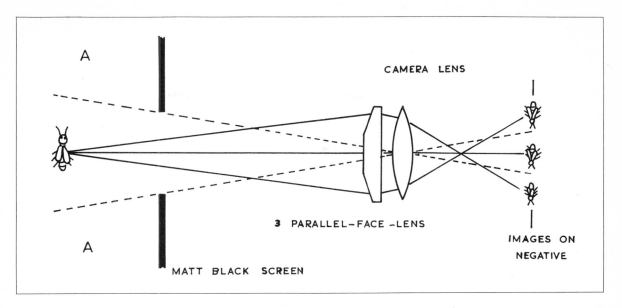

2.4 The light paths and images formed by the three-parallel-face lens shown in simplified diagrammatic form

effect of using the three-parallel-face lens attached to the camera in the normal way.

The two black screens are used to prevent image overlap in the peripheral parts of the field (represented by *A* in the diagram). These areas are not required in the photograph and can be removed either by masking them with the two screens, or by concentrating a spotlight on the specimen and using a black background (ie there will be no detail at *A* to register on the negative). The two screens are placed approximately 50 cm (20 in) from the camera and 15 cm (6 in) from the specimen. The size of the slot between the two screens is not critical and any width between 8 cm (3 in) and 15 cm (6 in) can be used. The total effect is, of course, visible in the camera viewfinder, and the screens, specimen and camera can be moved about as required. (This arrangement was used to photograph the wing movements of the locust as discussed in Chapter 8.)

Some thought can now be given to the actual length of exposure of each image and to the time lapse between the images. These parameters can be studied using a Panax timer/G.M. counter capable of registering time in milliseconds (ie 1/1000 sec). The equipment is placed in the position of the specimen, and photographed at 1/1000 sec exposure, with the two black screens in

place. (These are required because only the central part of the timer is needed, and any image overlap would be a nuisance.) Figure 2.5 shows the three images of the timer at an exposure of 1/1000 sec. The only dial which indicates any change across the three images is the millisecond dial, and this is as one would expect under these conditions. The length of each exposure should be the 1/1000 sec set on the exposure dial of the camera. The timer indicates that the first exposure was 1/1000 sec or slightly longer because the illuminated indicator dot is visible at digits 3 and 4. The second exposure shows the dots at digits 5 and 6 and the third at digits 8 and 9, thus confirming that the second and third exposures were of the same duration as the first. The interval between the first two exposures is approximately 1/1000 sec and between the second and third the interval is approximately 1/500 sec. Examination of other negatives indicates that a time separation of 1/500 sec occurred very frequently. The total time which elapses between the beginning of the first exposure and the end of the third is 6 to 7 milliseconds (ie from digits 3 to 9 on the dials) which is approximately 1/150 sec. To sum up then, this is a technique in which three exposures, each of approximately 1/1000 sec duration, can be made in the space of 1/150 sec, and the technique can therefore be used for photographing and analysing the movement of fast-moving structures such as the wings of an insect, the tongue of a frog or even the strike of a snake.

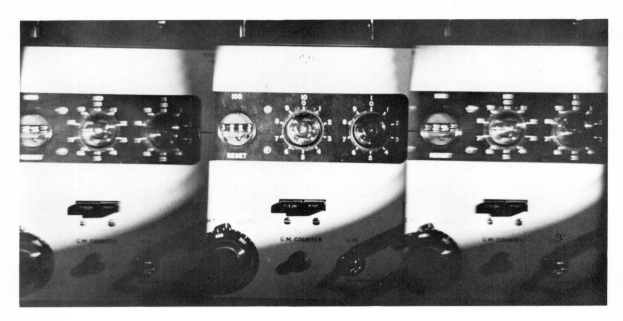

2.5 The three images of the timer produced with a camera shutter setting of 1/1000 sec

3 REMOTE-RELEASE SYSTEMS FOR OPERATING THE CAMERA SHUTTER

There are many occasions when it is not possible for the nature photographer to stay with his camera in order to operate it. Most animals are very timid and will not come near the camera while the photographer is in the vicinity. One can approach to within a certain distance of an animal, but when this limit is exceeded, the animal normally takes flight. This distance is often referred to as the flight distance and varies not only from species to species but also within any one species, depending on factors such as sexual condition, age, or even the time of the day. It is more satisfactory, therefore, to leave the camera set up and focused, and to retreat beyond the flight distance, when the shutter can then be released either by the photographer, or even by the animal itself.

There are several ways of achieving this, including mechanical, pneumatic, electrical and photo-electric methods, or even by using radio waves. The latter refers to a radio-controlled unit which will operate the camera shutter over considerable distances. It requires a transmitter to send the signal, and a receiver–amplifier near the camera to receive and amplify the signal, so that it can be made sufficiently powerful to operate the shutter mechanism. These units are not too difficult for an amateur radio enthusiast to build, working from a radio construction manual.

Mechanical methods

These methods utilise the principle that the camera shutter can be released by pulling the end of a long piece of attached wire or string. Unfortunately the force required to operate the shutter on an SLR camera is quite considerable and it is not easy to envisage a direct-acting system. However, a slight tug on a string can be made to release the potential energy of a coiled spring and this principle is used in both mechanical and electrical release systems.

A conventional mouse trap contains a spring mechanism which can easily be modified to make a very effective shutter-release unit. The method was described several years ago by the American nature photographer, Rus Kinne, in *The Complete Book of Nature Photography*. The unit described here is based on Mr Kinne's model, but it incorporates one or two modifications.

The basic mouse-trap spring is not satisfactory for two reasons. Firstly, the force of the released spring is much too great, and could easily damage the cable-release and shutter mechanism. Secondly, the spring swings through approximately 180° before it comes to rest on the mouse's neck and this angular movement is much

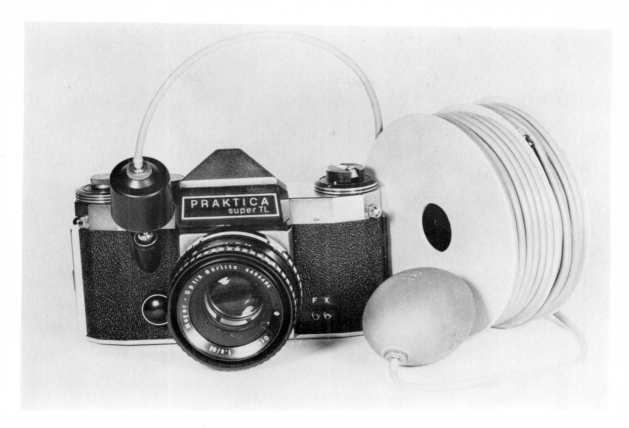

2.6 The Kagra 34 pneumatic release. This is a very simple but efficient release system and has been used on many occasions when it was not convenient to operate the camera manually.

too large to be compatible with the small movement required to operate the camera shutter mechanism.

The mouse trap should therefore be modified in the following way. Remove the short piece of straight wire holding down the spring, reshape it at the far end to form a step, and refit it at the other end of the trap. This wire can now be used to support the spring, which is approximately halfway through its movement arc and has, therefore, lost much of its power. The bait-holder can be removed and the vacant space used to mount the cable release. Solder a piece of tin plate into the wire frame so that it will make contact with the cable-release button when the spring is released. Then glue a wooden block containing a large flat-topped screw to the base of the unit, to act as a stop, and to limit the movement of the spring. This adjustment screw ensures that the

movement of the spring will be terminated as soon as the camera shutter had been released. The height of the adjusting screw may vary according to the type of cable release being used and the make of the camera (hence the necessity for this simple form of adjustment). Finally, glue a drilled block to the base to support the cable release.

To operate the unit, attach a pull-string to the bent wire by a loose loop, so that when the string is pulled, the spring is released and the string falls away from the unit. This is necessary because of the possibility of the string and the unit being dragged away by the animal being photographed. The use of this release unit is discussed in the chapter on mammals.

Pneumatic release

This system uses air under pressure, transmitted by a length of narrow-bore tubing, to push a piston, which in turn releases the camera shutter. The Kagra 34 (Fig. 2.6) is a widely available unit which can be used for distances of up to 10 metres (34 ft). The pressure is developed by squeezing a rubber ball which produces a fairly large force but

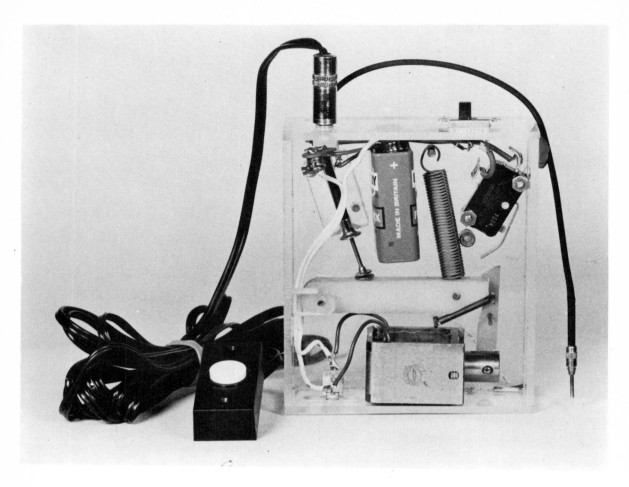

2.7 An electrical release unit designed and built by the author. In this version, the release was activated from a distance by pressing a bell-push switch

a small movement at the camera end. There is a definite time lag as the pressure builds up to a level sufficient to trigger the shutter mechanism and this makes the unit rather less useful than it would be otherwise. Longer lengths of tubing can be used, provided the material is not too elastic (polythene, rather than rubber tubing, should be used) and the small rubber squeezer could be replaced by something larger, such as a bicycle pump. A suitably modified squeezer can be incorporated into two small sheets of hardboard to make a pressure mat which would be activated by the weight of an animal walking over it. The main advantages of the pneumatic release is its utter simplicity and reliability; the disadvantage is the time lag, which increases considerably as greater

distances are involved. The photographs of the young swallows (Fig. 11.8) were all taken using a Kagra 34 pneumatic release extended to its maximum length.

Electrical release using a mechanical switch
This system operates on the same principle as the door-bell chimes in which pressure on the bell-push completes the electrical circuit, thus producing a magnetic field which attracts a soft-iron core which in turn strikes the chime bars. The coil of insulated wire producing the magnetic field, and the soft-iron core acting as a striker, together constitute a solenoid. The moving centre core could be made to operate the camera shutter directly, but it would require a very powerful solenoid to achieve this. In the release unit which I have designed, the solenoid is used to move a lever which releases a compressed spring producing sufficient force to operate the camera shutter.

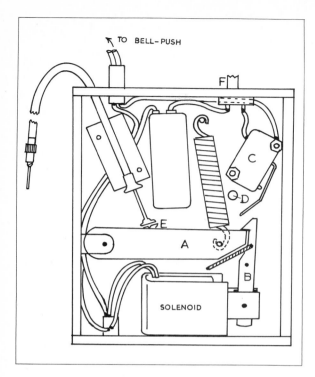

2.8 The electrical release unit: *A* – power arm; *B* – hooked lever; *C* – micro-switch; *D* – stop post; *E* – adjustment screw; *F* – on/off switch

Figure 2.7 shows the details of the release mechanism which was constructed in Perspex (Lucite) because this material is easy to work and pleasant to handle. The unit is 'primed' by depressing the power arm *A*, which is then held in place by the hooked lever *B* (Fig. 2.8). As arm *A* is moved, microswitch *C* is closed, thus completing the circuit at the release end, although it is of course still open at the bell-press end of the circuit. When the bell button is pressed, the circuit is completed, the solenoid is energised and the soft-iron core is drawn in, pulling the end of the hooked lever *B* with it. This in turn releases power arm *A* which moves towards the spring attachment point, squeezes the cable release, and operates the camera shutter.

The position of arm *A* in relation to the cable release was calculated for a particular make of camera and, in order to prevent any possible damage to the camera shutter, a fine adjustment screw *E* was added to arm *A*. The screw height was adjusted so that the shutter release was operated just as arm *A* reached the stop post *D*. As arm *A* swings towards post *D*, it moves the arm of microswitch *C*, thus breaking the circuit again. This switch is therefore a safety device which automatically switches off the battery once the spring has been released. It is not required when the spring-loaded bell-push switch is operated by the photographer himself, because as soon as the button is released the circuit is automatically broken. If, however, a switch is designed to be triggered by a passing animal, then the switch might stay closed for minutes or even hours and this would put an excessive load on the battery. Hence the importance of the automatic circuit-breaker, microswitch *C*.

A manual on/off switch *F* was wired in series with microswitch *C* and was mounted on the outside of the housing. Although this switch is not required when the release unit is triggered by a mechanical switch, it does become very useful when a photo-electric switch is being used. (This is described in the next section.)

The power requirements of the solenoid are not critical and a 9-volt dry battery was selected. The bulky PP9 has a large capacity, but the smaller PP3 has the advantage of being easily mounted inside the unit, so that all that remains outside is the twin flex and the terminal push switch.

Building the unit presented no problems as the components were either easily made or were readily available commercially. The one exception was the solenoid unit and, although I managed to find a 12-volt, 1-amp unit, most of those on the market at the moment are 250-volt units used, for example, in washing-machine switching gear. These will not operate on 9 volts due mainly to the very high resistance of the thousands of turns of very fine wire which make up the coil. However, one of these solenoids can easily be modified by removing the fine wire and rewinding the coil with approximately 500 turns of 32 swg enamelled copper wire. This may sound a very time-consuming task but in fact takes less than an hour to complete. Solenoids suitable for modification are regularly advertised in magazines such as *Practical Electronics* and *Wireless World*.

Electrical release using a photo-electric switch

This system uses the electrical-release unit described in the previous section, slightly modified by removing the 9-volt PP3 battery and including an 18-volt battery, which is housed under the

photo-electric switch circuit board. The bell-push switch at the far end of the circuit is replaced by a photo-electric switch, which is activated when a beam of light shining on it is momentarily interrupted.

The components of this system are: an electronic unit containing the photo-electric switch, a light source which can be focused to prodce a narrow beam, and the electrical-release unit modified as indicated above (Fig. 2.9).

The photo-electric switch unit
The circuit is based on the one provided by R S Components Ltd with their light-activated switch LAS 15. The latter is basically a combined photodiode and monolithic integrated circuit, designed to operate over a range of 11–20 volts. There are two modifications to the circuit; firstly transistor TR2 is included as a logic converter, because LAS 15 is light activated and the unit must be dark activated. Secondly the output, based on R S Components' specification, is approximately 120 mW using a 15-volt input, and this is insufficient to drive the 12-watt solenoid. To increase the output, TR3 is included in the circuit (Fig. 2.10).

The unit functions in the following way. When the beam of light shining on the photodiode LAS 15 is interrupted, the voltage from pin 2 drops and switches on the second transistor, TR2. The current from its collector goes to the base of TR3 and switches on this transistor, which in turn operates the solenoid unit. When the light beam to LAS 15 is restored, the above sequence of events is reversed and TR2 and TR3 are switched off again. The diode BY127 is included as a protective diode to prevent the induced voltage (back emf), produced as the magnetic field in the solenoid collapses, from damaging TR3. The power to the circuit is supplied by two PP4 dry batteries linked in series to give 18 volts. As mentioned earlier, the small PP3 must be removed from the solenoid unit when the photo-electric switch is being used.

For convenience the two PP4 batteries were housed in the base of the photo-electric switch unit, and the circuit board and components were placed on top. A sheet of plastic foam insulation was used to isolate the batteries from the circuit

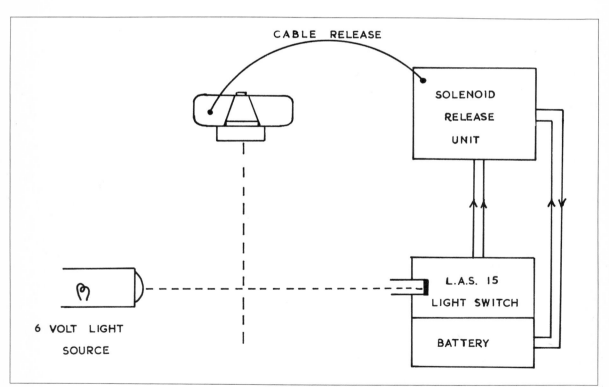

2.9 The main components of the electrical-release system and the interrupted-beam switching unit

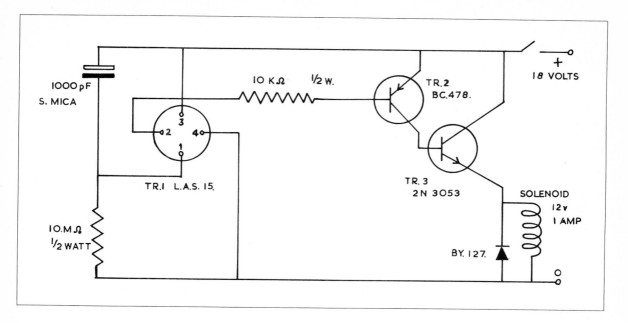

2.10 Circuit diagram of the main components of the interrupted-beam switching unit

board. Photo-diode LAS 15 was shielded from the ambient light by sliding a tube painted matt black over the end of it, so that when the beam of light shining down the tube was interrupted, it was sufficiently dark to trigger the switch.

After a few trial operations it was discovered that the unit became much more sensitive as the light intensity to LAS 15 was reduced. Therefore a sliding plate was fitted over the aperture leading to LAS 15 so that the amount of light entering the tube could be controlled. The ideal position for the plate is when it allows just sufficient light through, to keep the optical switch open.

When the equipment is switched on the current consumption is approximately $1\frac{1}{2}$ milliamps so the unit can be left on for several hours without draining the batteries.

All of the components are readily available and are listed in R S Components' current catalogue.

The light source

The system requires a focusing light capable of producing a narrow beam of light which can be directed onto the surface of the photo-diode. As the rest of the system is designed to operate in the field, an 11 amp hour 6-volt lead-acid battery forms the power supply for the macrolight unit. A 6-volt, 12-watt (motor-cycle) bulb and holder, and a short length of 4 cm ($1\frac{1}{2}$ in)-diameter plastic

water piping plus connector are also required. A lens of approximately 5 cm (2 in) focal length is required to produce a narrow beam of light which can be focused on LAS 15 at a distance of approximately 1 metre (3 ft). (Such a lens is readily obtainable from the H.W. English catalogue.) The lens is mounted in the end of the plastic connector and after removing the O ring, the connector slides onto the main pipe, providing the necessary focusing movement. The unassembled light unit is illustrated in Fig. 2.11.

Setting up the equipment

Let us suppose that the equipment is to be used to photograph a wasp as it alights on an apple. The sequence for setting up and testing the equipment would be as follows.

1 Arrange the light source so that the beam of light passes just above the apple (a white card held above the apple will help to position the light beam).
2 Locate the light switch unit so that the light shines down the tube onto the head of LAS 15.
3 Set up the camera and the solenoid release unit in the appropriate position.
4 'Prime' the release unit by depressing arm *A*. This will close micro-switch *C* but switch *E* will still be open.

2.11 The 6-volt light source built from pieces of plastic water piping. The bulb holder *A* is a press fit into the main body *B*, which in turn slides into the connector *C* at the end of which is located the 5 cm (2 in) focal-length lens.

5 Check that LAS 15 is being fully illuminated by the light beam and then complete the circuit by closing switch *E*. There should be no movement of the solenoid core at this stage. 'Sensitise' the unit by moving the sliding plate to the appropriate position over the aperture leading to LAS 15.
6 Move a pencil through the beam and if the equipment is working satisfactorily the spring will be released and the camera shutter operated.
7 Hold the pencil immediately behind the beam of light and focus on it. This is the point in space at which the photograph of the insect will be taken.

Figure 2.9 shows in diagramatic form the arrangement of the main components of the system. The single-beam system will locate the organism in two planes, but for precise three-plane location a two-beam system is required.

4 ELECTRONIC FLASH UNITS

The financial outlay on expendable flash bulbs can be very high if large numbers of bulbs are used. The best solution is to purchase an electronic flash unit, which, although costing more initially, reduces the cost per flash to an almost insignificant level. The long tube life (in excess of 10,000 flashes), constant colour temperature of around 6,000°K (close to daylight), and negligible heat production, make it a very useful light source for the photographer.

The flash is produced when an electrical discharge takes place in a sealed envelope containing one of the rare gases, usually xenon. The duration of the flash ranges from 1/500 sec to 1/1500 sec, depending on the design of the tube and its electrical circuits. Although the early electronic flash units were large and heavy, and required bulky high-voltage (eg 180 volts) batteries, the modern unit is light, very compact and is powered by either small low-voltage 'pen-lite' batteries (eg four in series would give six volts), or a hermetically sealed rechargeable nickel-cadmium accumulator, or direct from the mains.

Flash factors
The amount of light produced by an electronic flash is sometimes quoted in terms of the electrical energy stored in the capacitor, and is measured in joules (= watt seconds).

$$\mathcal{J} = \frac{CE^2}{2}$$

\mathcal{J} = power loading in joules
C = capacitance in microfarads (mfd)
E = voltage in kilovolts

Thus a 500-volt 800 mfd flash unit will have an output of 100 joules which is approximately the same flash power as a PF1B bulb. However, a much more useful way of describing the output of a flash unit is to state its *guide number* (sometimes referred to as the *flash factor*) for a particular film speed. Thus a guide number of 18 with 50–64ASA colour film means that, for correctly exposed negatives, the product of the lens aperture (ie f number) and the distance, must be 18. For

example, at a distance of 3 m (10 ft) the aperture would be f6 or at 6 m (20 ft) it would be f3. This information applies to both flash bulbs and electronic- units, and guide numbers for bulbs and tubes are always supplied with the equipment. Obviously the exposure obtained by this simple calculation may need modifying if working under 'abnormal' conditions. For example, if photographing a small organism inside a polished metal box or against a white background, the lens can usually be stopped down an extra stop to compensate for the highly reflective background. Similarly an animal photographed in the open at dusk would probably require a larger aperture than the one calculated, to compensate for the lack of light-reflecting surroundings. Experience becomes important under these conditions.

A few years ago the computer flash was developed so that correctly exposed negatives could be produced without having to calculate f numbers and distances. A typical example is the Mecablitz 213, in which the telecomputer is controlled by a highly sensitive photo-transistor, which measures the light reflected by the subject and feeds the value into the telecomputer. The flash duration is determined by comparison with a preset value and as soon as the correct amount of light has been produced the flash is switched off.

The duration of the flash ranges from 1/1,000 to 1/50,000 sec depending on the working distance, film speed and lens aperture. This unit will operate down to a distance of approximately half a metre (19 in) after which two problems arise which tend to prevent the effective use of computer control. Firstly, when working close to a specimen and using extension rings or bellows there is an extension factor to be applied to the basic exposure. The computer flash is unaware of this, and the negatives will be underexposed. Secondly, in close-up work one invariably uses a small lens aperture to obtain extra depth of field but with a computer flash this is not often possible. For example, when using 100 ASA film, one can select either f5.6 if working up to 4.5 m (12 ft) away from the specimen, or f11 if up to 2 m (6 ft) away. A small aperture of f22 can only be used when working within 2 m (6 ft) of the specimen and using fast 400 ASA film and it is unlikely that the nature photographer would use film of this speed very often.

The above information relates to the Mecablitz 213 which has a guide number of 25 metres (82 ft) with 100 ASA film, and a choice of two apertures.

Small apertures can be selected more readily when using a more powerful 'three-aperture choice' flashgun. In all cases the computer control can be switched off, when the flashgun reverts to manual operation.

Two small flash units (computer control is not essential – but useful on occasions), with guide numbers of approximately 25 metres (82 ft) with 100 ASA film, would enable the photographer to tackle successfully most of the nature photography assignments he is likely to encounter. Whether the units should be dry-battery operated or 'ni-cads' powered is to some extent a question of finance, but having used both types, I favour a rechargeable 'ni-cads' unit, which can also be operated direct from the mains supply. The Mecablitz 213 has a four-hour recharging time and, even after a one-hour recharge, ten flash photographs can be taken.

Flash synchronisation
It is necessary to know how the shutter mechanism is synchronised so that the peak output of the flash coincides with the time when the shutter is fully open. The different types of synchronisation for 'leaf-blade' shutters are as follows.

Class X synchronisation
In this form of synchronisation the electrical contact is made when the shutter blades are fully open. It is, therefore, ideal for electronic flash where the time to peak is so very short. All other bulbs can be used if the shutter is kept open long enough for the bulb to ignite and burn (see Table 2.1).

Table 2.1 Types of Flash Synchronisation

Type of flash	Type of synchronisation on camera	
	X	M
Class F bulbs	1/50 sec or longer	no good
Class M bulbs	1/25 sec or longer	all speeds
Electronic Flash	all speeds	no good

Class M synchronisation
Here the electrical contact is made 16.5 millisec before the shutter is fully open. This delay in the shutter opening allows time for a bulb to ignite and to reach 50 per cent light output by the time the

shutter opens. It is therefore ideal for Class M bulbs which can be used at all shutter speeds (see Table 1.1). Needless to say, an electronic flash would have been discharged long before (about 15 millisec) the shutter blades had opened.

Table 1.1 indicates that X and M synchronisation would cover all one's requirements and such a camera is often described as 'fully synchronised'. If only one type of synchronisation is available, then X would be the most useful, because it is the only one which allows the use of electronic flash. (The V marking located next to the XM markings simply denotes a 'delayed action' mechanism, and has nothing to do with the flash synchronisation.)

The synchronisation of focal-plane shutters is more difficult to achieve because it could take up to 30 millisec for the slit in the blind to travel across the film surface. During this period a flash bulb should be producing a constant level of illumination so that the negative is uniformly exposed over its entire surface. Therefore slow-burning focal-plane bulbs are required and this type of synchronisation is referred to as F.P. When using electronic flash, X synchronisation is available and the flash is triggered off when the entire negative surface is uncovered at one time. This occurs at a slow speed of between 1/30 sec and 1/60 sec. When electronic flash is the main source of light there are no problems, because the short flash duration will 'freeze' any moving object, but if the flash is used in bright light as a 'fill-in' light, the slow shutter speed necessary for its use may not be fast enough to stop 'blurring' of a moving object.

5 CAMERA SUPPORTS (TRIPODS, CLAMP TRIPODS, SHOULDER PODS)

How often does a photographer complain that his camera lens is a little on the 'soft' side and lacks 'bite', only to find on critical examination of the negatives that camera shake is the real culprit. One does not have to possess visibly trembling hands to produce camera shake, and this can be amply demonstrated by fixing an electric torch onto the camera and observing the shaking patch of light on a nearby wall.

A useful general guide as to whether a camera can be held is to check that the calculated exposure is no longer than the reciprocal of the focal length of the lens being used. For example, a 50 mm lens can be hand held at 1/50 sec or less, whilst a 200 mm lens would require a 1/200 sec. This only applies to the normal range of lens distance settings, and if one is working close to the specimen then the situation becomes more critical, and even shorter exposures are required to prevent camera shake being visible on the negatives.

A tripod is the obvious solution to this problem and the sturdiest that can be carried is recommended. If one intends to do a lot of nature photography indoors or in the garden, then I would suggest buying one of the heavy duty ex-government instrument tripods advertised in the H.W. English optical catalogue. They are not expensive, but they are heavy and very rigid. I also favour a pan-and-tilt head in preference to the conventional ball-and-socket, as the former seems to allow much better camera control than the latter.

The camera clamp table tripod is a useful little support and is worthy of a place in the gadget bag. It consists basically of a ball-and-socket head mounted on a G clamp. The latter can be fixed to a railing or bench when it is not convenient to use a conventional tripod. The body of the clamp contains three short legs and sometimes a very useful threaded spike. The former screw into the clamp base to form a small table tripod, and the latter, when attached, enables the clamp to be screwed into tree trunks and other soft wood. (The photographs of the young swallows, Fig. 11.8, could not have been taken without this useful camera support.)

A final method of supporting the camera is with a shoulder pod. This consists of a rifle butt with the camera attached to the 'firing' end. It is particularly useful when photographing moving animals and its use is discussed in the chapter on bird photography.

It is worth mentioning that, whichever camera support is adopted, maximum benefit can only be achieved by using a cable release. In this way the camera shutter can be operated without, as it were, 'touching' the camera, as no camera movement is introduced via the cable release.

3 Close-up Techniques_____

A naturalist often studies small organisms and therefore much of his photographic work has to be done at close range so that a large image can be produced on the negative. The term 'close-up' is used when the reproduction scale ranges from 1:20 (image to object ratio) to 1:1. Photomacrography refers to a reproduction scale from approximately 1:1 to 20:1, and photomicrography to a range from 10:1 to 1200:1. Close-up and photomacrographic techniques will be considered together, and this chapter will deal with simple arrangements using inexpensive cameras and then progress to the use of more sophisticated equipment.

CLOSE-UP WORK WITH A SIMPLE CAMERA

The fixed-focus camera can be used to photograph objects from infinity down to about 2 m (6 ft), but, in order to get closer than this, either the lens-to-film distance must be increased or the focal length of the lens must be reduced. The former is impossible with a fixed focal lens, but the focal length of the system can be reduced by placing a supplementary lens in front of the normal camera lens. This will bring the light to a focus in the film plane instead of beyond it (Fig. 3.1).

Supplementary lenses

The amount of convergence produced by a simple lens (ie its 'power') depends on its focal length. Unfortunately most manufacturers describe their supplementary lenses in terms of dioptric power, where a dioptre is the reciprocal of the focal length in metres; eg a 1 m (3 ft) focal-length lens is a one-dioptre lens, and a 0.5 m (19 in) focal-length lens is a two-dioptre lens. The dioptre is a unit used by opticians to express the magnifying power of spectacle lenses, and although these have ceased to

be used as camera supplementary lenses, the term lingers on.

Most supplementary lenses are of the convergent or positive type (designated '+') but divergent or negative lenses (designated '−') are available. If a simple supplementary lens were to be used with an expensive highly corrected camera lens, would the optical performance of the system be greatly reduced? In theory the answer is 'yes', but in practice this is not so for three reasons. Firstly, supplementary lenses tend to have a long focal length and little surface curvature, therefore many of the aberrations are correspondingly reduced. Secondly, because close-up work requires the use of a small working aperture to achieve an acceptable depth of field, only the centre of the supplementary lens is being used and this again reduces, or even eliminates, some of the lens aberrations. Finally, because the object of principal interest tends to be in the centre of the field, any fall-off in definition towards the edges will be obscured by normal out-of-focus effects and is quite acceptable or even desirable. High-quality supplementary lenses are ground and polished with the same degree of accuracy as the best photographic objectives and are even 'coated' to increase contrast and light transmittance.

Supplementary lenses can also be used on cameras which possess a focusing but non-interchangeable lens and, although most manufacturers supply information about camera lens distance settings and subject distances, the effect is very obvious when an SLR camera is being used.

Parallax problems

The next problem relates to the framing of the picture and is concerned with the disparity which exists between what is seen in the viewfinder and what the camera actually photographs. This was discussed fully in the preceding chapter and when

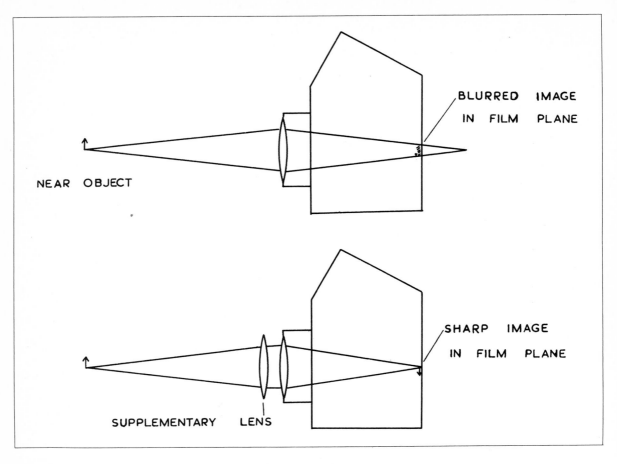

NEAR OBJECT

BLURRED IMAGE IN FILM PLANE

SHARP IMAGE IN FILM PLANE

SUPPLEMENTARY LENS

3.1 The function of a supplementary lens in close-up work

working at close quarters the problem is at its greatest. Several solutions have been found, resulting in methods which are slow in operation and useful only for static subjects. Some cameras can be fitted with a frame-finder in which different-sized masks are slotted in the front section, whilst the rear section is adjustable for height. A range of masks and rear-view positions are used for different distances and although the frame-finder solves the 'framing' problem, it provides no assistance in determining the working distance between the subject and the camera. It must therefore be used in conjunction with a tape measure, ruler or special close-up rangefinder.

Another method is to construct a wire frame (or frames) which can be attached to the lens mount. This can be adjustable, to operate at different distances (Fig. 3.2), or a series of separate units can be made to cover a range of distances. The size of

the frame can be determined by setting the camera at the required distance and focusing on a sheet of squared paper. If the camera back is opened and a piece of tracing paper, or ground glass, placed in the film plane, the limits of the image can easily be observed and the focusing checked.

The above discussion gives some indications of the problems involved in close-up work using a simple camera. These problems do not exist with the SLR, where, irrespective of object distance, the image seen in the viewfinder is exactly the same as that produced on the negative.

CLOSE-UP WORK WITH A SINGLE-LENS REFLEX CAMERA

In order to obtain a good close-up, either the focal length of the lens must be reduced, or the lens-to-film distance must be increased. A few SLRs, eg Zeiss Ikon Contaflex Super B.C. and Kowa S.E.

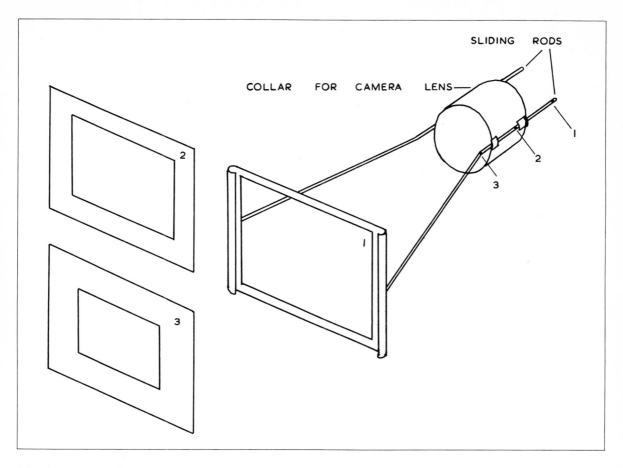

3.2 Close-up frames for non-reflex cameras

and H., have non-interchangeable lenses and therefore a supplementary lens must be used to shorten the focal length of the system. However, since most SLRs have interchangeable lenses it is not difficult to increase the lens-to-film distance. This can be achieved by using either extension tubes or a bellows unit and both are relatively cheap to buy and easy to use (Fig. 3.3).

Extension tubes are made up in sets of three or four of different lengths, and they can be used singly or in any combination. The cheaper ones are not automatic, ie they do not link the shutter-release button to the fully automatic diaphragm pin, and therefore, either a double cable release is required, where one cable operates the lens diaphragm and the other the shutter mechanism, or the lens diaphragm must be set on 'manual' and stopped down to the working aperture just prior to making the exposure.

The more expensive extension tubes are fully automatic and allow full use of the automatic diaphragm without the intervention of a double cable release. The main disadvantage of extension tubes in addition to the length of time it takes to select and fit them, is that occasionally one cannot obtain the desired length so that the image is a little too large or vice versa. The existing focusing mechanism of the lens can of course be used, but for these large lens-to-film distances it acts mainly as a fine-focusing adjustment.

The above problems can be overcome by using a bellows unit instead of extension tubes. Within the limits of the bellows any lens-to-film distance can be selected and the movement is smooth and accurate. A few years ago one had to search for a miniature bellows unit and then pay a high price for it, but today the great popularity of the SLR camera has allowed manufacturers to produce

31

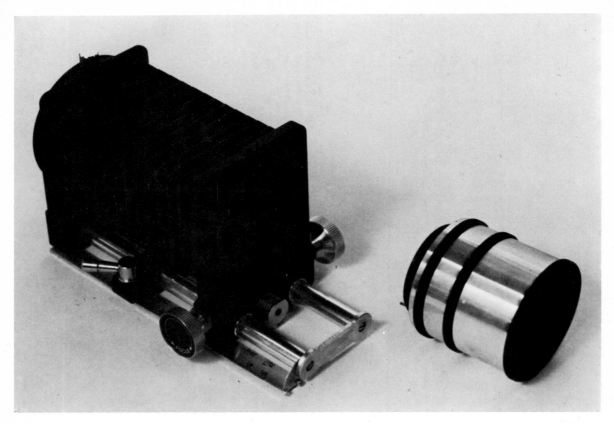

3.3 An inexpensive bellows unit and a set of automatic extension tubes

these units in volume and at very competitive prices. When using them with an automatic lens, a double cable release is required, or the lens diaphragm can be operated manually.

With a bellows such as the one illustrated in Fig. 3.3 the image to object ratio ranges from 1:1.3, with the bellows closed, to 2.5:1 with them fully extended. Twin guide rails are provided for maximum rigidity and accurate alignment. A two-stage focusing system allows the bellows to be quickly extended to approximately the correct position and then a micro-focusing knob is used for critical focusing, after which it can be locked in position.

The modern multi-element lens is so well corrected that it can produce satisfactory images down to an image:object ratio of 1:1. Symmetrical lenses are preferable and asymmetrical ones should be reversed when used for close-up work. Several manufacturers supply reversal rings for this purpose.

Although the standard 50 mm lens will produce very good close-ups there are sometimes difficulties with the illumination because of the very close proximity of the camera lens to the subject. If a lens of longer focal length is used, the working distance can be increased, thus making it easier to illuminate the subject and also to avoid disturbing it. Several manufacturers have designed special macro-lenses which operate with a normal bellows unit and permit a maximum magnification ratio of 1:1.3. This can be increased still further by the addition of extension tubes to the bellows unit. Originally only specialist manufacturers such as Leitz of Wetzlar produced macro-lenses but once again the popularity of the SLR camera has opened up the field of close-up work to all, and the demand for a highly corrected lens with a flat field has been met by several manufacturers at very competitive prices. A working arrangement consisting of a macro-lens and bellows unit is shown in Fig. 3.4.

could result in a reduction of resolving power. Most miniature cameras will stop down to f16 and this small aperture can safely be used to achieve a reasonable depth of field in close-up work (Fig. 3.5).

EXPOSURE

The f numbers on the lens mount only apply when the lens is focused at infinity, but over the normal focusing range of the camera, the lens-to-film distance does not alter sufficiently to cause an appreciable change in the f number. However, when used for close-up work, the lens-to-film distance could be double the normal value and the f number would change accordingly. The magnitude of this change, which is an increase, is called the extension factor F and it can be calculated using the increase in the lens to film distance v, the focal length of the lens f and the magnification M, according to the following equations.

$$ F = (\frac{v}{f} + 1)^2 \quad \text{or} \quad F = (M + 1)^2 $$

Table 3.1 Extension Factors in Close-up Work

Image-to-object ratio	Extension factor
1:20	1.10
1:10	1.21
1:5	1.44
1:2	2.25
1:1	4.00
2:1	9.00
4:1	25.00
10:1	121.00

Table 3.1 shows that when working with image-to-object ratios down to 1:5 the exposure does not increase appreciably, but for ratios of 1:1 or more the required increase in exposure becomes very large indeed.

Before applying an extension factor, there must be an exposure to modify. Exposure meters built into cameras, whether coupled or uncoupled, are not very satisfactory for two reasons (this does not apply to 'through-the-lens' metering systems). Firstly the angle of acceptance of the exposure meter will not be the same as that of the camera lens, and therefore the meter will be estimating the exposure of an area different from that seen by the camera lens. Secondly, the problem of parallax

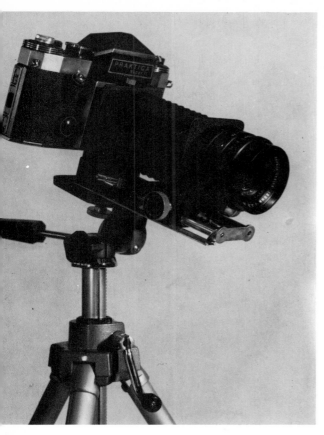

3.4 A typical working arrangement consisting of a macro-lens, bellows unit and camera, mounted on a substantial tripod

DEPTH OF FIELD

When doing close-up work the depth of field produced by the lens is a very important consideration. A general rule is: the greater the magnification, the smaller the depth of field. The depth of field for a 50 mm lens at f4 focused at 3 m (10 ft) extends from about 2.75 m (5 ft) to 4 m (13 ft), a total depth of 1.25 m (4 ft). When the same lens is focused at 1 m (3 ft) the depth of field at f4 extends over 8 cm (3 in) and with the lens focused at 25 cm (10 in) the depth of field is a mere 11 mm ($\frac{3}{8}$ in). This means that focusing accuracy is very critical at close distances, and in the absence of a focusing screen or special rangefinder, the distance must be measured with a tape measure. However the depth of field can be improved considerably by stopping down the lens, although overdoing this

3.5 Depth of field. The photographs were taken on the following lens apertures: f1.8 *A*; f5.6 *B*; f16 *C*. The camera was firmly supported on a tripod

will be very great and again the meter will be measuring light which will not be part of the negative. A separate exposure meter is perfectly satisfactory for close-up work in daylight, but can only be employed successfully with artificial light up to an image-to-object ratio of about 1:10. For photomacrography at higher magnifications, the normal exposure meter is not suitable unless it has a very small angle of acceptance. The difference between daylight and artificial light is here related to the size of the subject field being illuminated. In daylight a large area is evenly illuminated even when the subject field is small, but with artificial light only the subject tends to be illuminated and if the latter is very small it will be lost in the non-illuminated background, therefore the meter reading will not be accurate for the subject being photographed.

A possible solution to the problem would be to use a cadmium sulphide meter containing a small

photocell and having a narrow angle of acceptance. This could then be brought close to the subject being photographed, taking care not to obstruct the light beam. The image-to-object ratio would then be estimated, from which the extension factor could be obtained. The product of the basic exposure and the extension factor would give the actual exposure required.

None of the above problems arise with an SLR camera equipped with TTL metering. Any focal length of lens can be used with any length of bellows extension, because only light reaching the pentaprism area, via the taking lens, is being measured, and therefore a direct reading can be taken. There is no doubt that the advent of TTL metering has completely transformed the ease with which close-up work and photomacrography can be accomplished, and the time-consuming calculations and anxiety about correct exposures are completely eliminated.

ILLUMINATION FOR CLOSE-UP WORK

The chief sources of illumination for close-up work are daylight, electronic flash, flash bulbs and tungsten lamps.

Natural daylight allows work to be done in the field and this may be vital to an ecologist or animal-behaviour specialist. On a clear cloudless day the light is highly directional and the rays are almost parallel. This gives clear-cut shadows which often produce an apparent increase in sharpness of the image. It is certainly advantageous where finely sculptured surfaces, such as the wings of insects, are being photographed. A lightly overcast sky produces a softer more diffused light which on occasions can be more useful than a hard direct light. Unfortunately the photographer cannot 'switch on' the type of sunlight he requires and the author has spent many hours waiting for the best type of sunlight to become available.

A small electronic-flash unit can be a very useful light source in the field and it has been aptly called 'portable sunlight'. It represents the best source of illumination for close-up work and its characteristics of high light intensity, short duration and daylight colour temperature have already been discussed in Chapter 2. The high light intensity allows a small lens aperture to be used, which produces a much desired increase in depth of field. A very short flash duration of about 1/1000 sec is brief enough for the camera to be hand-held and to 'freeze' any movement of the organism being photographed. The colour temperature of

approximately 6,000°K allows daylight colour film to be used with electronic flash, both in the laboratory and in the field so that only one type of film need be bought. To achieve a three-dimensional effect (ie modelling), two, or even three, flash units can be used simultaneously, either linked together with extension leads or fired by electronic slave units. If the specimen is completely static the same flash unit can be fired from different positions thus building up a two- or three-flash effect on the same negative.

Electronic flash can be used in the field either as a 'fill-in' light or as the main source of illumination. As a 'fill-in', it is used to lighten some area of deep shadow and in the final print the effect should look natural, with the overhead sun providing the main illumination. This is achieved by using an exposure meter to estimate the basic exposure (eg 1/100 sec at f8) and then considering the effect of the flash.

If the flash unit were 1 m (3 ft) away from the specimen and the flash factor was 8, then an aperture of f8 would be required were the flash being used as the main source of illumination. Since it is being used only as a fill-in light, and as an acceptable highlight/shadow ratio is about 3:1, then the effect of the flash needs reducing to about one-third of its main light value. The aperture must, therefore, be reduced from f8 to f16. To keep the main light exposure (the sun) equal to its correct original value of 1/100 sec at f8, it now becomes 1/25 sec at f16. The aperture is now correct for the fill-in flash, and the shutter speed of 1/25 sec coupled to an aperture of f16 would be correct for the main source of illumination.

If the flash unit is used as the main source of illumination, then the ambient light could be ignored almost completely by changing the shutter speed from 1/100 sec, which allows daylight to play a part, to 1/1000 sec, when the effect of daylight would be almost nil, but the effect of the flash would be exactly the same. This technique will work only with leaf-blade shutters, which are synchronised for electronic flash at all speeds and cannot be used with focal-plane shutters which are synchronised at a relatively slow speed of approximately 1/30 sec.

Electronic flash is also ideal for photographing nocturnal animals in their natural environment at night. The camera can be set up and focused, after which the operator retires some distance away and at the appropriate moment actuates the camera and the flash via a long remote-control release – eg the

Kagra 34 extends to 11 m (36 ft) — or by an electronic switching device. It is of course possible to set up trip wires or light beams so that the animal itself triggers off the camera and flash by disturbing the trip wire or interrupting the beam. The foregoing discussion about the use of electronic flash also applies to flash bulbs, in particular the blue-coated bulbs which are balanced for daylight colour film.

The third source of illumination is the tungsten lamp. There are many different types ranging from the 100-watt domestic lamp to the overrun photoflood, and the high-intensity low-voltage halogen lamp. A small object or animal can be illuminated by an ordinary domestic lamp but, when it is brought close enough to give sufficient illumination for a short exposure, much of the light does not fall on the specimen; however, the amount of heat emitted becomes considerable due to the closeness of the lamp. Since the colour temperature of the domestic lamp is around $2,900^\circ$K, colour film balanced for artificial light should be used. Photofloods, on the other hand, are relatively cheap to buy, and give a high light output, but because they are 'overrun' (ie running at a higher voltage than would be normally acceptable) they also emit large quantities of heat. The colour temperature of a photoflood lamp is approximately $3,400^\circ$K.

In close-up work one is dealing with small areas and therefore any light source, to be efficient, must be concentrated to cover this small area. This can be achieved by incorporating an optical system into the illumination source. At its simplest, this would consist of a concave mirror behind the lamp and a convex lens in front of it, thus producing a miniature spotlight. A naturalist might not possess a spotlight, but he probably has access to a slide/filmstrip projector which has basically the same optical system as a spotlight. It would not matter if it were equipped with a mains-voltage tungsten lamp or a high-intensity low-voltage tungsten lamp, although the latter often produces a 'whiter' light (ie a higher colour temperature) and emits less heat.

Unfortunately, because the light is concentrated onto a small area, so also is the heat, and if the specimen is temperature sensitive, a heat filter, such as a glass heat filter, or a water bath, or a 25 per cent ferrous sulphate solution, must be used. This can be introduced into the beam of light at any point before it falls on the specimen.

It is worth remembering that a specimen can be illuminated from above by placing the slide projector on top of a box and reflecting the horizontal beam off a 45°-inclined mirror down onto the specimen. This eliminates the need to move the projector from the normal horizontal position to the very abnormal vertical position in which its lamp would very quickly burn out, because it is not designed to operate in this position. The colour temperature of tungsten projection lamps is in the range of $3,000^\circ$K to $3,200^\circ$K.

Another type of tungsten lamp which is becoming increasingly popular is the quartz halogen lamp, in which the tungsten filament burns at a very high temperature in the presence of a halogen such as iodine. The tungsten, which normally evaporates from the filament, and condenses on the glass, causing blackening and the eventual failure of the lamp, reacts with the halogen to form a volatile compound which is carried by convection currents back to the filament area where it decomposes, liberating atoms of tungsten and halogen. The tungsten atoms concentrate as a cloud around the filament, thus decreasing the evaporation rate of the tungsten. This results in a longer and more efficient life for the lamp. Because of the high temperatures involved, the lamp is made of very hard glass, or in quartz, hence the name quartz halogen. These lamps have a colour temperature of between $3,200^\circ$K and $3,400^\circ$K which remains unchanged during the long life of the lamp. They are used in slide projectors, microprojectors, high-intensity microscope lamps and as substitutes for normal photofloods in close-up and portrait work.

Finally one should mention that in close-up work the camera should be mounted on a firm tripod, so that it can be accurately focused and the specimen carefully positioned. A tripod with an adjustable centre column and a substantial pan-and-tilt head is ideal. The centre column allows very rapid vertical movements of the camera without disturbing the tripod legs and the author has found that a pan-and-tilt head seems to be easier to use than the more conventional 'ball-and-socket' head, particularly when the centre of gravity of the camera has been disturbed by the addition of a bellows unit or telephoto lens. Because a tripod is being used, a cable release is an obvious necessity and this combination should eliminate any possibility of camera shake. Finally an efficient hood is desirable, particularly when some degree of back lighting is involved.

4 Photomicrography _____

This chapter deals with image/object ratios ranging from 10:1 to 1200:1 and in all cases a microscope is the basic requirement. The low-power work is usually done with a binocular microscope producing a magnification of × 10 or × 20, whilst the high-power work is achieved with the conventional monocular microscope. If a considerable amount of high-quality work is to be done then either an SLR camera, or a complete photomicrographic attachment will be required.

THE MICROSCOPE
The nature photographer unfamiliar with the modern microscope may never have contemplated buying, or even attempting to use, such an instrument because it looks so expensive and complex. Yet a satisfactory secondhand microscope can be bought for the price of a good-quality telephoto lens and its basic operation can be mastered in a few hours.

The modern microscope is merely a sophisticated magnifying glass, the sole function of which is to produce a highly magnified image of a very small specimen (Fig. 4.1). It consists of a magnifying system to enlarge the specimen being studied, a lighting arrangement to illuminate it, and a focusing mechanism to bring the specimen into sharp focus. The instrument stands on a base consisting of two or sometimes three feet and is supported by a backbone which is usually referred to as the limb. The slide containing the specimen is placed on the microscope stage and held in position by a pair of spring clips.

Magnification system
The final magnification is achieved by using two separate magnifiers: an objective lens, which is screwed into the rotating nosepiece, and an eyepiece lens, which is located at the end of the eyepiece tube. The objective lens is of multi-element construction and its magnification and numerical aperture (see page 46) are engraved on the lens barrel. Objective lenses are available in a range of magnifications from × 2.5 to × 100 and those most useful to the nature photographer are at the lower end of the range, ie × 2.5, × 6 and × 20. Much interesting work can be done using only one objective, such as a × 6, whilst others can be bought as required. Fortunately the diameter and thread are standard and with few exceptions there is complete compatibility between different manufacturers' products.

The objective lens is the prime magnifier and is responsible for the resolution of fine detail in the material being studied. The other half of the magnifying system is the eyepiece lens and its function is to magnify the image produced by the objective lens and thus make the final detail visible to the eye. Eyepieces are simpler in construction than objectives and are therefore much less expensive. The two most popular eyepieces are the × 6 and the × 10 although × 4 and × 20 are readily available. The final magnification is the product of the magnifications of the objective and the eyepiece, thus a × 20 objective and a × 6 eyepiece will produce a final magnification of × 120, and by changing the eyepiece for a × 10, the final magnification will increase to × 200.

Illumination
The function of the illuminating system is to deliver maximum light onto the very small specimen being studied. The latter must be almost transparent so that the light can pass through it from below, then through the objective lens and eyepiece, and finally into the eye. The simplest arrangement is to allow light from a nearby window or reading lamp to be reflected from the surface of a concave mirror, and brought to a focus on the surface of the microscope stage where the

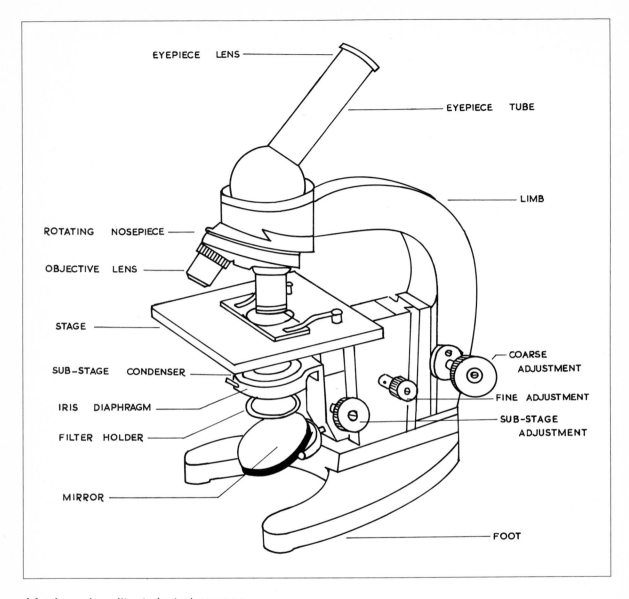

EYEPIECE LENS

EYEPIECE TUBE

LIMB

ROTATING NOSEPIECE

OBJECTIVE LENS

STAGE

SUB-STAGE CONDENSER

IRIS DIAPHRAGM

FILTER HOLDER

MIRROR

COARSE ADJUSTMENT

FINE ADJUSTMENT

SUB-STAGE ADJUSTMENT

FOOT

4.1 A good-quality student microscope

specimen is located on a slide. This is quite satisfactory when using low-power objectives but for higher magnifications a more complex system is required to concentrate more light onto a smaller area.

This consists of a light source, either built into the microscope or as a separate unit, and a condenser lens to concentrate the light onto the specimen. The distance of the condenser lens from the specimen can be varied to enable different-sized specimens to be fully illuminated. When using a condenser lens, the light-concentrating property of the concave mirror is not required, and it is rotated to bring the plane mirror into use. Below the condenser lens there is an iris diaphragm which controls the amount of light reaching the specimen.

The objective lens does not have its own iris diaphragm but its working aperture can be accurately controlled, albeit rather remotely, by

adjusting the sub-stage condenser diaphragm. When the top element of the objective lens is fully illuminated, it is then working at its full numerical aperture, but, as the condenser diaphragm is stopped down, so the working aperture of the objective lens becomes smaller resulting in an increase in depth of field and a reduction in light intensity.

Beneath the iris diaphragm there is a filter carrier which can be swung into the beam of light when required. A range of standard filters is available, and their specialised use is discussed later in this chapter. For normal work the filter carrier is left empty.

Focusing mechanism

The specimen being studied is brought into focus by moving the magnifying system either towards or away from the specimen. On traditional microscopes, the objective lens, body tube and eyepiece lens move as one unit, whilst the stage and specimen remain stationary. Today, many microscopes have a fixed optical system and a moving stage, in other words the specimen and stage are moved towards the magnifying system until the specimen comes into focus.

In both systems the movement is controlled by a coarse adjustment (rack and pinion) which brings the specimen into focus, and then by a fine adjustment (screw) which produces the very small movements necessary to examine the specimen at all levels. The higher the magnification, the more critical is the focusing and when using a $\times 45$ objective lens the working distance (ie the distance between the top of the slide and the bottom of the lens) is only 0.5 mm. Under these conditions the coarse adjustment is just not sensitive enough and the fine adjustment is in use all the time.

Setting up the microscope for transmitted light

The microscope must be set up correctly if good results are to be obtained, and the following sequence of operations is suggested.

1 Select the lowest-power objective and rotate the nosepiece to bring the objective into the light path.
2 Place the slide containing the specimen on the microscope stage and position it centrally over the circular hole in the stage. Apply two spring clips to the slide. This does not prevent movement of the slide but merely makes for easier control.

3 Place a reading lamp about 15 cm (6 in) from the stage and adjust the lamp so that the light shines down onto the mirror.
4 Adjust the mirror (plane side if condenser lens is fitted, concave side if not) so that the light falls on the centre of the specimen. To achieve this, observe the slide from the side of the microscope and not by looking down the eyepiece.
5 Now look down the eyepiece and adjust the mirror so that the field of view is evenly illuminated. Move the condenser lens up or down to achieve maximum illumination.
6 Move your head to the side of the microscope and, using the coarse adjustment, rack down the objective lens to within a few millimetres of the slide.
7 Look down the eyepiece and, using the coarse adjustment move the objective away from the slide until the specimen comes into focus. This method is much safer than focusing down onto the material, when there is a great danger of the objective touching, and often cracking the slide. Check the mirror and condenser-lens positions.
8 Remove the eyepiece and look down the tube to observe the top of the objective lens being used at the time. Stop down the sub-stage iris diaphragm until a dark ring appears around the edge of the bright circle of light, and continue until the bright circle is reduced to about three-quarters of the total diameter of the objective lens.
9 Replace the eyepiece and examine the specimen. The objective lens has now been stopped down and the image should be evenly illuminated and clearly defined. The iris diaphragm can be stopped down still further, when greater depth of field will be obtained at the expense of the brightness of the image.

Many microscopists omit stages 8 and 9 and adjust the iris diaphragm according to the density of the specimen and the type of work being done. When examining a specimen at fairly high magnifications the fine adjustment should be in almost constant use so that visual information collected at different levels through the specimen can be processed by the brain, resulting in an appreciation of the full three-dimensional structure of the specimen.

When buying a new or secondhand microscope, one should avoid any which have smaller than standard objective lenses, ie toy microscopes. Their optical performance is well below that required for photomicrography and they are not sufficiently robust to withstand the stresses

imposed by an attached camera. Even a full-sized microscope can be stressed out of optical alignment by the weight of the camera on the sloping eyepiece tube. Where possible, vertical eyepiece tubes should be used, but even these sometimes slip because of the weight of the camera and throw the image out of focus. These problems do not arise when using a microscope with a fixed optical system and a moving stage. Apart from these special considerations the same principles can be applied as when buying a secondhand camera (see Chapter 1).

Availability of slides

Temporary preparations can be readily made by placing the specimen on a clean slide, covering it with a drop of water and placing a coverslip over it. Pond insects, moulds, green algae, pieces of feather, parts of insects and scales of fish are just a few of the readily available materials which can be mounted in this way and photographed without further preparation. These slides are only temporary, because the water soon begins to evaporate and the specimen dries out and shrivels up. Permanent preparations are quite difficult to make and involve dehydrating the specimen to preserve it, clearing the specimen to make it more transparent, and finally mounting it in a clear transparent medium such as Canada balsam. This is really beyond the scope of the beginner, but fortunately commercially produced slides are readily available from biological supply companies (see the Suppliers List at the end of this book).

Societies for microscopists provide excellent opportunities for meeting fellow enthusiasts, but unfortunately such societies are not very numerous. In Britain, the famous Royal Microscopical Society in Oxford is limited to professional workers, whereas the Queckett Microscopical Club is for amateurs.

FIXED-LENS CAMERAS

In photomicrography the eye is, in effect, replaced by the film and a camera lens is not required. The only essential requirement is a light-proof box to house the film, and a microscope. However, a camera with a fixed lens may be used and quite good results can be obtained if a little care is taken. The first requirement is to focus the microscope with the eye relaxed. This is difficult for the inexperienced worker, who invariably closes one eye and squints with the other, but it is normal practice for a biologist to work with both eyes

open. Under these conditions the image produced is almost at infinity, and if the camera is supported over the eyepiece of the microscope and the camera lens set at, or near infinity, a reasonably sharp image should be obtained. Some workers suggest setting the camera lens at 8 m (26 ft) rather than at infinity, but in fact it makes little difference whether the infinity setting or the near-infinity setting is used.

Anyone attempting this for the first time should include exposures made at both settings and then decide, after examining the negatives under a microscope, which setting produces the sharpest image. Incidentally, a person who normally wears distance spectacles should wear them when focusing the microscope even though this may not be his normal practice.

The ideal distance between the microscope eyepiece and the camera lens is one in which the Ramsden disc (ie the point at which the diameter of the emergent light beam is at its smallest above the eyepiece) lies in the centre of the front element of the camera lens. This point can be determined by holding a piece of white paper on top of the eyepiece, and raising it until the patch of light diminishes to its smallest area. The camera should then be firmly fixed in this position and, if required, some dark material can be draped round the eyepiece and camera-lens mount to keep out any extraneous light. This precaution is not necessary if the camera lens is sunk into its mount and the mount is almost touching the microscope eyepiece. If the iris diaphragm of the camera lens is left fully open (closing it cuts off some of the light rays and makes the picture much smaller) and the shutter mechanism is operated by a cable release, then an exposure can be made.

What length of exposure is required, and how much of the image seen in the microscope eyepiece will actually appear on the negative? Exposure is discussed below, but the problem of the 'blind' camera will be considered now. In this context, a 'blind' camera is one which, when attached to the microscope, cannot produce the microscope image in its viewfinder. Thus all cameras except SLRs are blind when used in photomicrography. The way round this problem is to set up the camera without film, open the back, place a piece of tracing paper or ground glass in the film plane, and observe the image, when both framing and focusing can be checked. The ground-glass screen is then replaced by a film. This method is suitable only for static material and the image produced is

always a circular patch in the centre of the negative. No useful image can be obtained unless the microscope eyepiece is in position.

INTERCHANGEABLE-LENS CAMERAS

As stated earlier, a camera lens is not required for photomicrography, and if it can be removed from the camera so much the better. This allows the 'direct' method to be used, where the image formed by the microscope is projected directly onto the film in the back of the camera. The connecting tube between the camera and the microscope eyepiece is threaded at one end to take the camera body and adapted at the other end to fit securely over the microscope eyepiece.

If the camera is 'blind' (ie not a single-lens reflex) then once again the problems of focusing and framing are present. These can be solved either by placing a piece of tracing paper in the camera back, focusing and framing the material, and then replacing it with film, or by making a focusing and framing tube. This consists of a tube fitted at one end with a ground-glass screen fixed in the same plane as that of the film in the camera. When the specimen has been focused on the ground glass, the focusing tube is removed and replaced by the camera (Fig. 4.2). Focusing and framing methods of this type are suitable only for static material and some form of reflex viewing or a beam-splitting device is required for moving organisms.

POLAROID LAND INSTRUMENT CAMERA

The ED10 Land Instrument camera consists basically of a dark box, a focusing tube, and an eyepiece adapter (Fig. 4.3). The dark box has the normal Polaroid film-pack holder at one end and a simple shutter (one setting only 'T') at the other end. The microscope eyepiece fits into the eyepiece adapter, which is then slid over the microscope tube and lightly fixed in position using three hand-screws. The focusing tube is then slipped onto the eyepiece adapter and the material on the slide is brought into focus using the normal focusing mechanism. The tube is then replaced by the dark box and the exposure made. A black and white print is available within 15 seconds of making the exposure while colour prints take 60 seconds to develop.

The idea is good in theory but in practice the following points must be borne in mind. The equipment tends to be rather bulky and if used on a vertical microscope tube, one must kneel on a stool in order to use the focusing tube. When using a normal-angled microscope tube, the viewing height is more convenient, but the dark box must be supported because its weight is sufficient to slightly misalign the optical system and produce unsharp pictures with obvious vignetting at two corners.

The rather long eyepiece-to-film distance of

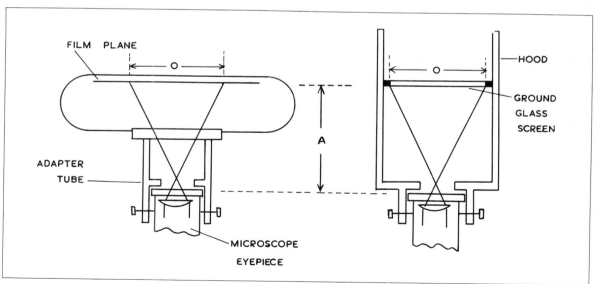

4.2 A focusing/framing tube for use with a non-reflex camera

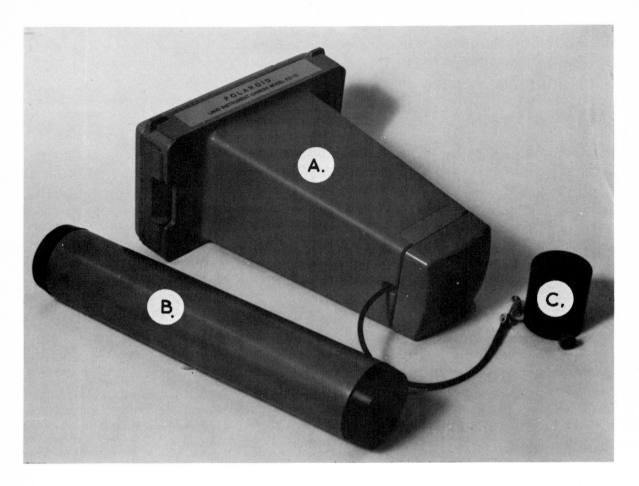

4.3 The Polaroid ED 10 Camera for photomicrography. Note the large dark box *A*, the long focusing tube *B* and the short microscope eyepiece adapter *C*

approximately 20 cm (8 in) is an attempt by the manufacturers to produce a print-image magnification approaching that of the visual magnification. This would require a 25 cm (10 in) focusing tube, a bulkier dark box and an even larger film size, if most of the visual field were to be included on the final print. A compromise situation therefore exists in which the 20 cm (8 in) eyepiece-to-film distance produces a photographic image about 0.8 × the visual image and this distance coupled to an 83 × 108 mm ($3\frac{1}{4} \times 4\frac{1}{4}$ in) film size means that about 20 per cent of the visual area does not appear on the final print.

Finally, because there is no built-in exposure metering system, exposure times must be estimated or guessed and even then the 'T' shutter allows only relatively long exposures (the handbook suggests two seconds or more) to be accurately made. Both these points reduce the effectiveness of the equipment, and, although the Polaroid Handbook for this camera goes to some trouble to explain how to estimate the correct exposure after a test exposure has been made, it nevertheless involves at least one test exposure per preparation, and this can become costly both in money and time.

SINGLE-LENS REFLEX CAMERAS
The cameras discussed so far all have severe limitations when used for photomicrography. Even the very expensive Leica M4 is 'blind' in the realms of photomicrography, unless the expensive Visoflex III Reflex Housing is used, when it becomes, in effect, a single-lens reflex camera.

This does not apply to the Leicaflex, which is a single-lens reflex camera complete with pentaprism and through-the-lens metering.

In the field of photomicrography the single-lens reflex camera reigns supreme because there are no problems of framing and focusing. The size and frame of the picture and the sharpness of the image can all be seen on the focusing screen of the camera. Irrespective of which combinations of

4.4 A typical photomicrographic set-up using an SLR camera in which the lens has been replaced with a microscope adapter tube. This particular adapter is hinged so that the microscope eyepiece can be changed without removing the camera

eyepiece and objective are selected, the image seen on the focusing screen will be exactly the same as that on the final negative. The only extra piece of equipment required is a simple connecting tube to attach the camera to the microscope and, since the external diameter of the microscope eyepiece tube is fairly standard at 25 mm (1 in), one tube with an Edixa/Pentax thread can be used with many different types of cameras and microscopes (Fig. 4.4). The length of this tube is not critical because the focusing is done on the focusing screen of the camera, but the longer the tube, the larger will be the image produced.

Hitherto, the problem of exposure determination was very much a question of trial and error, plus experience, but with the advent of through-the-lens metering this problem has also been solved, making the single-lens reflex camera absolutely ideal for this type of work.

PURPOSE-DESIGNED SEMI-AUTOMATIC EQUIPMENT

Excellent results can be produced with equipment which is specifically designed for photomicrography and the Nikon Microflex EFM unit (Fig. 4.5) is a typical example. This is a beautifully engineered piece of equipment which possesses all the inherent qualities of sturdiness, dependability and precision, qualities long associated with Nikon cameras.

It consists basically of a body unit, complete with a shutter mechanism, a cadmium sulphide exposure meter, an ocular finder, and a dark box for housing the film (Fig. 4.6). The dark box is simply a camera body without the lens and shutter mechanism. The film is loaded into the dark box in the usual way and the movement of a lever transports the film and operates the counting mechanism. Two negative sizes are possible, the normal whole frame, 36×24 mm ($1\frac{1}{2} \times 1$ in), and half frame, 18×24 mm ($\frac{3}{4} \times 1$ in). When the dark box is not in use, the front aperture can be closed by a metal slide which keeps the interior dust-free and prevents light entering, should a partly exposed film be inside. The dark box is attached to the main body unit by an adapter tube.

The shutter is located towards the upper end of the body unit and is of the multi-blade type. Shutter speeds of 1 sec to 1/250 sec are available in the following steps: 1, $\frac{1}{2}$, $\frac{1}{4}$, 1/8, 1/15, 1/30, 1/60, 1/125, and 1/250; 'B' and 'T' are also present. The shutter is synchronised for electronic flash at all speeds (ie 'X' synchronisation).

4.5 A Nikon Microflex EFM unit attached to a conventional microscope. Although the unit is quite heavy there is no focus shift because the microscope has a fixed optical system, and a focusing stage

The exposure meter is of the cadmium sulphide type and is powered by a 1.3-volt mercury battery such as a Mallory PX-13 or an EverReady E-625. The film speed is set by rotating the selector ring to the appropriate mark and the exposure then determined by rotating the shutter-speed selection ring until the meter needle is lined up in the centre of the small circle. At shutter speeds of 1/250 to 1 sec the meter reading is coupled to the shutter mechanism but, should the light intensity be too low to obtain a reading, the shutter can be disengaged from the meter, and freely rotated when exposure readings of up to 30 sec can be obtained. The shutter is then coupled up again, set on 'T', and the appropriate long exposure given, using a stopwatch. The cadmium sulphide cell is located in the side of the unit and light passing vertically through the unit is turned through 90° by a 45° prism. At the moment of exposure, this prism swings away and allows the light to pass up to the dark box and the film.

Because the camera (dark box) is blind, a suitable viewing and focusing system must be incorporated into the equipment. This is of the ocular type, the eyepiece being focused by a very accurate system of double cross-hairs and, once focused, need not be touched again unless another person uses the equipment. Light reaches the ocular finder through a cube-shaped prism (actually two 45° prisms fixed hypotenuse to hypotenuse) which allows about 15 per cent of the light to reach the ocular finder and the remaining 85 per cent passes straight through to reach the film. Just prior to reaching the film, the light passes through a $\frac{1}{2} \times$ relay/projection lens which reduces the size of the image to that seen in the eyepiece.

A great advantage of this equipment is its versatility. For example, three types of eyepiece adapter exist for use with standard microscopes, Nikon stereoscopic microscopes and Nikon polarizing microscopes, and adapter rings are available to fit any non-standard make of microscope. Three relay/projection lenses are listed, the $\frac{1}{2} \times$ for use with 35 mm film, the 1.3 × for roll film, sheet film and Polaroid Type 100 film and the $\frac{1}{4} \times$ for 16 mm cine film. Finally the 35 mm dark box can be replaced by a 35 mm single-lens reflex camera, a 6 × 9 cm ($2\frac{1}{4} \times 3\frac{1}{2}$ in) roll-film holder, a 6 × 9 cm ($2\frac{1}{2} \times 3\frac{1}{2}$ in) sheet film/plate holder, an 8 × 10 cm ($3\frac{1}{4} \times 4\frac{1}{4}$ in) Polaroid camera, or a 16 mm cine camera.

MICROSCOPE REQUIREMENTS

The Microflex EFM is a piece of precision equipment but high-quality results can be obtained only if it is attached to a microscope of similar quality. The basic microscope was discussed earlier, but the optical system is so important that it is worth considering in some detail.

There are three basic types of objectives – achromatic, fluorite, and apochromatic. The first, the achromat, is the one commonly used in student microscopes and is fully corrected (achromatised)

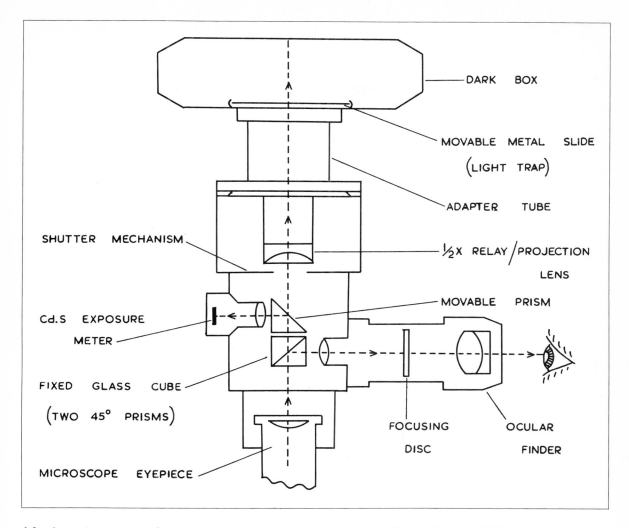

DARK BOX

MOVABLE METAL SLIDE

(LIGHT TRAP)

ADAPTER TUBE

½X RELAY / PROJECTION

LENS

MOVABLE PRISM

SHUTTER MECHANISM

Cd.S EXPOSURE

METER

FIXED GLASS CUBE

(TWO 45° PRISMS)

MICROSCOPE EYEPIECE

FOCUSING

DISC

OCULAR

FINDER

4.6 A semi-automatic photomicrographic attachment based on the Nikon Microflex EFM unit

for red and blue light. These two colours are brought to a focus at the same point. There remains a residual chromatic error, called the secondary spectrum, consisting mainly of green and violet light which are brought to a slightly shorter and longer focus respectively. These objectives are also corrected for spherical aberration for one colour, usually green, and therefore from this viewpoint they give their best performance with green light. The achromatic objective is generally satisfactory for both black and white and colour, unless one is aiming at a particularly high standard of work.

Several manufacturers have produced a variation on the basic achromatic objective and these objectives have flat fields and are virtually free from coma and astigmatism. They also have the achromatic type of colour correction but shorter working distances than normal achromatic objectives. They are approximately double the price of achromatic objectives but their flat-field characteristics make them of some interest to the photomicrographer.

The best results are obtained by using an apochromatic objective which is greatly superior to, but much more expensive (approximately four times), than an achromat. Chromatic aberration is fully corrected for red, blue and green and the residual colour error is practically eliminated. In addition, these objectives are corrected for spheri-

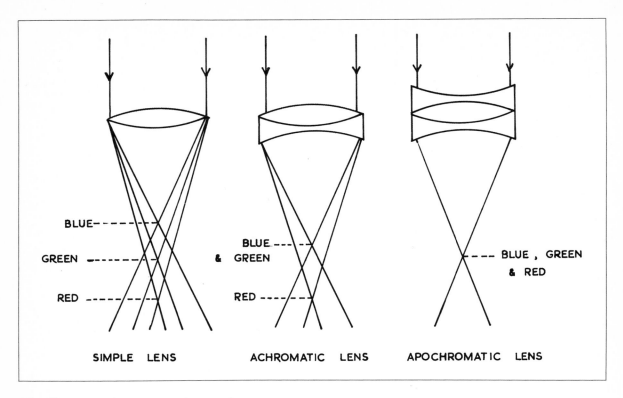

BLUE

GREEN

RED

SIMPLE LENS

BLUE

& GREEN

RED

ACHROMATIC LENS

BLUE , GREEN

& RED

APOCHROMATIC LENS

4.7 Chromatic aberration in objective lenses

cal aberrations for two colours instead of just one as in achromatic objectives (Fig. 4.7). This is achieved by very careful design, an increase in the number of elements, and the use of fluorite and special glasses. In semi-apochromatic (or fluorite objectives) the optical corrections are intermediate between those for achromats and apochromats.

The term 'numerical aperture' (NA) is used in microscopy to describe the light transmission of a lens. If light from a point P, located at the focal point of lens (Fig. 4.8) falls on the lens, and the cone of rays between point P and the lens has an angle of $2a$ then $\mu \sin a$ is the formula for the numerical aperture. (μ is the refractive index of the medium between P and the lens.)

ie NA $= \mu \sin a$

A small NA indicates a small value for angle a and thus represents a lower light transmission than a high NA value. A point source very close to a dry lens (ie one in air) would have a cone angle of almost 180° (ie angle $a = 90°$) and therefore the theoretical maximum NA would be 1.0, but in practice 0.95 is the highest value reached. When an

oil-immersion lens is used, the air gap is replaced by oil which has a refractive index of 1.5, so that the NA would be $0.95 \times 1.5 = 1.42$.

Finally, the resolving power of a microscope is dependent on the NA and the optical quality of the lens, and mathematicians have produced the following formula:

$$r = \frac{0.61\lambda}{\text{NA}}$$

where r = minimum resolvable distance, and λ = wavelength of the light used. Thus it can be seen that the resolution improves as the wavelength is shortened.

The most common type of eyepiece used in student microscopes is the 'Huygenian' eyepiece. This consists of a lower plano-convex field lens which collects light from the objective, and an upper eye lens which magnifies the image from the field lens. These two lenses are separated by a field diaphragm which lies at the focus of the eye lens and limits the field of view. Another type of eyepiece of particular interest to the photomicrographer is the compensating eyepiece. This

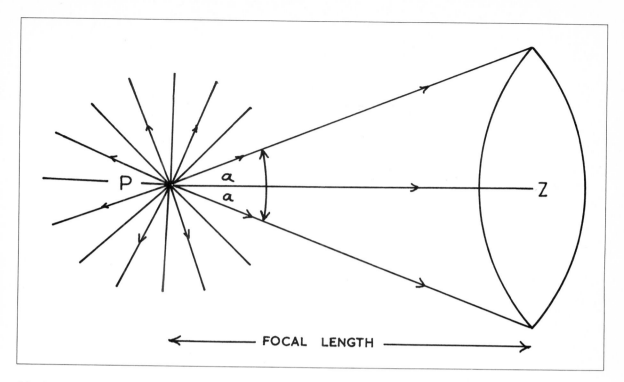

4.8 Numerical aperture

is computed to eliminate the chromatic differences in magnification which occur with objectives of × 40 and over, and although especially designed to be used with apochromatic objectives, they will certainly improve the performance of an achromatic objective. They are about double the price of the standard Huygenian eyepiece. Also of interest are the projection eyepieces available from most microscope manufacturers. These have a flatter field than the Huygenian eyepiece and when used with a flat-field objective give an image which is sharp over its entire surface.

SOURCES OF ILLUMINATION

When considering the type of illumination suitable for photomicrography, there are three important requirements which need to be fulfilled. These are that the illumination should be concentrated onto the relatively small area of the mirror, that the intensity should be high enough to enable short exposures to be made when using living material, and that the colour temperature of the light should match that of the colour film being used.

The simplest method would be to use daylight and this gives a very evenly illuminated field but its

intensity and its colour temperature are so variable that it cannot be considered a viable proposition.

Microscope lamps are an obvious possibility. These range from a simple 60-watt lamp in a conventional reflector, to a sophisticated high-intensity low-voltage lamp which fulfils the requirements of Köhler illumination. This method of illumination provides a bright uniformly lit field, even when working at very high magnifications, which is impossible to achieve using a normal pearl or opal bulb in a conventional reflector. The essential requirements are that the filament image can be magnified and focused by means of an auxiliary lens, and that the area of illumination can be controlled by an adjustable iris diaphragm (field stop).

The 60-watt lamp normally has a detachable front which, when removed, gives wide-angle lighting suitable for dissecting large specimens. The front also has provision for the attachment of colour filters. This type does not provide very concentrated illumination and the colour temperature is rather low at around 2,800°K, although a colour-correcting filter can be used to bring it up to the level required for artificial-light colour film.

47

High-intensity microscope lamps are ideal for all forms of photomicrography and a typical example is the Vickers Intense Lamp (Fig. 4.9). The light source is a 48-watt 6-volt solid-source filament lamp with a pre-focus cap so that no centring adjustments are necessary. The light is controlled by a focusing condenser lens and iris diaphragm, and the focal length of the condenser lens is such that the sub-stage condenser aperture of the microscope can be filled with light to fulfil the conditions for Köhler illumination. The lamp is run from a step-down transformer housed in the base, which also contains a rheostat to control the light intensity. There is provision for colour filters and heat filters. This type of lamp is eminently

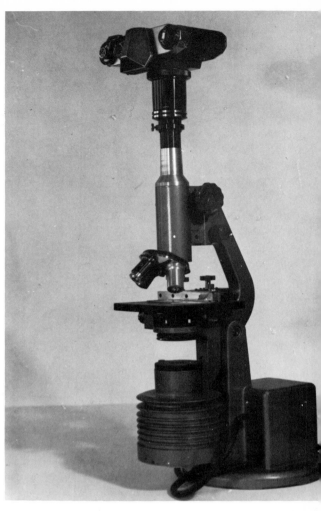

4.10 A useful photomicrographic set-up consisting of an SLR camera attached to the eyepiece tube of a microprojector

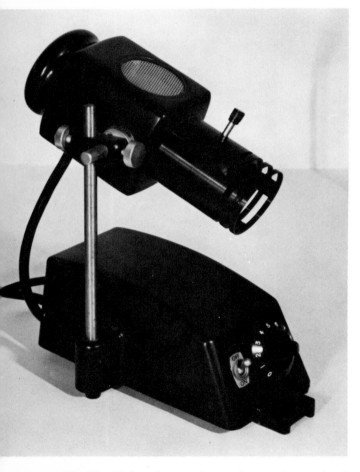

4.9 The Vickers Intense Lamp. A typical example of a high-intensity lamp which is very useful in photomicrography. It comes complete with focusing system and iris diaphragm

suitable for all forms of photomicrography and if one is already available then the problems of illumination are solved, but they are rather expensive to buy and only frequent use can justify such a high expenditure.

Another useful source of illumination is a slide projector and its use in close-up work has already been discussed in the preceding chapter. High-intensity low-voltage models are fairly cool in operation and are very useful for photomicrography. Unfortunately their light output is much too high – and even harmful – for visual observation of the material in the microscope, and

overheating can cause drying out of living material. These problems can be solved either by putting a 'dimmer' unit in the circuit or by interposing a piece of ground glass or several sheets of tracing paper between the light source and the microscope mirror. Once the material has been set up and focused, the interposing screen can be removed and the exposure made.

The types of illumination discussed so far have been separate units producing a beam of light which has been reflected into the microscope via the mirror. Another form of illumination dispenses with the separate light unit and mirror system and uses a high-intensity illumination built into the base of the microscope. This refers to a microprojector, which is basically a microscope in which the low-output lamp has been replaced by one of very high output. During recent years the low-voltage tungsten lamp has been superseded by the quartz iodine lamp. A typical example is the CD model (Fig. 4.10) manufactured by Scientific Instruments Ltd, in which the normal type of illumination has been replaced by a 12-volt, 100-watt quartz iodine lamp run from a step-down

transformer attached to the base. The lamp house is well ventilated and a disc of heat-absorbing glass is included to protect living material. A dense ground-glass swing-away filter is mounted on top of the lamphouse to permit visual observation of the material before it is photographed (or projected). This unit forms a good basis for a photomicrographic set-up but it could be improved by having a rheostat in the circuit to control the light intensity. The colour temperature of the quartz iodine lamp is about 3,400°K, ideal for Type A colour film.

Another development in this field is the Microprojection Illuminating Base manufactured by Philip Harris Ltd of Birmingham (Fig. 4.11). Although designed specifically for microprojection work, it is also ideal for photomicrography. The light requirements of the photomicrographer are a high level of illumination, good quality

4.11 The Philip Harris Microprojection Illuminating Base. This is a fairly sophisticated high-output unit, providing full Köhler illumination which is very useful for photomicrography

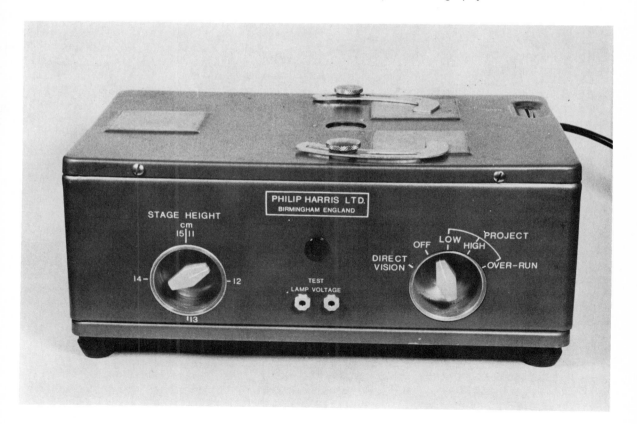

illumination for maximum image detail, and a colour temperature similar to artificial-light colour film. These requirements are all met in this piece of equipment. It provides Köhler illumination and is therefore complete with field condenser and adjustable-field iris diaphragm. The lamp is a 100-watt 12-volt quartz iodine type (colour temperature 3,200°K) and its output is controlled by a five-position switch. When the microscope is being used for direct-vision work, a neutral-density filter is automatically inserted into the light path and for microprojection work three voltage settings marked 'Projection Low', 'Projection High', and 'Projection Over-run' are available. Finally, in order to protect living material, a special heat filter is built into the top of the unit.

METHODS OF ILLUMINATING THE SPECIMEN

Two systems can be used to illuminate the specimen in readiness for microscopic examination and photography. The first is by transmitted illumination, in which the light passes through the specimen, and the second is by incident illumination, in which the light is reflected from the surface of the specimen.

Transmitted illumination

This can be applied in several ways.

1 *Bright ground* This is the method most frequently used for examining specimens, and was described at the beginning of this chapter. To summarise, light from a reading lamp is reflected from a mirror, through a condenser lens onto the specimen. The latter is viewed through the microscope eyepiece and is seen as a clearly defined image against a brightly lit background. It is an easy method to use and requires less light than the methods described below (Fig. 4.12a).

2 *Dark ground* The set-up is basically as described above, but the central rays of light are blocked and only the peripheral rays are allowed through. These rays are too oblique to enter the objective lens directly, and the only light to reach it is that which is scattered by the specimen. The final result is a brightly lit specimen on a black background (Fig. 4.12b). To achieve this striking effect, a disc of black paper approximately 20 mm ($\frac{3}{4}$ in) in diameter (ie 2/3 of the diameter of the sub-stage filter-holder) is glued to the centre of a 32 mm ($1\frac{1}{4}$ in)-diameter disc of clear, colourless plastic or celluloid. The microscope is set up for

normal bright ground illumination and the disc (black centre and colourless surround) is dropped into the filter holder. The sub-stage iris diaphragm must be fully open for this method to work successfully. Different diameter stops can be tried until the best result is obtained.

A disadvantage of this technique is that every mark and blemish on the slide or coverslip becomes very obvious indeed, so all slides should be carefully cleaned and polished before use. Another disadvantage, particularly if photographs are to be taken, is that the level of illumination is rather low, and therefore a very powerful light source should be used. Dark ground illumination is particularly recommended for the study of diatoms, hard-shelled protozoans, sponge spicules and small aquatic crustaceans.

3 *Rheinberg illumination* An interesting extension of dark ground illumination was first described by Rheinberg at the turn of the century. It is officially known as the Rheinberg Differential Colour Contrast method and consists of replacing the central black patch used in dark ground illumination with a disc of transparent coloured celluloid. The result is a brilliantly lit organism on a dark-coloured background. Rheinberg extended the technique still further by using a transparent coloured outer ring instead of clear celluloid, when the organism took on the new colour against the background colour of the central patch. Contrasting pairs of colours are usually employed – for example, a blue centre and a yellow surround, or a deep-red centre and a light-green surround. One needs to experiment with the size of the centre patch and the density of the filters but, with a little skill and patience, extremely attractive results can be obtained. Rheinberg illumination is very effective for sponge spicules, diatoms, small shells and hard-shelled protozoans.

4 *Polarised illumination* A polarising filter is a sheet of transparent material (looking rather like a neutral-density filter), containing crystals of quinine di-iodosulphate (Herapathite) which have the property of polarising any light passing through them, ie the light emerging from the filter

4.12 Globigerina ooze (consisting mainly of the empty shell of protozoans belonging to the order Foraminifera) illuminated by different types of lighting
(a) Normal brightground illumination
(b) Dark-ground illumination
(c) Polarised illumination

is vibrating in one plane only. If this plane polarised light is then passed through another polarising filter (called the analyser) some of the light will be held back depending on the position of the analyser. When the analyser is rotated, the field is darkened and lightened twice in each complete revolution.

The microscope is set up for normal transmitted light and then a 32 mm ($1\frac{1}{4}$ in)-diameter disc of Polaroid sheet is cut and placed in the sub-stage filter-holder. Another disc, 20 mm ($\frac{3}{4}$ in) in diameter is cut and attached to the microscope eyepiece. Placing it on top of the eyepiece is unsatisfactory, as it soon becomes soiled by contact with the eyelashes, whilst resting it on the diaphragm inside the eyepiece tube is not ideal because it is then exactly in the focal plane of the specimen image and each tiny speck of dust or small blemish will be very obvious. A third possibility is to unscrew the top lens of the eyepiece and wedge the filter under the lens before replacing it.

Having set up the polarisers the specimen is placed on the stage and examined in the normal way. As the eyepiece is rotated, the brilliantly lit specimen shows up against a black background (Fig. 4.12c). Each time the specimen is moved slightly the colour patterns change. A small 5 cm (2 in) square of Polaroid sheet (type HN 22), (purchased from Brunnings or H.W. English, UK, for approximately £1) is sufficient for the two discs required. Materials which respond well to polarised light are sugar grains, copper sulphate crystals, rock sections, fish scales and bone sections.

5 *Phase contrast* Phase contrast is rather difficult to set up correctly, and requires expensive additions to the microscope. It is beyond the scope of this introductory chapter and interested readers are referred to the bibliography at the end of this book.

Incident illumination

Much of the material of interest to the nature photographer is not transparent and yet is well worth examining under the microscope. Materials such as fungal spores, small shells, seeds, moss capsules and parts of insects appear as dark silhouettes when examined by transmitted light, but under incident illumination they take on a fascinating three-dimensional appearance. There are basically two ways of using incident light.

1 *Oblique top illumination* To achieve this, the microscope lamp is arranged at approximately 30° to the horizontal and the specimen fully illuminated. As much of the light is scattered from the surface of the specimen and does not enter the microscope objective lens, the lamp should be very powerful. It should also have a focusing mechanism so that a narrow beam of light can be concentrated onto the specimen. If a lower power objective (ie × 3 or × 6) is used, then the working distance between the slide and the objective is large enough to prevent the latter casting a shadow over part of the specimen. If the unlit side of the specimen is too dark, a second lamp, or a mirror, may be set up on the opposite side.

Oblique top lighting is very effective against a dark or even black background and this can easily be achieved by placing a piece of black cloth, or black card, on top of the sub-stage condenser, after the latter has been moved away from the stage. This type of lighting is used in the chapter on micro-organisms.

2 *Vertical incident illumination* Many low-power binocular microscopes are equipped with built-in illumination producing a vertical beam of light which can be focused on the specimen. This results in a bright, shadowless, low-contrast image rather similar to that produced by a ringflash when used for close-up work. A conventional monocular microscope can be set up in a similar way by reflecting a horizontal beam of light from a microscope lamp or a slide projector off a 45°-inclined mirror located next to the microscope-body tube. This technique is suitable only for low-power work and when greater magnification is required a special built-in incident illuminator should be used.

This unit, which is fitted in place of the usual rotating nosepiece, projects a beam of light down the microscope objective lens onto the specimen. The objective lens serves the dual function of focusing the light onto the specimen and collecting the light from it to form the image in the eyepiece. Thus light is travelling in opposite directions through the objective lens at the same time.

USE OF FILTERS

A considerable amount of discussion has hinged around the colour temperature of the lamps being used, but it should be made clear that, for black-and-white work, colour temperature is of no significance. Even in colour work the quality of the light source is important only if accurate colour rendering of the material is required. It is possible

to match up very precisely the colour temperature of the light with that of the film by using special filters manufactured for this purpose.

What would be the effect if daylight colour film were to be used in artificial light? As a result of the difference in colour temperature the transparencies produced would have an overall bias towards the red end of the spectrum, ie everything would take on a warmer than natural tone. A pale-blue filter would increase the colour temperature of the light and bring it more into line with that of the film, thereby producing a more accurate colour rendering of the subject. Since these conversion filters absorb certain wavelengths of light, an increase in exposure is required when they are being used and the manufacturer supplies this information with each filter.

Whilst on the subject of colour it would be appropriate to discuss the use of colour filters in black-and-white work. When a beam of light passes through a colour filter it produces three effects on the final negative. Firstly, the definition increases as the waveband of the light is narrowed, but this would require a deep filter to produce any noticeable effect on the negative. Secondly, the tone rendering of coloured objects would be altered on the final print, and thirdly, a fairly large amount of light will be absorbed by the filter and the negative will tend to be thin. Basically, a colour filter will allow light of its own colour to pass through and will absorb the rest. The degree of absorption of the other wavelengths depends mainly on the colour density of the filter.

An example will help to clarify the situation. A red filter allows red light to pass through and absorbs many of the other wavelengths so that light reflected from a red object passes through the filter and produces a dark tone on the negative. Other colours tend to be held back and produce lighter tones on the negative. On the print the red object, therefore, appears lighter, and the rest darker, than normal. Most photographers reduce this lengthy description to a short statement: 'A colour filter lightens its own colour on the final print.'

Great use can be made of this fact when photographing stained material. For example, if a section of plant tissue has the non-lignified tissue stained green with 'light green' stain and the lignified tissue stained red with 'safranin' stain, then, when using normal panchromatic film, the contrast between the red and the green will be very low and the two tissues, lignified and non-

lignified, will not be easily distinguishable.

If, however, an orange or red filter is used, on the final print the red lignified tissues will appear as a lighter tone than the green non-lignified tissues. Thus contrast between them has been achieved (Fig. 4.13). All prepared materials should be carefully examined with particular reference to tonal contrast but it should be noted that, when a glass or gelatin filter is used, it absorbs some wavelengths and a filter factor must be applied to the basic exposure. A medium-yellow filter has a filter factor of two (ie double the basic exposure), whilst a red filter can have a filter factor of up to eight, depending on the density of the dye in the filter.

EXPOSURE

A few years ago it was common practice to make a series of test exposures. The correct exposure was then noted, together with a description of the material, the degree of magnification, and the quality and intensity of the illumination. Soon a comprehensive reference collection of data was compiled which was referred to when trying to establish the exposure required for later work. Fortunately the widespread availability and cheapness of the cadmium sulphide exposure meter has taken most of the 'trial and error' out of exposure determinations. The meter must of course be calibrated for use with a particular piece of equipment.

This is done by making a series of test exposures, increasing each exposure by a factor of two, eg 1/250, 1/125, 1/60, 1/30, 1/15, 1/8, 1/4, 1/2, 1, 2, and 4 sec. The meter is then held over the eyepiece of the camera, if it is an SLR camera, or over the eyepiece of the microscope if it is not, and a reading taken. Many modern cadmium sulphide meters have a very small diameter window for light entry and it is necessary to bring this into contact with the eyepiece of the camera or microscope.

The meter should be moved slightly about the vertical axis and the highest reading taken. Suppose this reading is 1/15 sec at f5.6. A series of test exposures is then made as suggested above and, after development of the film, the exposure time of the best negative is noted. Suppose it is 1/250 sec, then looking at the exposure meter dial, one would see that 1/15 sec at f5.6 is equivalent to 1/250 sec at f1.4. The meter is now calibrated for future use, in that the exposure given at f1.4 is the one to be used.

The person who possesses an SLR camera with

4.13 A transverse section of a pine twig magnified 100×. The dead supporting tissues *A* are stained red and the living non-supporting tissues *B* are stained green.
(a) A normal photomicrograph using white light
(b) A photomicrograph produced using green light. Note that area *B* has been lightened and better contrast exists between it and area *A*
(c) A photomicrograph produced using red light. The green areas *B* are now very dark and the general effect is unacceptable

'through-the-lens' metering is in the best possible position to do excellent photomicrography with the minimum of expenditure of time and effort. He simply removes the camera lens, attaches the camera body to the microscope by means of an adapter tube, and rotates the shutter-speed selector dial until the meter needle indicates the correct exposure. The first roll of negatives will soon indicate if the metering has been absolutely accurate or whether a modification to the exposure, ie a slight increase or decrease, will be required for future work. The advent of 'through-

the-lens' metering was looked upon by many photographers as little more than an expensive gimmick but it has proved to be of inestimable value, particularly to those involved in close-up work and photomicrography.

The Nikon Microflex EFM has its own built-in cadmium sulphide metering system (as described earlier in this chapter). It has proved to be very accurate and speedy in use and enables one to tackle a wide variety of materials at magnifications ranging from 15 × to 1,000 ×.

A final word of caution. It should be remembered that the exposure meter will normally give an overall reading of the light reflected from the subject area and in some instances, eg a small dark organism on a very light background, this may not be the best exposure. In the example cited, the organism which is probably the centre of interest will be underexposed. Only experience will enable the photographer to assess the exposure characteristics of the subject and thus enable him to modify the meter reading if necessary. However, under most conditions a reasonable negative can be obtained if the meter reading is used unmodified.

5 Micro-organisms

The unaided human eye allows us to observe the beauty of the world of nature and as photographers we are well aware of it and use most of our photographic talents trying to capture it on film. Nearly three centuries ago a Dutchman, Anton van Leeuwenhoek, made the first simple microscope, and on the day he discovered micro-organisms, he exclaimed: 'Of all the wonders I have discovered in nature, this is the greatest ... And I must say that I have never known so pleasant a sight as that of thousands of these small creatures living in a drop of water, stirring as one group, yet each having its own movement.' This is indeed a fascinating world. The sheer perfection of shape and structure revealed, when a few strands of fungus from a piece of mouldy bread are examined under the microscope, is thrilling to observe. A black and white print cannot do justice to this material and even a colour photograph is a pale reflection of the three-dimensional structure and beauty inherent in it. However, the purpose of this chapter is to try and capture some of the secrets of the micro-world.

DISTRIBUTION OF MICRO-ORGANISMS

These tiny organisms form the foundations of both the plant and animal kingdoms. In the latter the first two groups or phyla are the Protozoa and the Coelenterata and both include micro-organisms. The Protozoa (Greek *protos* – first; and *zoon* – animal) are all of microscopic size, live in a fluid background, usually fresh water or the sea, and number about 30,000 species. Some are just visible to the naked eye as tiny specks of matter,whilst others are too small to be seen without a microscope. A few, like Trypanosoma and Plasmodium cause disease (tropical sleeping sickness and malaria respectively) in man, but the majority are harmless. They are all single-celled animals and manage to feed, digest, excrete and reproduce within the confines of the single cell.

One may be familiar with *Amoeba proteus*, that shapeless piece of protoplasm which moves about very slowly by pushing out a false foot or pseudopodium and flowing into it, or even Paramecium – the slipper animal which slowly rotates and moves around the plant material in a most interesting fashion. Vorticella with its delightful bell-shaped body, and contractile spring-like stalk, may also be remembered from school days. The Protozoa is a fascinating group of animals and is large and important enough to be a subject area – Protozoology – in its own right.

The Coelenterata (Greek *koilos* – hollow; *enteron* – intestine) is a group of animals which includes sea-anemones, jelly-fish and corals but also one or two micro-sized organisms like *Hydra fusca*, which resembles a short piece of brown cotton with frayed ends, and *Sertularia* which consists of colonies of animals forming a mat-like covering on the surface of brown and red seaweeds. The coelenterates are multicellular animals in contrast to the unicellular protozoa and all have a sac-like body with only one opening, the mouth, through which food enters and indigestible wastes make their exit.

In the plant kingdom the simplest members belong to the algae and they are widely distributed in the sea, lakes, rivers, ponds and also on land in damp situations. The most conspicuous members are the seaweeds, such as bladderwrack and sea grass which are common inhabitants of the rocky shore. There are, however, a few micro-organisms in this group including familiar examples like the unicellular green alga Chlamydomonas which often gives pond water a greenish colour, and the green cottonwool-like material Spirogyra and Oedogonium which are also found in ponds and lakes. Another interesting fresh water alga is a colonial form called Volvox, consisting of many

hundreds of green cells arranged to form a spherical colony which rotates through the water like a miniature planet. The damp powdery green growth seen on the bark of trees consists of millions of cells of Pleurococcus, Protococcus and other related species. All these green algae contain chlorophyll pigments which are required in the food-making process called photosynthesis. The algae mentioned above look extremely attractive when magnified a modest 30 × and make excellent material for the nature photographer.

Another group of plants which includes many micro-members is the Fungi. The larger members are considered in the chapter on non-flowering plants, but the micro-fungi will be considered in this chapter. In the world of micro-organisms, the fungi or moulds are a most interesting group to study and photograph. This might be because they look so commonplace and uninteresting to the naked eye, merely an unwanted mould on a piece of dry bread, but under the microscope their subtle coloration and exquisitely delicate structure are delightful to observe.

Familiar examples include the common bread mould *Rhizopus nigricans* with its 'root-footed' hyphae and black sporangia, and the black mildew *Aspergillus sp* which grows on bread and damp clothing, and when magnified resembles water leaving a watering-can rose, hence the name Aspergillus, which means 'a little sprinkler'. Another important group of moulds which grows on bread is the genus Penicillium. There are several common species and all are bluish green in colour and when magnified about 100 × show a brush-like appearance, hence the name Penicillium from the latin word *penicillus* – a paint brush. These organisms are famous for their antibacterial properties, first discovered by chance by Alexander Fleming in 1929 but not developed commercially as the antibiotic Penicillin until the early 1940s.

Moulds consist of masses of fine intertwining hair-like filaments called hyphae which spread over the surface and often penetrate the material on which they are growing. They lack chlorophyll and are therefore unable to make their own food. Nearly all are saprophytes, ie they live on dead organic food material like dead animals and plants, bread, leather, jam, etc from which they absorb nourishment through the hyphae. They cause the gradual breakdown and disintegration of wood, paper, rope and textiles and can cause considerable damage in the process.

All moulds reproduce asexually although in some species sexual reproduction between positive (+) and negative (−) strains does occur. In asexual reproduction hyphae grow up from the ground into the air and spores develop at the ends, either exposed and in chains or clusters, or inside special structures called sporangia. When ripe, the spores are liberated into the air and, being microscopic in size, they are not noticed. These spores are always present in the air and tend to settle on horizontal surfaces and in dust. They are very resistant to low temperatures and desiccation, and then on being provided with moisture, warmth and a suitable substrate they start to grow.

The yeasts are small unicellular plants lacking chlorophyll like the rest of the fungi. Under normal conditions yeasts exist as single-celled fungi, but under certain conditions some grow hyphae like the moulds. Yeast cells can multiply in a number of ways and budding, which gives rise to clumps or chains of cells, is the most common method. Yeasts are widely distributed in nature and are to be found on the skin of grapes and other fruit, on vegetables, in milk, water, dust and soil and are quite frequently observed in cultures derived from throat swabbings. Many species are found as contaminants in brewers' and picklers' vats and several appear to live like bacteria on human skin. Species of an organism called Saccharomyces are well known as bakers' and brewers' yeast and are basically fermenting organisms, producing mainly alcohol and the gas carbon dioxide from sugars under anaerobic conditions of growth. The alcohol-forming power is used in the manufacture of wines and beers, and their carbon dioxide producing property is important in the baking trade.

Bacteria and viruses are microscopically small organisms lying on the boundary between the plant and animal kingdoms. Viruses are much too small to be seen with an ordinary microscope and even bacteria require a high-quality instrument and a magnification of 500 × or more before they can be clearly seen. They do not hold much interest for the nature photographer, and will not be discussed further.

AVAILABILITY OF MATERIALS

For most of the time the world of micro-organisms goes unnoticed but fortunately it is ever present and materials are not difficult to obtain. There are three basic sources of supply: the local environment, home cultures, and specialist suppliers. The

first involves collecting material from the natural environment and, although material is not usually available throughout the year, it costs no more than a little time and patience. The second source of supply is from home culturing of the organisms and this requires the setting up of a solid-food substrate and a small aquatic environment which will encourage the organisms to thrive and multiply. The third way of obtaining material is to buy it commercially. There are many suppliers who specialise in the culturing of micro-organisms and these cultures are reasonably priced, considering the work involved in producing and maintaining them (see the Suppliers List at the end of the book).

Materials from the natural environment

Protozoa and small coelenterates like Hydra live in ponds and streams, and species like Amoeba can occasionally be obtained from the surface of mud and decaying leaves at the bottom of ponds and slow-flowing streams. Hydra can sometimes be found attached to the leaves and stems of pond weeds like the Canadian pond weed, *Elodea canadensis*. A quantity of pond water and weed should be collected and a small amount removed with a medicine dropper, placed on a slide and examined under the microscope.

A very good method of collecting small organisms is to use a modified fine-mesh fishing net. A hole is cut in the bottom of the net and a small bottle (eg a pill bottle or small paste jar) is fixed in the hole. As the net is dragged through the water small organisms are pushed down the net into the bottle. This is really a method of concentrating the organisms which are widely dispersed in the water, into the very small volume of water in the bottle. Filamentous algae like Spirogyra and Oedogonium are very obvious to the eye and can be collected by hand or by using a stick. These algae look like green slime or wet green cotton-wool and, besides being interesting in themselves, they often form a micro-environment in which other small animals live.

Micro-fungi and yeasts are present all round us and, once our interest is aroused, finding them is not difficult. They are usually associated with dampness and food. Bread left for a few days in a damp environment soon becomes covered with moulds, whilst stored apples which are beginning to go rotten quickly become the host for many species of micro-fungi. Most cheeses provide an excellent substrate for the growth of moulds and these will develop in a few days if the cheese is left exposed to a warm damp atmosphere. Leather goods, particularly old shoes, quickly become covered with moulds if left unattended in a damp situation. It is not surprising that moulds grow with alarming speed in damp tropical climates and are a constant source of soilage and spoilage of clothes, shoes and fabrics.

Culturing of organisms

Home culturing is a rewarding way of providing one's own supply of materials to photograph. The requirements are minimal and the techniques straight-forward. Protozoa and micro-algae can be cultured by setting up a hay infusion. One can begin by collecting some twigs and grass, including several grass plants complete with roots, from an area where water stands in puddles after the rain. The location should be free from pollutants such as oil, which might affect the living organisms. The grass and twigs are chopped up and put into two jars containing pond water from the same area, or rainwater from a water butt. Tap water should not be used because some of the chlorine, put in at the filter works to kill micro-organisms, is likely to be present. If rainwater is not available, distilled water, obtainable from a chemist or garage, can be used.

The jar tops should be loosely covered and one jar put in the dark whilst the other is left in the light. Both cultures would benefit from being kept warm. The jar kept in the dark will encourage a different population of organisms from the one kept in the light. Within a week or so, micro-organisms which were present as little spores on the original grass and twigs will have burst out and be thriving and multiplying in the water. Using a medicine dropper a few drops can be extracted from near the grass and twigs, placed on a slide, protected by a cover-slip, and examined under the microscope.

The spores of moulds are mostly too small to be seen with the naked eye but are present almost everywhere. They float about in the air, settle on all surfaces and need only a suitable substrate, moisture, and a little warmth, to germinate and produce the typical mould so familiar to us all. Moulds grow well on bread and a useful technique to produce a variety of moulds is to moisten a cube of bread about 5 cm (2 in) square, wipe it across a kitchen table, place it on a saucer and after about an hour cover it with a glass jar to retain the moisture. In a few days, moulds, which came

5.1 Various common moulds, including Rhizopus and Penicillium species, growing on a cube of damp bread

either from the kitchen table or from the air, will begin to appear and after two or three weeks the bread will be completely covered as illustrated in Fig. 5.1. Bluish-green Penicillium moulds grow extremely well on fruit, particularly oranges and melons and a good growth can be obtained by first streaking a knife blade several times through the mould and then using the unwiped blade to cut deeply into the skin of the orange. Put the orange on a saucer with a little water and cover it with a glass jar to prevent desiccation. After a week or so the mould will have grown and spread along the cut area.

If one wants to grow pure cultures of moulds, the method used by professional micro-biologists is worth mentioning. This consists of preparing a food-enriched substrate, called nutrient agar, and inoculating it with a little of the fungus to be cultured. Nutrient agar is a jelly-like extract from a red seaweed Gelideum, to which food substances have been added during manufacture. There are many types of agar and each is designed to encourage the growth of a particular group of micro-organisms.

The agar tablets are dissolved in water, sterilised in an autoclave (or pressure cooker) for 15 minutes at 15 psi pressure, poured onto a sterilised Petri dish (or saucer) and immediately covered with a Petri dish lid (or larger saucer) to prevent contamination from the atmosphere. In about 15 minutes the agar will have set and a little of the mould can then be smeared across the agar surface. A few days in a warm atmosphere will produce a very good growth of the pure mould. The Penicillium plate shown in Fig. 5.2 was produced in precisely this way, using agar tablets manufactured by Oxoid, Oxo Ltd.

Gelatin (table jelly) can be used as a substitute for agar, but it tends to become rather sticky at body temperature and does not contain the nutrients required for the growth of the fungi. Gelatin was widely used in micro-biology laboratories prior to 1883, when a worker in Koch's laboratory suggested that agar might be used as a

5.2 Penicillium species growing on an agar plate. Strong oblique lighting was used. Exposure 1/30 sec. at f16 using a 75 mm enlarging lens mounted on a bellows unit

substitute. It was another student in Koch's laboratory, R. J. Petri, who suggested pouring the agar into a flat circular glass dish and immediately covering it with a glass top – thus preventing contamination by the air but allowing examination of the material.

Yeasts, like moulds, are present in the air all the time but the most convenient way of obtaining a yeast culture is simply to add a piece of yeast cake to a jar of warm sugary water. If the solution is kept in a warm place, the yeast cells thrive and multiply and after a few days the smell of alcohol can be detected. The sugary solution will be laden with budding yeast cells which are quite easy to observe, on a slide, under the microscope. Yeasts will also grow well on nutrient agar plates.

EQUIPMENT AND METHODS
Lenses
Both macro- and microphotographic techniques are used for photographing micro-organisms. For macro-work in which the image:object ratio varies from 1:1 to 20:1, one can obtain a large image on the negative by using one of several methods. A close-up lens will effectively shorten the focal length of the working system at the expense of a reduction in definition, unless the camera lens is stopped well down. A second method is to use either extension tubes or bellows (automatic or manual), thus increasing the distance of the lens from the film and so producing a larger image on the negative. The camera lens can be attached to the bellows in the normal way but a significant increase in definition will be obtained if the lens is attached in the reverse position, and for this a reverse-lens adapter will be required. A third method is to use a specially computed macro-lens which is designed to work efficiently at close distances. The latter is very expensive but a good substitute is a high-quality enlarging lens, and in this chapter all photographs were taken using a 75 mm (3 in) six-element Komuranon E enlarging lens attached to a manual bellows unit. Most enlarging lenses have a 39 mm ($1\frac{1}{2}$ in-diameter) Leica thread, and adapters are readily available to

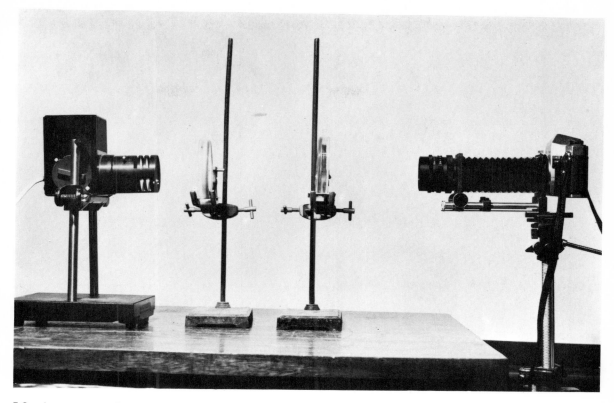

5.3 Arrangement for photographing micro-organisms using transmitted light. Note, from left to right, the high-intensity microscope lamp, diffusing disc, Petri dish containing the growing culture, enlarging lens, bellows unit and camera body

convert this to the 42 mm (1⅝ in) Pentax screw thread, or to any bayonet fitting.

Lighting

The lighting used in the examples was a 100-watt quartz-iodine 12-volt high-intensity microscope lamp working through a variable resistance to control the intensity of the output. A slide projector could be used if a microscope lamp is not available. Two forms of lighting have been employed to produce quite different effects. Figure 5.3 illustrates a set-up using transmitted illumination. The lamp is on the left and its beam is projected through a diffusing material, such as ground glass or translucent plastic, and then through the specimen in the Petri dish. The camera is on the right and focused on the specimen. This technique produces a dark-toned specimen on a light background. Without the

diffusing material, the light was too directional and the results were unacceptable. The *Rhizopus nigricans* mould illustrated in Fig. 5.4 was taken using this technique and, because of the high level of illumination, exposures were normally 1/60 sec at f16–f22.

The other form of illumination was incident illumination in which the lamp was positioned on the same side of the specimen as the camera but to one side, thus giving oblique or grazed lighting. This produces two effects: the first is to enhance surface texture as illustrated in Fig. 5.5 and, when pushed to the limit to produce the 'mountain ranges' of Penicillium illustrated in Fig. 5.2. If the growth is relatively sparse and the hyphae are growing away from the substrate, it becomes possible to graze the specimens with light and to leave the substrate unlit. This results in very light-toned specimens on an almost black background as demonstrated in Fig. 5.6, which shows the bread mould Rhizopus growing on an agar plate. Fig. 5.7 is of similar material photographed at the same magnification, the only difference being in the direction of the lighting. The type of the illumination has a profound effect on the impact of the

5.4 *Rhizopus nigricans*, common bread mould, photographed using the set-up shown in Fig. 5.3. Note the large black sporangia which contain small spores, which when dispersed float about in the air and may germinate into a new plant if they fall on a suitable damp surface (*top left*)

5.5 Not an aerial view of a tropical jungle but the surface of a piece of mould-covered damp bread. Exposure 1/30 sec. at f22 using an enlarging lens mounted on a bellows unit (*left*)

5.6 *Rhizopus nigricans* illuminated by grazed lighting, which picks out the hyphae and sporangia leaving the background unlit. Exposure 1/30 sec. at f11 (*top right*)

final photograph and it is worth spending some time experimenting with various lighting arrangements.

Photomicrography

For photomicrography, a conventional student microscope and a Nikon EFM Microflex unit are suitable. I use a Czechoslovakian Meopta microscope with 3 × and 10 × objectives and a 10 × eyepiece, giving final magnifications of 30 × and 100 × respectively. The use of two low-power achromatic objectives and a simple 10 × Huygenian eyepiece, rather than the very expensive apochromatic objectives and compensating eyepieces, will enable any photographer with

5.7 Bread mould growing on damp bread. Note the interesting arrangements of the sporangia and their supporting hyphae. Exposure 1/30 sec at f16

access to a basic student microscope to produce comparable results. The EFM Microflex attachment is used for speed and simplicity of operation, and in no way affects the quality of the results, since it consists merely of a light-tight box to hold the film and a simple leaf-blade type of shutter.

Any SLR camera should produce similar results since only the shutter and camera body are being used. The only extra piece of equipment needed is a microscope adapter-tube to link the camera body to the microscope. This replaces the camera lens and is quite inexpensive to buy, particularly for cameras using the 42 mm ($1\frac{5}{8}$ in)-diameter Pentax/Praktica screw thread. Accurate focusing and exposure determination might cause some problems, but these can usually be overcome with a little care and thought. The focusing screen on a typical SLR camera is really too coarse for photographic work, making it rather difficult to know when the image is exactly in focus, but with practice one soon gains enough experience to recognise when the image is at its sharpest.

Some SLR cameras have interchangeable screens and a special cross-hairs clear field screen is usually available for photomicrographic purposes. If the camera has TTL metering, a few

trial exposures soon determine whether any recalibration of the metering system is necessary. If, when the negatives are examined, double the suggested exposure is required, this can be calculated each time a new exposure time is being determined, or the film can be set at half its normal ASA rating, when the direct reading will be correct.

Lighting and filters

The two forms of lighting used in the preceding section can also be employed in work using the microscope. The conventional lighting for a microscope is transmitted illumination, where the light from the lamp is reflected from a plane mirror, through an optical condensing system, which brings the light to a very bright focus in the region of the specimen. Because the specimen is very small, the illumination needs to be very bright and highly concentrated, and any light which does not fall on the specimen is largely wasted. The material illustrated in Figs. 5.8 and 5.9 were both taken using this form of illumination and exposures were usually around 1/30 sec with the substage iris diaphragm about 1/3 closed.

As the earlier material was non-pigmented, and therefore looked greyish and translucent, there was nothing to be gained from using contrast filters, but a green filter was included to obtain maximum quality from the optical system (see

5.8 Volvox consists of a colony of hundreds of similar small green cells. In the centre of the photograph is a large Volvox containing six daughter colonies. The parent colony eventually dies and disintegrates, liberating the small colonies as seen at the bottom of the photograph. Magnification 100×. Exposure 1/4 sec. A red filter was used

5.9 *Hydrodictyon reticulatum*, a green alga, photographed using transmitted light. Magnification 30×. Exposure 1/60 sec. Red filter

Chapter 4). When the green algae were involved, the possibility of using contrast filters was considered. Volvox colonies (Fig. 5.8) and Hydrodictyon (Fig. 5.9) are both pale green in colour, and so they produced an acceptable image on the negative when using white light, but when a red filter was used the image was darker, thus giving greater tone separation from the background and a more balanced photograph.

The principle, discussed at length in Chapter 4, is that a colour filter transmits its own wavelength (colour) and absorbs the rest of the spectrum in varying degrees. Therefore a green filter will lighten green material and darken the other colours. The converse is also true, so that to darken a colour one chooses a colour filter as far away from the colour in question as possible. The green algae were darkened by using a red filter.

This technique must be used intelligently and it is most effective when other colours are present. Had the green algae been swimming in a very thin layer of red liquid, then the red filter would have had a very dramatic effect, but using clear water, only a small but useful increase in contrast was obtained. This discussion applies only to black and white photographs, and when colour film is being used one rarely needs filters, except, perhaps, to balance the colour temperatures of the light and the film.

The other form of illumination that can be used is incident lighting, set at about 45° to the microscope stage. The sub-stage condenser can be removed, and non-reflecting black paper put in its place, to produce an illuminated specimen on a dark or black background. This is known as dark ground illumination, and is the most successful method of achieving this result. If there is difficulty in getting sufficient light onto the specimen, the light from the microscope lamp should have an additional optical condensing system attached to it, to concentrate the beam to a fine point on the specimen. In this form of illumination, the light is scattered from the surface

of the specimen, and only a very small proportion of it actually passes through the microscope to the eye. This is in great contrast to the transmitted illumination (ie the normal illumination for a microscope), where practically all the light passes through the instrument into the eye.

Exposures can be extremely long, up to 12 seconds, and unfortunately, although this would be acceptable when using permanent slides, it is of little use when working with wet preparations, even if the material is dead, since organisms living or dead tend to be moved about in the water on the slide, owing to convection currents and capillary effects. Therefore, for wet preparations, an electronic flash should be used, and the Microflex unit is synchronised for electronic flash at all speeds (a great advantage of the leaf-blade type of shutter over the focal-plane shutter).

The best method is to use two flash units, one triggered from the camera and the other from a slave unit. Both have the same output (GN 90 or 30 m using 125ASA film) and are positioned on either side of the stage in the 45° position. The working distance, when using a 100 × magnification on the microscope, should be about 7 cm (2¾ in) from the slide, and the exposure should be 1/250 sec. If photographing algae, which are green in colour, a green filter can be used to produce a light-toned specimen on a dark background. To improve the contrast and to make satisfactory prints, the negatives should be printed on hard paper.

Figure 5.10 illustrates the technique, using the alga *Hydrodictyon reticulatum*, and it is interesting to compare the photograph with Fig. 5.9, which shows exactly the same material photographed by normal transmitted illumination. The dark-ground technique seems to give the material a three-dimensional appearance which is completely absent using the other method. The rather spotty background is caused by material suspended in the culture medium in which the organisms were growing; to eradicate this spotting, use filtered water.

Most protozoans are much smaller than the algae used in these examples and because of the light magnification required, it is not possible to provide sufficient illumination for incident lighting. Therefore transmitted lighting should be used, and since most of these organisms lack pigmentation, contrast filters would not be beneficial. To obtain maximum resolution with achromatic objectives, use a green filter. Illumination

5.10 *Hydrodictyon reticulatum* – dark-ground illumination from two flash units. Exposure 1/250 sec. Green filter

can again be provided by a high-intensity quartz iodine lamp.

The protozoan *Vorticella similis* is normally attached to suspended debris by a long slender stalk which holds the body in an advantageous position to secure the microscopic matter on which it feeds. The beating cilia, located on the periphery of the cup, circulate water containing food into the mouth, which is just below the ciliated rim of the bell-shaped body. When disturbed, the 'open' bell-end closes and the stalk contracts, pulling the body into the protection of the substrate. Under adverse conditions, for example, drying up of the environment, the body detaches itself from the stalk, moves into the debris and buries itself. The movements associated with the contraction of the stalk are too rapid to 'freeze' using a shutter speed of 1/30 sec and therefore exposures are normally made either before or immediately after a contraction.

Figure 5.11 shows several Vorticellae fully extended, one contracted and two half-buried in the debris. The suctorian *Discophrya collini*, illustrated in Fig. 5.12, is attached by a non-contractile stalk to the substratum. The spherical

5.11 The protozoan *Vorticella similis*, consisting of a bell-shaped body supported on a long contractile stalk. Several individuals are fully extended, one in the centre is contracted and two are half buried in debris. Magnification 100×. Exposure 1/15 sec. Green filter (*left*)

5.12 The protozoan *Discophrya collini*, consisting of a spherical body surrounded by several delicate protoplasmic rods with knob-like 'sucker' ends which are used to catch food. Magnification 450×. Exposure 1 sec. Green filter (*bottom left*)

5.13 The protozoan *Actinosphaerium eichorni* belongs to the order Helioza and the radiating stiffened pseudopodia originally suggested the name 'sun animalcule'. This organism, like most protozoans, reproduces by splitting in two; this is called binary fission. The photograph illustrates the splitting process – a constriction, which eventually nips the organism into two, is just visible. Magnification 450×. Exposure 1 sec. Green filter (*below*)

body is surrounded by several delicate protoplasmic rods or tentacles, each of which terminates in a round knob acting as a sucker to catch small ciliates that are used for food. *Actinosphaerium eichorni* (Fig. 5.13) belongs to the order Helioza and the radiating stiffened pseudopodia suggested the name 'sun animalcule'. This organism belongs, rather strangely, to the same class as amoeba since both possess pseudopodia which are used for food capture and movement.

Retardation techniques

Paramecium bursaria and many other active protozoans belong to the class Ciliata and are characterised by the presence of beating cilia, which often cover the entire body. Paramecium feeds on bacteria and other microscopic organisms, which are wafted by cilia down a special groove, the gullet, into a small sac known as a food vacuole. As the vacuole becomes full, it moves into another part of the cell and is replaced at the end of the gullet by another vacuole.

Photographing this organism is difficult because of its rapid movements and some technique must be employed to slow it down. This can be achieved by making the background liquid so viscous that the animal has great difficulty in moving about in it. This can be done by using a thick mixture of wheat paste, or wallpaper adhesive (such as Polycel), which is quite transparent and certainly inhibits the movements of the Paramecia; other suitable substances are glycerol and water-glass.

The photograph of *Paramecium bursaria* (Fig. 5.14) was taken using a wallpaper adhesive mixture, and although the exposure of 1/30 sec was not short enough to render the cilia sharp, their presence can be deduced from the disturbance in the polycel surrounding the body.

Always try to photograph living, rather than dead material, even though it makes the task of producing a sharp image on the negative much more difficult. During the process of dying, changes occur in the organism which often produce distorted, and therefore inaccurate, shapes. When dying, Paramecium ceases to pump out water and consequently begins to swell and finally bursts. Most soft-bodied protozoa living in fresh water behave in much the same way as Paramecium, whilst those living in sea water tend to lose water on dying, and change their shape as they become smaller.

To produce more contrast and detail in the small protozoans, phase contrast lighting can be used (see Chapter 4). Results using black and white film are fairly disappointing, and not up to the standard of the conventionally lit photograph, but with colour film the results are most attractive indeed.

5.14 The 'slipper' protozoan, *Paramecium bursaria*, slowed down in a 'polycel' mixture. The surface cilia are not visible but their presence can be deduced from the disturbance in the polycel. Magnification 200×. Exposure 1/30 sec. Green filter

6 Non-flowering Plants_____

The non-flowering plants, which consists of the Thallophyta, Bryophyta and Pteridophyta are a very large section of the plant kingdom. The Thallophyta are simple plants and include the Algae (e.g. seaweeds), the Fungi (mushrooms, mildews, moulds) and the Lichens (algae and fungi growing together for mutual benefit). The Bryophyta includes the mosses and liverworts, whilst the Pteridophyta embraces the ferns, horsetails and clubmosses.

FUNGI

This is a large and very important group of plants, many of which are microscopic, whilst the rest are typically fairly large and conspicuous. They have one feature in common in that they lack the green pigment chlorophyll. Thus they are unable to manufacture food by photosynthesis as do normal green plants, and must therefore use ready-made food. They obtain this by either living on other organisms as parasites, or living on dead decaying remains of animals and plants as saprophytes. The absorption of food takes place through minute filaments called hyphae which secrete digestive juices to liquify the food so that it can be absorbed.

The part of the fungus which is normally visible is the fruiting body and this produces the microscopically small spores that germinate to give rise to a new mass of hyphae. These fruiting bodies are often large and complex in appearance but in reality they consist merely of simple hyphae densely woven into a mass of tissue called a mycelium. Although some of the bracket fungi persist for many months or even years, most fruiting bodies grow very rapidly and survive for only a few days during which time they disperse the millions of spores which they have produced (Fig. 6.1).

The larger fungi are divided into two main groups based on the structure of the spore-forming organs. The two groups are the Ascomycetes and the Basidiomycetes. In the former, the spores, usually eight in number, are formed inside a club-shaped sac or ascus, and there are thousands of asci present in any one fruiting body. Common examples of Ascomycetes are the cup fungi (*Peziza* sp.), the morels (*Morchella* sp.), the truffles (*Tuber* sp.) and the earth tongues (*Geoglossum* sp.). The microscopic yeast fungi (*Saccharomyces* sp.) also belong to the Ascomycetes. The other large group is the Basidiomycetes, which includes most of the larger fungi. The basidiospores, usually four in number, are produced on small pointed projections on the end of club-shaped cells called basidia. Examples of Basidiomycetes are almost too numerous to mention, but include the common mushrooms (*Agaricus* sp.), ink caps (*Coprinus* sp.), fleshy toadstools (*Boletus* sp.), puff-balls (*Lycoperdon* sp.) and the bracket fungi (*Trametes* sp.).

Fungi are of considerable interest to man – many types are edible, and although most people eat only the common mushroom, in some countries, particularly France, other species such as puff-balls, parasol mushrooms, beef-steak fungi and the underground truffles, are regularly eaten and enjoyed. Several fungi are poisonous and any would-be fungus eater should learn to recognise such species as the death cap (*Amanita phalloides*), the 'destroying Angel' (*Amanita virosa*), *Clitocybe rivulosa*, *C. dealbata* and some species of *Inocybe*, particularly *I. napipes* and *I. patouillardi*. Several fungi are used in the preparation of antibiotics and the best known are the micro-fungi *Penicillium notatum* and *P. chrysogenum*, which are used to

6.1 Stages in the development of the stinkhorn, *Phallus impudicus*. The egg-like peridium bursts and in a few hours the fruiting body, complete with spore-covered cap has emerged

manufacture penicillin. Finally, several micro-fungi cause diseases in both animals and plants.

Availability

When and where does one start looking for fungi to photograph? The fine thread-like hyphae grow underground and remain there for most of the year, whereas the conspicuous fruiting bodies appear above ground, yet survive for only a very short time. In Britain, September, October and early November are the months during which most species are producing their fruiting bodies. There are some exceptions of course, such as the crustaceous fungi of the *Corticium* genus and the winter truffle *Tuber brumale* which produce fruiting bodies during the winter months, whilst the morels and cup fungi fruit in the spring. Perennial woody bracket fungi, such as the common ganoderma and polyporus species, persist for years on tree trunks and can therefore be photographed in the winter when the leaf canopy is absent.

Fungi seem to appear almost anywhere during the autumn months but a closer study soon reveals that they have two basic requirements. The first is a supply of food from, for example, fallen timber, leaf mould and compost, and the second is a moist environment. Fungi produce very poor fruiting bodies in dry conditions but a short period of wet weather, followed by a rise in temperature, is almost guaranteed to yield a good flush within a few days. Late autumn frost, however, kills off most species very rapidly.

Equipment

Since photographing fungi involves a fair amount of close-up work the most useful camera would be an SLR, in which the problems of parallax do not arise. In addition one would also need either close-up lenses, extension tubes, or bellows. Much time will be spent at ground level, and the fixed pentaprism is not ideal, because in a wet environment it is often very difficult and uncomfortable to get low enough to see the specimen in the viewfinder. The best solution would be to replace the pentaprism with a waist-level finder, but unfortunately most 35 mm SLR cameras made today have a fixed pentaprism. Another good solution would be to attach a right-angle viewfinder to the eyepiece of the camera, thus enabling one to view from above. Lighting can often cause problems and so the equipment should also include a silver/white reflector and a small electronic-flash unit.

Photographing fungi

Photographing fungi in the field is not difficult if one or two points are borne in mind. Having decided which fungus or cluster of fungi are to be photographed, the first task is to set up the camera and frame the specimens. Composition is the main

6.2 *Phallus impudicus* in a typical environment of fallen, rotting timber. The sticky spores have an offensive foetid smell which attracts flies. The latter represents some of the important biological information imparted by the photograph. Exposure 1/60 sec at f11 in diffused daylight

task at this stage and it is particularly important when working on 35 mm film when most of the negative area must be used if high-quality results are to be obtained.

At this time, line, tone distribution and balance should be uppermost in one's mind. The final print must be interesting as a piece of photographic composition, as well as being a vehicle for imparting biological information (Fig. 6.2). Having decided what is to be included in the picture, it is then necessary to do a little 'gardening'. This involves tidying up the environment without altering it too drastically. The human eye will accept many things in the field which it would find extremely distracting on a photograph. For example, the eye seems to be attracted to an out-of-focus foreground and makes strenuous but futile attempts to pull it into focus. Therefore, as a general rule, foregrounds should be in focus. This will often necessitate removing leaves, twigs or grass stems from the area between the specimen and the camera, leaving the foreground uncluttered (Fig. 6.3). Ruthless gardening, however, can almost destroy the surrounding environment, leaving the fungus looking rather exposed and naked and much of the point of the photograph will have been lost.

Next, study the background in the viewfinder, and if possible stop down the lens to the taking aperture. This will bring into focus many structures which are discreetly out of focus at full aperture. In most cases the background should be natural but unobtrusive, and twigs, leaves and branches may have to be removed to achieve this end. Distracting highlights in the background should also be eliminated, so that in the final photograph the eye concentrates on the centre of interest, the fungus. If the 'gardening' has been cleverly done the scene will look completely natural and, as it were, untouched by human hand.

When working in dense tangled vegetation a short-focus (ie wide-angle) lens is often useful because it enables one to move much closer to the specimen and still retain the same image size on the negative. Another use of the short-focus lens is when the fungus needs to be shown against a characteristic background, eg the fly agaric *Amanita muscaria* in a birch wood.

6.3 *Mycena tintinnabulum* growing on rotting timber. The foreground had to be cleared of out-of-focus debris which would have caused some distraction

Focusing must be accurate and the very shape of the fungus makes it difficult to decide whether to focus on the pileus (cap) or the stipe (stalk), which are unfortunately in different planes. Increased depth of field can be obtained by stopping down the lens, and most photographs are taken at f16 or even f22 if possible. This often requires a long exposure in a location which may be rather dark, as fungi are frequently found on the ground in woods where the leaf cover reduces the already failing autumn sunlight. Shadows caused by the pileus can be lightened a little by placing a white or silver reflector in the appropriate position.

When working in a natural light, it is tempting to select specimens which are in direct bright sunlight, on the assumption that the final print will sparkle with light. The result will be a very disappointing 'soot and whitewash' photograph with which even the softest grade of paper will be unable to cope. This is because direct sunlight produces a brightness range of well over 100:1, and whilst the negative and, to a large extent, the colour transparency will accept this, a photographic paper will not. The paper has a limited range of about 20:1 and therefore one can print either for the shadows or for the highlights but not for both. The much more limited brightness range of diffused sunlight would be more appropriate and produces a pleasant soft lighting (Fig. 6.4).

Although I would always advocate the use of natural light where possible, one should not hesitate to use flash if the ambient light is not strong enough. An experienced photographer can combine daylight and flash quite successfully (see Chapter 3). The flash can be used either as the main light or as a fill-in light, but in both cases the harshness of the flash light should be reduced by covering the flash-head with a white handkerchief. If flash is used as the sole source of illumination (eg at a high shutter speed with a leaf-blade shutter) great care should be taken to ensure that unacceptable 'midnight' effects are not produced in which the distant background and sky are almost black.

The angle of view is quite important and many people take their photographs from just above the horizontal (ie looking slightly down onto the top of the fungus). This enables the details of the pileus and stipe, including the ragged membranous ring or annulus if present, to be seen, but omits any view of the gill region under the pileus (Fig. 6.5). If it is important to include gill details, then the old trick of picking a nearby specimen, and placing it on its side amongst the group being photographed,

6.4 *Mycena galericulata* growing on stump of sawn-off birch tree. The low viewpoint shows to advantage the details of the gills. Exposure 1/60 sec at f16 in diffused daylight

can be indulged in, although some photographers think it rather spoils the natural appearance of the photograph.

When small encrusting fungi are involved, the camera should be set up with the film plane parallel to the encrusted surface, so that most of the fungus can be kept in focus. This is particularly important for very small specimens, when the depth of the field might be only a few millimetres. Once again a well-stopped-down lens would help. The photographing of bracket fungi on the trunks of trees should not present any problems, although it is

Plate 1.
Amanita muscaria, the fly agaric. A very conspicuous fungus due to the bright-red pileus. A favourite subject for artists and craftsmen, and one of the few fungi which is featured widely in children's books. An infusion of the pileus in milk was once used to kill flies, hence its name. Photographed in natural light in the autumn using Kowa Six camera (see Chapter 6).

Plate 2.
Caterpillar of a Chinese oak silkmoth, *Antheraea pernyi,* actively feeding on hawthorn leaves. Photographed indoors in artificial light against a contrasting background (see Chapter 8).

Plate 3.
The moon moth, *Actias luna,* photographed out-of-doors in natural sunlight, to show the details of the head, including the compound eyes and beautiful antennae. Kowa Six camera and close-up lens (see Chapter 8).

Plate 4.
Ladybirds, *Coccinella 7-punctata,* congregating on a green algae-covered post. This was a completely natural grouping of insects and, due to poor lighting conditions, electronic flash was used. Kowa Six camera and close-up lens (see Chapter 8).

Plate 5.
Fuchsia flowers, *Fuchsia magellanica,* photographed from a low angle so that the blue sky and clouds form an interesting uncluttered background. Natural daylight in September. Kowa Six camera with an ex-government achromat used as a close-up lens (see Chapter 7).

sometimes necessary to use either a telephoto lens or a step ladder so that a large enough image of the fungus will appear on the negative (Fig. 6.6). Care should be taken when estimating the exposure, because a direct meter reading will probably include a fair amount of sky, resulting in the fungus and bark being underexposed and lacking in detail. One stop more exposure will produce a better tone distribution in the fungus at the expense of a rather burnt-out sky.

When colour film is being used, there is little difficulty in producing really attractive photographs. Diffused daylight is ideal, although the

6.5 The 'Shaggy Cap' or 'Lawyer's Wig', *Coprinus comatus*. Often found on cricket pitches which contain buried fragments of rotting wood. The slightly above-the-horizontal viewpoint allows details of the pileus, stipe, and annulus to be included in the photograph

6.6 The birch polypore, *Piptoporus betulinus*, growing on a fallen birch tree. The growth persists for many years and being very absorbent, has been used as an ink blotting pad. Exposure 1/125 sec. at f16 in bright diffused daylight

colour temperature of the late autumn sun will probably be on the low side (ie too red), but the fastidious worker could raise the colour temperature by using a pale-blue correction filter. If the sun is filtering through green or yellow leaves this could also affect the final colour of the fungus and should be avoided where possible. Overhanging branches of trees or ferns often cast diffuse shadows over the pileus, giving it a blotchy appearance. This is not always obvious, as many fungi do have such an appearance, but some care should be taken to avoid unwanted shadows. If flash is used, the colour temperature will be ideal but the flash light should be softened by using the white handkerchief technique (Fig. 6.7).

When black and white film is being used one must try to imagine the scene without colour and although in the field the brown of the pileus would be in contrast to the green of the background, on black-and-white film the two colours might well be indistinguishable. Often the resulting photographs have little appeal to the eye because there is no difference in tone between the fungus and the background. One can tackle the problem in two ways. The first is to pay special attention to the lighting and to use it to highlight the fungus. If the photographer wishes to produce an exhibition print, then two or even three flash units could be set up in a similar fashion to that used in human portraiture, but taking care to see that the results still look natural rather than contrived. The second way is to use a colour filter to separate the specimen from its background. One must remember that a filter transmits its own colour and absorbs the other colours in varying degrees, so an orange filter lightens an orange-coloured fungus and darkens the grass, on the finished print. This principle can be applied to obtain tone separation in any multicoloured environment and though this may sound a little 'unnatural' it is no more so than any black and white photograph of a coloured original.

There is little need to photograph fungi indoors, because the natural background is important and this is often difficult to arrange artificially. Also, most fungi, with the exception of the woody types, either dry up or go rather slimy after being picked and transferred to a warm atmosphere. However if spore prints are required, these are best produced indoors, by removing the stipe, placing the pileus on a suitable card and covering it with a glass jar. After a few days the spores drop onto the card and a beautiful spore pattern is formed.

6.7 The common earth ball, *Scleroderma aurantium*. Found on slopes in woods and on peaty ground. Powdery spores escape after irregular cracking of the peridium. Exposure 1/60 sec at f22 using flash

LICHENS

Lichens are rather unusual plants and although there are about 1500 species they are somewhat inconspicuous and little known. Their peculiarity lies in the fact that they consist of an alga combined with a fungus, each helping the other in a relationship known as symbiosis. Generally the plant body and shape is produced by the fungus whilst the algal cells are squeezed between the fungal hyphae. These algal cells are either green or green-blue algae; *Nostoc* is the commonest blue-green, and *Trebouxia* the commonest green alga. The fungi involved are usually Ascomycetes although a few are Basidiomycetes. The algal cells photosynthesise and make food, some of which is utilised by the fungus, which in return probably supplies the alga with essential mineral salts. It would be convenient to suppose that the fungus protects the delicate algal cells against desiccation but, although this is a commonly held belief, there is little evidence to support the theory.

Typically lichens are small greyish-green plants but, depending on the pigments present, various shades of red, orange, yellow and even black, can also be found. They are very slow-growing plants and tend to be found in rather extreme habitats such as bare rock, roofing tiles, stone walls, in fact in areas which other plants find difficult to colonise.

Three basic types of lichen can be recognised. The fruticose form is characterised by a flattened branching thallus growing either upright like the reindeer 'moss' Cladonia or hanging from trees as in the beard lichen Usnea. The foliose form is leaf-like, and often resembles a liverwort, whilst the crustose type develops as a crust on the surface of rocks, headstones etc, and they are often so closely attached to the substrate that it is impossible to remove them. Lichens are very sensitive to air pollution and in particular to sulphur dioxide, so that very few grow in or around cities.

Lichens have some economic importance in certain countries. Reindeer 'moss' provides valuable fodder for Arctic reindeer and caribou, and man has eaten lichens but without relish and only in an emergency. Litmus, probably the best known acid-alkali indicator in chemistry, is extracted from the lichen *Roccella*, and certain lichens have been found to contain antibiotic substances active against gram-positive bacteria. One might not be particularly interested in either reindeer 'moss' or litmus, but the nature photographer can find much to stimulate him in the fascinating shapes, patterns and colours to be found in the lichens.

LIVERWORTS AND MOSSES

Liverworts and mosses constitute the Bryophyta (*bryon* = moss). They are small and rather inconspicuous plants and are either flattened creepers or erect structures a few centimetres ($\frac{1}{2}$–1 in) high. The common Bank Hair Moss, *Polytrichum commune*, is probably the largest British moss and may reach a height of over 20 cm (8 in) but this is quite exceptional. Although mosses prefer damp shady areas, they do have a very wide distribution, because they can tolerate conditions which would be totally unsuitable for most other plants. They spread from the Arctic to the equator and are at their most luxurious in tropical rain forests. In the British Isles they are more abundant in the west where there is a high annual rainfall. Mosses can be found in difficult habitats such as bare rock surfaces, brickwork, footpaths, walls, or in more favourable areas such as woodland, meadows and shaded river banks. Mosses are often pioneer organisms in that they are among the first plants to colonise burnt ground, disturbed soil or exposed rock. In areas of sparse soil, they tend to stabilise it and thus help to prevent water run-off after rain.

Bryophytes have little direct economic importance to man, with the exception of *Sphagnum*, the moss that grows in bogs and which finally forms the basis of peat. Some species are restricted to specific habitats and can make good indicator organisms. For example, the copper mosses occur only on heavy deposits of copper and antimony, whilst other species are acid sensitive and will only thrive in a limited range of pH.

It is not difficult for the experienced botanist to distinguish between liverworts and mosses but for the amateur naturalist the clearest distinction is in the structure of the sporophyte (spore-bearing structure). The liverwort sporophyte is a simple spherical sac whereas the moss sporophyte is a complex, often cylindrical organ with a special arrangement of teeth-like structures at the distal end to aid in the dispersal of the spores.

Mosses and liverworts have a similar life cycle, in which the plant is the gametophyte generation and produces the gametes or sex cells which on fusion develop into the sporophyte generation. This is the spore-bearing part and actually grows on the gametophyte (Fig. 6.8). When the spores are ripe, they are dispersed and germinate into a new plant. Mosses and liverworts can also reproduce vegetatively (ie without the intervention of

6.8 A common hair moss of the genus Polytrichum. The conspicuous aerial part is the spore-bearing sporophyte generation which grows on the moss plant which is the gamete bearing or gametophyte generation. Exposure 1/2 sec at f16 using artificial light indoors

the sex cells) by producing small buds or gemmae which become separated from the parent plant and develop into new plants. Under favourable conditions even pieces of the thallus can grow into separate plants.

Liverworts can be broadly classified into two groups, the thalloid types and the leafy types. The thalloids, which supposedly resemble lobes of human liver – hence the name liverworts – are represented by species such as *Marchantia polymorpha*, the common liverwort, and *Conocephalum conicum*, the great scented liverwort. They are usually soil organisms and the thallus is a fairly simple structure anchored to the ground by fine hairs or rhizoids. The form of the thallus is varied

but is typically flattened, branched and creeping. The other group contains the leafy liverworts and typical examples are *Alicularia scalaris*, the ladder-like scale moss, and *Plagiochila asplenioides*, spleenwort scale moss. In this group there is a definite distinction between stem and leaf making it rather difficult in some cases to distinguish them from the mosses. However, the leaves tend to be flattened and arranged in one plane in two overlapping rows.

The moss plant consists of a stem and leaves with the latter arranged more or less spirally around the stem. The leaves usually have a midrib but are never lobed or divided as in the liverworts. The plant is attached to the ground by root-like rhizoids. There are over 14,000 species of mosses and the common ones include species of *Sphagnum*, bog mosses, *Polytrichum*, hair mosses, *Funaria*, cord mosses, and *Mnium*, thread mosses.

The bryophytes are an interesting group of plants which are fascinating to study and photograph. They have a basically simple structure but

the shape and arrangement of parts such as the thallus and capsule are of great interest to the nature photographer and deserving of both time and effort.

Photographing lichens, liverworts and mosses

The techniques used for photographing lichens are very similar to those required for liverworts and mosses. In all three groups the plants tend to be small and therefore close-up facilities are required. An SLR camera becomes almost a necessity, plus close-up lenses, extension tubes or bellows. Most of the photographs included in this chapter were taken on a Canon SLR camera, equipped with automatic extension tubes.

Focusing and lighting are the chief problems to be dealt with if high-quality photographs are to be produced. When working a few centimetres (1–2 in) from the specimen, the depth of the field is extremely small and critical focusing is essential. This is difficult to achieve with a hand-held camera, even if the exposure is short enough to permit this, and therefore a camera support is necessary. On level ground a small table tripod would probably suffice, but a better idea, which is suitable for all types of ground, is to use a monopod consisting of a metal spike about 20 cm (8 in) long with a ball-and-socket head attached permanently to the end. When pushed into the ground this spiked monopod forms an ideal support for the camera.

Another piece of equipment which can help to make accurate focusing at close distances much easier is a tripod rack. This is positioned between the camera and the ball-and-socket head and allows the camera to move back and forth so that the specimen can be brought into focus. Once in focus, the lens should be stopped down as far as possible to obtain maximum depth of field. The difficulties of focusing, particularly when working at ground level, can be somewhat alleviated by replacing the pentaprism with a waist-level finder or by attaching a right-angle viewfinder to the eyepiece of the camera as suggested in the section on fungi.

The other problem is lighting, and most of the advice given in the section on fungi would be applicable here. However, there are one or two additional points that can be made which are particularly appropriate when working very close to the specimen. When the image to object ratio is 1:1, the extension factor is 4× and this increases

very rapidly as the magnification increases (refer to chapter on close-up techniques), and therefore at small apertures, long exposures are often required. In a shady environment this is not normally possible because of the low light intensity and under these conditions electronic flash might well be considered. This can be used 'direct', when the lighting might then be considered too contrasty, or it can be softened by covering the flash-head with a white handkerchief.

A very useful form of flash lighting is the portable macrolight described in Chapter 2. This provides sufficient light from the four 6-volt bulbs for focusing and modelling purposes and the flash lighting itself is softer and less contrasty than direct flash. The unit can be attached to the camera in place of the lenshood, and is most useful when working at close range (Figs. 6.9 and 6.10). A typical exposure using 125ASA FP4 film and an electronic-flash unit, with a flash factor of 22 for the same film, is f22 at 50 cm. The macrolight can also be used away from the camera to provide oblique lighting and many encrusting lichens show more surface detail and contrast when illuminated in this way.

It is usually necessary to do a little gardening before taking the photograph because most of the specimens are rather small, and dead leaves, grass and stems can look extremely conspicuous and distracting on the finished photograph.

Photography in the studio

In view of the small size of most mosses and lichens there is much to be gained from taking them indoors to be photographed. There, they are in a controlled environment where they can be set up at optimum working height and illuminated exactly as required (Fig. 6.11). Electronic flash can be used, but unless it is combined with an accurate modelling light, the results, particularly when more than one light is being used, are rather unpredictable. The macrolight is ideal for this purpose. Half-watt lighting is easily controlled and can be set up with ease and accuracy but, because the specimens are so small, the light needs to be concentrated into a fairly narrow beam. Slide projectors, focusing microscope lamps and high-intensity lamps can all be used and a particularly convenient unit is the Vickers Intense Lamp which has a built-in variable resistance to control the intensity of the light. This gives added flexibility to the system and not only allows a range of highlight to fill-in light ratios to be easily

6.9 A very small trumpet-shaped lichen, *Cladonia fimbriata*, photographed at close range using the macrolight unit, which produces a rather pleasant soft flash. Some 'gardening' was done but one or two dried-up pine needles were inadvertently left behind

6.10 The Crescent Cup Liverwort, *Lunularia cruciata*, in which the crescent-shaped cups containing the gemmae are clearly visible. The camera was set up with the film plane parallel to the liverwort so that all the plants would be in focus. Exposure 1/2 sec at f16 using artificial light indoors

achieved, but also permits the lights to be run at low intensity and therefore minimum heat, until the exposure is about to be made. Using two of these microscope lamps most tasks can be tackled with considerable success (Fig. 6.8).

As mentioned earlier, working indoors allows full control of the materials and the background. When photographing the Great Scented Liverwort and the Crescent Cup Liverwort, the specimens were arranged parallel to the film plane so that they were all in focus (Fig. 6.10). When photographing moss plants complete with setae and capsules, the same problems arise of keeping all in

6.11 *Parmelia incurva*, a greenish-grey lichen common only in the north of Britain. Note the growth of the lichen (top left) around the broken edge of the stone. Macrolight electronic flash f16

focus and this can be solved by cutting away and discarding part of the moss tuft. Figure 6.12 was produced by discarding the material behind line AB and removing the setae and capsules at *C* and *D* (Fig. 6.13). The final photographs look quite natural and all the setae and capsules are in focus. Most of the photographs included in this section were taken with half-watt lighting at apertures of f16 or f22 and given exposures ranging from 1/10 sec to 1/2 sec. The camera was equipped with automatic extension tubes, mounted on a firm tripod, and the shutter triggered from a cable release.

PTERIDOPHYTA

The Pteridophyta include the ferns, horsetails and clubmosses. They are all more complex in structure than the fungi and mosses, and each plant consists of a definite stem, root and leaf (the fronds of ferns) system. Reproduction is by means of spores, which are located in different positions in the three groups. In the ferns they are usually found on the undersurface of the frond, often protected by a shield-like cover, whereas in the horsetails and larger clubmosses they develop in cones at the tips of the stems. In the smaller clubmosses, the spores occur on the upper side of the leaf bases.

The ferns as a group have persisted over millions of years and they were one of the dominant plant groups at the time when dinosaurs roamed the earth. There were many large tree-like ferns and they are represented today by several species in the tropical rain forests of Africa and South America. In Western Europe they rarely exceed 1.5 m (4½ ft) in height, and the majority are no more than 0.5 m (1½ ft) high. Well-known examples are the common bracken, *Pteridium aquilinum*, which grows on heathland and in open woods, the male fern *Dryopteris filix-mas*, which prefers damp sheltered places, such as woods and

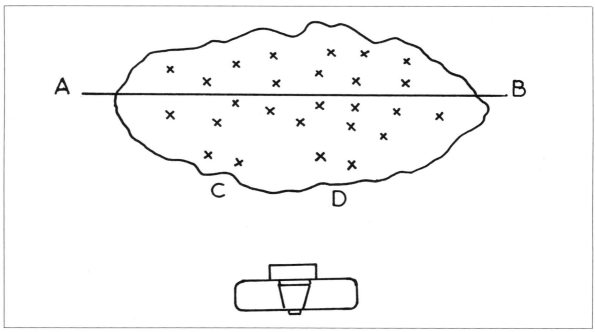

6.12 *Funaria hygrometrica* photographed in artificial light against a black background. The moss capsules and setae were kept in focus by adopting the procedure outlined in Fig. 6.13

6.13 Plan of set-up for photographing mosses. The plant tissue was cut along line *AB* and the rear piece discarded. Plants at *C* and *D* were removed leaving several capsules and setae in the same plane of focus.

the shady banks of streams, and the polypody, *Polypodium interjectum*, which grows in crevices in rocks, and on walls and hedgebanks.

The horsetails, *Equisitum* species, are the descendants of another very ancient group which is fast dying out. They dominated the landscape during the Carboniferous period, some 250 million years ago, when they attained tree-like proportions. Fossil remains are fairly abundant in the coal measures laid down at that time. The species found in Britain are all small and relatively inconspicuous, although a few tropical species may reach a height of 8 m (26 ft). The spores of horsetails, unlike those of ferns, are soft and green and produced in cones at the tips of shoots.

The clubmosses were also a dominant feature of the landscape during the Carboniferous period and many also achieved tree-like proportions. However, over the years, they too have declined and at the moment there are only half-a-dozen British species and five of these belong to the single genus *Lycopodium*.

Photographing ferns

Much of the interest in ferns lies in the variation of frond shape and a photographic study of this can be both interesting and rewarding. Some fronds such as those of the Hart's Tongue Fern and the Polypody have simple but divided fronds. The Hay-scented Fern and the Shield Fern are much more complex, the latter having a frond consisting of up to 40 pairs of main lobes, each divided into smaller lobes with toothed margins, and long hairs at the tips of the teeth. When photographed in the field, the details of the frond are best seen lit by frontal-oblique lighting against a dark background. Figure 6.14 illustrates this technique and was taken in late autumn against the dark background of a pine wood.

A technique which can be used indoors is to arrange the fronds on a well-lit translucent surface and photograph them from above. This is the method used to photograph the developing frog's

spawn, described in Chapter 10. Another technique, not involving the use of the camera, is to arrange the fronds on a piece of enlarging paper and cover them with a sheet of glass. The paper is then exposed under the enlarger lamp and the print developed. A grade of paper can be selected to suit the type of print required.

An interesting series of photographs can be produced, beginning with the uncurling of the young fern fronds in the spring and culminating in the production of the spores in the autumn. Figure 6.15 shows the early development of tightly rolled fronds and illustrates an aesthetic rather than a naturalistic approach to the subject. It was taken in the late afternoon in spring and is an example of extreme back lighting. The sun was so low in the sky that the normal lenshood was quite useless and a hand had to be held in front of the camera to cast a shadow over the lens. The negative was deliberately underexposed to reduce the detail in the

6.14 Common bracken, *Pteridium aquilinum*, illuminated by frontal oblique lighting, against a dark background of conifer trees. Exposure 1/50 sec. at f8

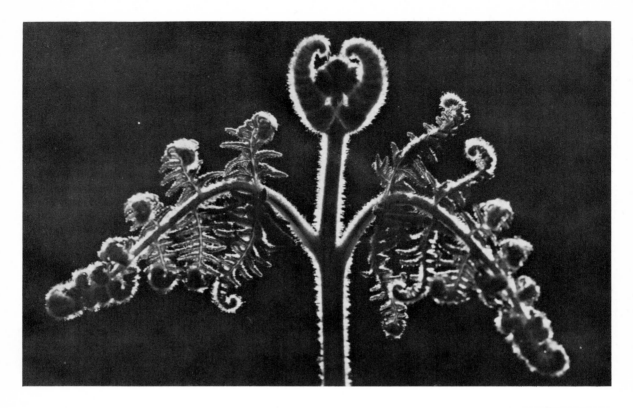

6.15 Tightly curled fronds of the common bracken unrolling in the spring. Strong back lighting was used to produce this 'artistic' rather than 'naturalist' picture. Photographed outdoors in natural sunlight

6.16 Uncurling fronds of bracken. The more natural oblique lighting eliminates the silhouette effect seen in Fig. 6.15 and includes more detail of interest to the naturalist

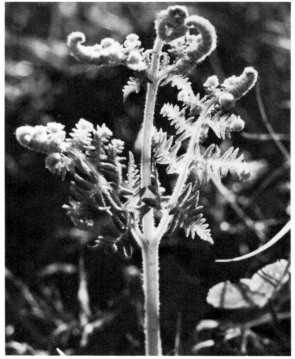

shadows. Figure 6.16 also illustrates the early stages in the developing frond and shows the sort of detail which would be of interest to a naturalist. The lighting in this photograph was oblique and the final effect is rather different from that produced by the back lighting in the previous photograph.

In the autumn the spores are produced on the undersurface of the frond and these can be photographed in the field if a frond is bent back to expose them. Much more control is possible if the material is taken indoors and photographed by artificial light.

At the end of the growing season the fronds exhibit a range of warm autumn tints and they are best photographed in colour. This is a fairly

straightforward task if one remembers that, when working in colour, the highlight/shadow ratio should be greatly reduced by using soft diffused lighting rather than the bright contrasty lighting of a typical summer's day. This should produce very attractive prints or transparencies which are full of detail in both the highlights and the shadows.

7 Flowering Plants_____

BIOLOGICAL CHARACTERISTICS

The flowering plants were the final group of plants to evolve and fossil evidence indicates that they first made their appearance about 120 million years ago in the Cretaceous period. The presence of flowers is the most obvious feature of the group as a whole, although in the grasses the flowers are rather small and inconspicuous. A fundamental characteristic common to the whole group is the presence of a box called the ovary, in which are found the ovules. After fertilisation the ovule develops into the seed and the ovary becomes the fruit. The fruit can be soft and fleshy as in plums and pears, woody in nuts, or dry and papery in honesty and sycamore.

Botanists divide the flowering plants into two groups: the monocotyledons which have one cotyledon (a starchy food reserve) and the dicotyledons which have two cotyledons. An example of the latter is the garden pea; when its skin is removed, the seed falls into two halves which are the cotyledons. Near the edge of one of them is a tiny structure called the embryo, and this gives rise to the root and shoot when the pea germinates. The monocots have only one cotyledon but the seed structure tends to be more complicated than that of the dicot seed. There are several other characteristics which distinguish the two groups. Dicot plant leaves are usually broad and net-veined, whereas monocot plant leaves are generally long and narrow with straight parallel veins. Dicot stems are often woody and grow into large permanent structures, whereas monocot stems tend to be non-woody and relatively small. Dicot flower parts are often in multiples of four or five; monocot parts are usually in multiples of three. These are general trends and characteristics but there are always exceptions to the rule. Typical monocots include the grasses, cereals, lilies, tulips, and orchids whilst the majority of other plants,

including most wild flowers, shrubs and trees are dicots.

The conifer trees will be included in this chapter, although from a strictly botanical viewpoint they should be considered on their own. They produce flowers but, as in the grasses, there is an absence of petals. They also bear seeds which are, however, naked and exposed instead of being enclosed in a case (fruit). The name 'conifer' derives from the fact that the seeds are borne collectively in structures called cones. Well-known examples of conifers are the pines (*Pinus* species), spruces (*Picea* species) and larches (*Larix* species).

NAMING AND GROUPING OF PLANTS

The scientific names of plants (as opposed to their popular names) are in Latin because, when the early work on the naming and grouping of plants and animals was done in the mid-eighteenth century, mainly by the Swedish botanist Carolus Linnaeus (1707–78), Latin was the language of scholars. Books were already being printed in many different languages by this time, but Latin was retained for the names of animals and plants. This universal use of Latin names allows botanists all over the world to refer to the same plant by the same name. Popular or vernacular names are not subject to any rules but are often based on local tradition, and the same plant could have several popular names in any one country thus leading to possible confusion. The letter 'L' after a name refers to Linnaeus who worked out the binomial or two-name system which is universally used today. For example, the scientific name for the meadow buttercup is *Ranunculus acris*, where *Ranunculus* refers to the name of the genus (or surname!) and *acris* is the species name (or Christian name!). When a person's Christian name is not known he is

referred to by his surname only. The same principle applies to animals and plants so that if the species name is not known then it is referred to only by the generic name. Finally, plants possessing similar characteristics are grouped together into a family so that the marsh marigold, wood anemone, meadow buttercup, lesser celandine, water crowfoot and many others form the family *Ranunculacae* – the buttercup family. There are some 60 families of wild flowers in Britain and upwards of 5,000 species of flowering plants have been recorded.

In this chapter, flowering plants will be divided into three groups: wild flowers and garden flowers which are all dicots; grasses, sedges and reeds which are monocots; and finally trees which are also dicots. Each group poses its own problems for the nature photographer.

EQUIPMENT AND APPROACH

A 35 mm or a 6 × 6 cm ($2\frac{1}{4} \times 2\frac{1}{4}$ in) SLR camera with a standard lens and a medium telephoto lens are required, plus close-up facilities in the form of extension rings, close-up lenses or bellows. A tripod, an electronic-flash unit and a portable reflector complete the equipment list.

The approach can range from that of the ecologist, who is primarily interested in photographing plants in their natural environment, to that of the creative photographer who uses plant materials as a vehicle for expressing his artistic ideas. The ecologist photographs plants mainly in the field; his photographs illustrate the plant's form and structure, and the way in which it fits into its environment and copes with competition from surrounding species. The final photograph should be of high quality, such that it is more than merely a record of the plant. It should be well composed, balanced, and satisfying to the eye. The creative photographer will usually bring his material into the studio or laboratory and spend much time and effort arranging and lighting it. Oblique and back-lighting techniques are often employed to heighten visual effect. Clearly defined aims are very important, if the photographer is to gain maximum interest in the subject, and the following suggestions cover some of the most important areas offered by this subject.

1 Portraits of flowers (either singly or in groups) in the studio, allowing full scope for artistic expression.

2 A study of a plant life-cycle, including winter buds, flower opening, fruit and seed production, and germination of the seedling.

3 Growth processes – for example, the opening of flowers and buds – studied by time-lapse techniques.

4 A study of trees throughout the year, concentrating on the gross shape and changes in colour.

5 Fruit and seed dispersal methods related to either one agency, such as the wind, or to one family of plants which includes several methods of dispersal.

FLOWERS IN THE FIELD

When photographing flowers in the field, the normal practice is to find specimens which are complete and undamaged and typical of the species. The photograph should show the plant in its normal environment and although very little of the background needs to be included, there should be sufficient to differentiate between, for example, a woodland flower and a meadow flower (Fig. 7.1). If, however, it is important to include a large expanse of background to make it obvious to the observer that the particular plant is specific to this background, then a wide-angle lens (28 or 35 mm focal length) should be used. If the plant is occupying the foreground, a considerable area of background can be included in the photograph and since the depth of field is quite large with a wide-angle lens, most of the important features can be kept in focus.

The selection of the viewpoint is very important. A low camera position will isolate the flowers against the sky, whereas a high viewpoint will include the immediate background. The latter can be either thrown out of focus or darkened by casting a shadow over it, or a combination of both methods can be used (Fig. 7.2). An artificial background, such as a piece of cartridge paper or sheet of hardboard, can be held behind the plants, but this tends to look rather unnatural. A little judicious 'gardening' will usually have to be done (as discussed in Chapter 6) but always resist the temptation to transfer the plant to a 'better' habitat, because it seldom looks natural and an expert can usually spot the change.

Lighting

Another factor of great importance is the direction and quality of the illumination. If the photographer is mainly interested in recording the delicate tracery of the stems and flower-stalks of

lighting with bright highlights and very dark shadows, whereas a completely overcast sky produces flat shadowless lighting. If given a choice, most photographers would opt for a slightly hazy sky where the sun's rays are diffused to produce good modelling and some detail in the shadows. In conditions of high-contrast lighting, a fill-in light in the form of either a portable reflector (eg a white painted board, a white handkerchief, or aluminium foil crumpled then smoothed out and glued on to a piece of hardboard) or a small electronic flash can be used, as discussed in Chapter 6.

Windy conditions

The wind is one of the nature photographer's chief enemies and the problem is at its worst when he is photographing grasses or flowers which are

7.1 The common cotton-grass, *Eriophorum angustifolium*, photographed on the famous Ilkley Moor. The late afternoon sun was used as a back light. The surrounding vegetation of bilberry plants helps to 'locate' the cotton-grass in its correct environment ie on high wet moors (Although called cotton-grass this plant belongs to the sedge family Cyperaceae.)

grasses, then they tend to look very effective when back-lit. When photographing garden flowers one is trying to record the texture of the petals, or the delicate hairy stems, or the finely sculptured surface of the leaves. These characteristics are difficult to photograph in the field but as a general guide, oblique frontal lighting tends to show up surface texture; oblique back lighting highlights the delicate hairs on stems and high-intensity back lighting is usually very effective when photographing translucent petals (Fig. 7.3).

A bright clear sky produces high-contrast

7.2 The garden bluebell, *Endymion hispanicus*, photographed in natural sunlight against a dark shadowy background. Exposure 1/50 sec at f11

7.3 Crocuses, *Crocus purpureus*, on a spring morning after a light overnight fall of snow. Back lighting was provided by the morning sun and some of the snow behind the crocus heads was melted using an electric hair-dryer

supported on swaying stems. To achieve sufficient depth of field to make the important features of a small flower appear sharp and clear to the eye, a small aperture of f16 or f22 must be used. This will often necessitate a fairly slow shutter speed of perhaps ¼ sec. This slow speed is insufficient to 'freeze' the movement of a swaying stem and it is therefore hardly worth attempting any photography under breezy conditions.

However, if photographs must be taken despite windy conditions, then some form of wind-break should be used. This can be a haversack placed next to the plant, or even a willing helper kneeling down, but the most satisfactory wind-break is the type used by holiday makers on windy beaches. Some enthusiastic photographers have been known to use a home-made cellophane tent which is erected over the plant to be photographed. This works extremely well but is only worth the time and effort if much plant photography is to be undertaken.

Another solution to the wind problem is to use electronic flash as the main light source, but the problems of producing a natural looking photograph are considerable and unless the camera has a leaf-blade shutter (and most SLRs do not), then a troublesome after-image invariably appears on the negative. Flash is best employed as a fill-in light and then only to lighten the shadows, rather than to eliminate them completely.

Filters

The use of filters was discussed fully in the chapter on photomicrography, and they can be of particular value when photographing flowers in both colour, and black and white. In many ways, photographing flowers in colour is much easier than working with black and white film. The eye registers colour, and what is seen in the camera viewfinder will be fairly accurately represented on the final print or transparency. The lighting can be fairly diffuse or even flat, because the modelling is achieved by changes in colour, and not by variations in tone distribution which are so important in black and white work.

Modern colour films are very faithful in their rendering of colours and few problems exist when photographing flowers. Sometimes, however, purple-blue flowers do not photograph very accurately and different makes of film have slightly different renderings of these colours, but unless colour fidelity is of supreme importance these differences can largely be ignored. The use of filters in colour work is therefore limited to either 'warming up' or 'cooling down' the light illuminating the scene.

Colour films are balanced for average daylight (5,400°K), whereas early morning light has a slightly higher colour temperature, and is more blue in colour, and evening light has a lower colour temperature and is more red in colour. These effects can be minimised by using a pale-pink correction filter (No. 81A) for morning light and a pale-blue filter (No. 82A) for evening light. This extra filtration is not essential and many photographers prefer the often attractive, if inaccurate, effects of using unfiltered light.

There are two main reasons for using filters when working with black and white film. Firstly

7.4 Fuchsia flowers, *Fuchsia magellanica*, photographed indoors to show the effect of different coloured filters
(a) Red filter – the red flowers are too pale and the green leaves are too dark – the photograph is unacceptable
(b) No filter – the tone rendering of the flowers and the leaves is quite acceptable
(c) Green filter – the flowers look almost black, and the leaves are rather light – an unacceptable photograph

the colours of the spectrum are replaced by a white through grey to black tone scale and although modern panchromatic films do this extremely well, greens do tend to appear rather dark, and blues,

rather too light, on the final print. Secondly, the colour which will normally separate a flower from its leafy green background is absent in a black and white photograph, and the final result might be unacceptable to the eye. A yellow-green filter is usually used to lighten foliage and improve its tone rendering, whilst blue flowers and blue sky can be darkened by using a yellow or orange filter. Flowers can be lightened or darkened at will and this is illustrated in Fig. 7.4 using the dark-red fuchsias as an example.

Finally, whether working outdoors or indoors, a small atomiser or scent spray can be a very useful accessory. Water, if sprayed onto a flower or leaf will simulate dew, often adding mood and atmos-

phere to the photograph. This allows one to photograph flowers under the best possible lighting conditions, rather than at dusk when the natural dew is just forming, or in the pale light of dawn before the dew has evaporated.

Time-lapse photographs

Time-lapse techniques can be usefully employed when studying the growth of parts of the organism. An obvious example is the opening of a flower bud and the unfolding of the petals. Other examples are the development of leaves, the ripening of fruit, and the germination of seedlings. The method involves taking a series of photographs at regular intervals, so that the main stages in the development sequence are recorded. The simplest way to present the results is by a set of photographs depicting the important stages in the sequence. However, a more interesting technique is to superimpose the images onto one photograph so that an impression of growth and movement is created. For the best effect the number of images on any one photograph should be between three and six, depending on the characteristics of the material. Fewer than three images hardly constitutes a sequence and more than six tends to produce too much image overlap resulting in a burnt out and confused sequence of ghost images.

The camera must be fixed firmly on a tripod and operated via a cable release. If the camera shutter can be reset without winding on the film, several exposures can be made on the same negative and the task of printing the photograph is straightforward. If, however, multiple exposures are not possible, separate negatives will have to be made and the final print produced either by projecting each negative onto the same printing paper and grappling with the problem of accurately registering the images, or by taping the negatives together and printing from the negative sandwich. The taking of the photographs can be fully automated by using an electronic timer operating a motor drive attached to the camera. The lighting should be arranged so that none falls on the background, which should remain matt black. This allows the images to be clear and bright and prevents any background images from ghosting through the sequence images.

The best flowers for the time-lapse treatment are those which open in a fairly dramatic way, and which alter their position during the process. A daffodil can be selected in which the flower bud is pointing downwards at an angle of about 60° to the

horizontal. As the flower opens, the angle decreases and the final exposure shows the fully open flower with its head held well above the horizontal position (Fig. 7.5). This opening sequence will produce three or four well-separated images and represents the ideal in this type of work.

GRASSES

Grasses are extremely common and widespread, and yet are usually ignored by most nature photographers. The probable reason is that at first glance grasses appear uninteresting and hardly

7.5 An opening daffodil, *Narcissus pseudonarcissus*, photographed by time-lapse photography. This particular photograph was produced from a three-negative sandwich; the enlarger lens was stopped down to f22 to obtain acceptable definition from the rather thick sandwich

7.6 Flower heads of the meadow foxtail, *Alopecurus pratensis*, covered in masses of ripe stamens. Photographed outdoors in natural sunlight. Exposure 1/125 sec at f11

(although not strictly a grass), illustrates these points (Fig. 7.1).

The camera was positioned slightly above the plant to concentrate attention on the delicate downy heads. The late afternoon sun was directly behind the plant, producing a back-lit effect and there was sufficient reflected light around not to need a fill-in flash. A little 'gardening' was done, particularly in front of the plant, to remove out-of-focus or distracting material. The viewpoint was selected to include an area of dark tone behind the cotton-grass heads thus concentrating attention on them. The wind on the moors was rather strong but a wind-break placed about 1 m (3 ft) from the plant was effective in preventing swaying of the

worthy of the photographer's time. Flowers are present although they are very small and inconspicuous and therefore most people would not think of them as flowering plants. The complete absence of petals adds weight to this commonly held idea. However the reproductive parts, in the form of stamens and ovary, are always present and after pollination seeds are produced in the normal way (Fig. 7.6).

Grasses in the field
Photographing grasses in their natural environment is difficult and often unrewarding because the floral parts are small and lack any conspicuous colour to make them stand out from their background. If it is important to photograph grasses out of doors, great care should be taken when selecting the viewpoint, and observing the direction and quality of the light. The photograph of the cotton-grass *Eriophorum angustifolium*

7.7 The wood meadow-grass, *Poa nemoralis*, photographed against a natural dark background to enhance tone separation. A viewpoint was selected to ensure that all three grass stems were approximately the same distance from the camera and therefore in focus

and a yellow or orange filter is used to darken the blue and therefore increase the contrast between clouds and sky.

Grasses in the studio

The photographs of the cotton-grass (Fig. 7.8) and the wood meadow grass (Fig. 7.9) were both taken indoors and illustrate a more artistic approach to the subject. The cotton-grass stems were arranged, taped onto a support to hold them in one plane and strongly illuminated from above and behind. A 35 mm slide projector produces a powerful beam and is very suitable for this purpose. A small fill-in light was used to add tone to the otherwise unlit parts of the plant. Both grey and black backgrounds were tried and the latter seemed to produce the most interesting result.

The photograph of the wood meadow grass was made using plants which had been pressed overnight and then carefully arranged in one plane so that all parts were in focus. The grasses were illuminated by a powerful back light but no fill-in light was required, because of the translucent

7.8 Cotton-grass photographed indoors. A powerful back light was employed, and a small fill-in light added some tone to the otherwise unlit frontal parts of the plant

flower stems. The final photograph looks quite natural and shows the cotton-grass plant in its normal environment amongst heather and bilberry plants.

The photograph of the wood meadow grass *Poa nemoralis* (Fig. 7.7) was taken using a similar technique. The sun was shining from a clear sky and although not a back-lit arrangement, the effect is much the same. The shadowy background helps to give the tonal separation needed to make the grasses clearly visible. A little tidying up was done and a viewpoint was selected to ensure that the three grass stems were (approximately) in the same plane.

Another method of preventing background confusion is to select a very low viewpoint and to use the sky as a background. This can be very effective if there are cumulus clouds in a blue sky

7.9 Wood meadow-grass photographed indoors. Lighting as in Fig. 7.8. Exposure was kept to a minimum to reduce halation effects

nature of the material. The exposure was minimal to prevent halation effects on the negative. (When a bright spot of light falls on the negative it tends to spread, producing a halo effect which reduces the sharpness of the image. This is known as halation.)

TREES

Tree studies can include photographs of groups of trees in natural woodland settings, individual trees in splendid isolation, or close-ups of various parts of trees such as their buds or flowers. It is often quite difficult to find a complete and typical example of any particular species. Many have lost branches due to natural disease or human intervention, whilst others have a distorted appearance as a result of overcrowding or other environmental pressures. The lower part of the trunk is often concealed behind hedges or walls, or the foreground is blocked by vegetation, electricity pylons or other man-made structures. It is worth searching for a good specimen before deciding to do any serious photographic work.

Seasonal approach

In the winter, deciduous trees, having lost their leaves, present a bare outline, and the characteristics of the branching system are very obvious. Winter trees usually photograph well when lit from behind, and although the surface details of the trunk and branches will be lost, their outlines stand out very clearly. A slightly overcast sky is preferable to a bright clear one, since the latter tends to produce halation effects on the film, resulting in the loss of detail in the fine branch endings.

In the spring, with the development of the young leaves, the tree takes on a delicate green mantle. This is best photographed in colour but even if black and white film is used, back lighting will always highlight the young translucent leaves, which look very attractive against a dark background.

In the summer the trees are in full leaf and the branching system is completely masked, leaving only the gross shape to photograph. This is best done by oblique or grazed lighting when the tree will take on a three-dimensional textured appearance. This effect is heightened if the photograph is taken in the late evening when the sun is low in the sky.

Autumn is usually a photographer's paradise and colour work comes into its own. An observant

photographer will notice that there is a peak period of a few days when the trees are at their best. In the early autumn the leaves begin to wilt and change colour, but green is still the predominant colour. Gradually the warm-toned yellows and browns begin to dominate the scene and the trees are at their most photogenic stage. Frontal and side lighting for colour work and backlighting for black-and-white will show up the autumn tints very clearly (Fig. 7.10). Shafts of sunlight can be made much more obvious if one beats the ground to disturb the fine dust particles which, when airborne, reflect the sunlight.

Then suddenly, often during a spell of unsettled weather, the leaves fall in large numbers and the trees seem to be shaking off the last vestiges of summer and preparing for the long cold winter. Photography at this time can be very disappointing.

Parts of the tree

Focusing one's attention on parts of trees can produce ultimately some very rewarding photographs. Figure 7.11 showing the opening of horsechestnut buds was taken indoors using a powerful back light to highlight the delicate hairs and 'fluff' on the young leaves. A small amount of frontal lighting was used to introduce some detail into the bud scales and other structures which would otherwise have been lost in shadow.

Figure 7.12 illustrates the male flowers of the pussy willow and was photographed using a similar lighting arrangement. The white flowers of the hawthorn show up magnificently against the thick foliage of large dark-green leaves. The photograph (Fig. 7.13) was taken out of doors in natural sunlight and the overhanging branch was so low that no artificial support was needed to reach it. A series of photographs can be built up showing the winter buds, the opening of the leaves and flowers, the fully open flowers, and finally the fruits and seeds. This idea can develop into an interesting and worthwhile photographic project.

Each tree has its own particular bark characteristics and producing a set of photographs which illustrates and compares different types of bark can be very rewarding work. These photographs should all be taken at the same distance from the trees so that features such as fissures and general

7.10 A woodland scene in the late afternoon. This was a back-lit photograph but the carpet of wet light-reflecting leaves provided some fill-in light

7.11 Opening buds of the horse chestnut, *Aesculus hippocastanum*. This photograph was taken indoors using a frontal fill-in light and a powerful back light. Note the delicate hairs and 'fluff' on the young leaves, highlighted by the back lighting (*top left*)

7.12 Male flowers of the pussy willow, *Salix caprea*, photographed indoors using the same lighting arrangement as in Fig. 7.11 (*bottom left*)

7.13 The common hawthorn, *Crataegus monogyna*, photographed outdoors in the late afternoon sun (*top right*)

roughness can be accurately compared. The most satisfactory type of lighting for bark studies is 45° frontal lighting, which not only fully illuminates the bark and allows detail to be observed, but also shows the texture without the shadows being too obtrusive.

The best time of the year for this work is in the winter or spring before the leaf canopy has developed. A hazy sun will produce soft directional lighting and this is preferable to the harsh contrasty lighting of a bright cloudless sky. A reflector to lighten the shadows would be necessary if the latter conditions prevail. Tree barks also provide a niche for many small animals and plants, and a study of these can often be usefully incorporated into the same project.

FRUITS AND SEEDS

In view of the fact that the flowering plants first made their appearance about 120 million years ago, it is not surprising that they have become well adapted to survive in the very competitive environment in which they live.

A study of the fruits and seeds of common hedgerow plants, and their methods of dispersal, can result in the production of some very exciting photographs. The general form and detailed structure of many of them is extremely interesting, particularly when photographed in close-up and illuminated to advantage. Most important is the ability to recognise an interesting pattern of light and shade, a delicately sculptured surface, or an attractive shape.

If a plant species is to survive it must be capable of producing seeds which can be scattered, so that they can germinate into next year's plants. A range of wonderful mechanisms has been evolved so that effective dispersal of fruits and seeds does take place.

There are, basically, four ways in which fruits and seeds are dispersed – by the wind, explosive mechanisms, water, and animals. In several plants two agencies might be involved. For example, the seeds of legumes are primarily dispersed by explosive mechanisms, but might be further dispersed by animals. The photograph of the thistle illustrates dispersal by wind, using a parachute mechanism, and was taken indoors using an electronic flash unit held about 60 cm (2 ft) above and slightly in front of the specimen, thus providing a natural sunlit effect (Fig. 7.14). The technique was to set up the camera and flash unit, then blow onto the specimen and almost simultaneously squeeze the cable release. After a little practice it was possible to photograph the fruits just as they were leaving the thistle head and before they had moved out of the frame.

The common willow herb, one of the first flowering plants to colonise burnt or waste ground, develops parachute seeds neatly packed in a pod-like structure. As the pod dries, it splits open, exposing the damp, wrapped up 'parachutes'. The sun dries the hairy pappus and the seeds are ready to become airborne. Figure 7.15 illustrates the stages in the reproductive cycle of the willow herb. At the top of the plant are the flowers, below these are the closed pod-like structures, and on the lower part of the stem the hairy seeds are entangled in the

7.14 Fruit and seed dispersal in the thistle, *Cirsium vulgare*. The photograph was taken indoors with 45° frontal lighting provided by an electronic-flash unit

7.16 Fruit of the sycamore, *Acer pseudoplatanus*, spinning to the ground. This was an attempt to illustrate the dispersal method and is discussed fully in the text

7.15 The rose-bay willow-herb, *Epilobium angustifolium*, photographed outdoors in natural sunlight. The dark background consists of out-of-focus trees in deep shadow. Stages in the reproductive cycle, from the flowers on the tip, through the closed seed pods in the centre, to the despersing seeds at the base, are clearly visible on this one stem

Plate 6.
The Red Admiral butterfly, *Vanessa atalanta*, in free flight. Photographed by ultra-high-speed flash in a flight tunnel (see Chapter 8).

Plate 7.
The sea urchin, *Echinus esculentus*, lives from extreme low water to depths of up to 200 metres. Photographed in a rock pool. Note the delicate tube-feet between the rows of spines (see Chapter 9).

Plate 8.
The American green tree frog, *Hyla cinerea*, leaping towards an upright twig, photographed by high-speed flash (see Chapter 10).

dried-up remains of the pod. This photograph was taken in the field, using natural sunlight.

Trees such as the ash, elm and sycamore have evolved pericarps, or fruit-coats, with large wing-like structures. These are fairly effective in carrying the fruits some distance, thus reducing the tendency to overcrowding under the parent tree. The photograph of the sycamore fruit (Fig. 7.16) was designed to show them spinning through the air to the ground. The specimen was suspended from its stalk by a length of black cotton. After

several turns of the pericarp 'propeller', the fruit would rotate for a few seconds.

The camera was set up to produce a vertical tilted action. The blurred, swirling image was formed by slowly tilting the camera with the shutter open. During the exposure an electronic flash was fired to produce the sharp image of the

7.17 A red campion, *Melandrium dioicum*, dispersing its seeds. The photograph was taken indoors using electronic flash

fruit. A dark background was used and an exposure of 1 sec at f16 was given. The technique was fairly complicated, since during the exposure the camera mirror was in the 'lock-up' position and therefore the viewfinder was inoperative! Finally the print was turned upside down because the centre of gravity of the specimen dictates that after being blown from the tree it would descend to the ground 'heavy end' first, as in the photograph.

Several plants make use of the forces of tension which develop as parts of the fruit dry out. Classic examples are to be found in the legume family – peas and beans – in which the pod dries and splits (dehisces) into two parts, each containing a row of seeds. Then as each part dries, it twists, so that the seeds are nipped, and eventually shot out.

The poppy utilises both the wind and dehiscence. When the seeds have matured, the capsule or 'seed box' dries out and dehisces at several points just below the apex to produce a ring of small pores. When the wind blows, the seeds are shaken out of the perforated box. The seeds of the campion are dispersed in a similar way, in that the capsule dries and develops ten slits which extend a short way down the ovary and as the tissue dries these curl downwards to form ten teeth. These teeth open wide on fine days, but remain closed when the weather is wet. The wind blows the capsule about and the seeds are thrown out. The photograph of the red campion was taken indoors with electronic flash (Fig. 7.17). The method used was to lightly tap the stem of the plant and simultaneously squeeze the cable release.

7.18 Goose grass, *Galium aparine*, illustrating dispersal by animals. A strong back light was used to highlight the delicate hooks on the fruits, leaves and stems

Dispersal by animals occurs in the beech. The fruit falls to the ground, splits open and exposes the seeds, which are collected by mammals, such as squirrels, and either eaten immediately or carried away and hidden in a food store. The fruit consists of a four-lobed woody pericarp, surrounding the dark-brown triangular-section seeds.

There are many examples of animal dispersal of hooked fruits and seeds such as geum, burdock, enchanter's nightshade, and agrimony. The one chosen to illustrate this method is the 'sticky Jack' or goose grass (Fig. 7.18). This is very common in the hedgerow and rather uninteresting to look at until one examines it very closely, when the beauty of the structure becomes apparent. Not only are the tiny fruits, which are a mere 3–4 mm ($\frac{1}{8}$ in) in diameter, covered with delicate minute hooks, but the leaves and stem edges are similarly equipped. Here is a rare example of almost the whole plant being dispersed, instead of just the fruits and seeds. The photograph was taken indoors, using a strong back light and just sufficient front light to put a little detail into what would otherwise be a black mass.

8 Insects

Insects are a very successful class of animals, as shown by the large number of individuals and the wide variety of species which exist. There are over 850,000 named species and it has been suggested that this figure might represent only about one-quarter of the total number in the world today. When one realises that three-quarters of all known animal species are insects, one begins to appreciate just how widespread and numerous they are. Fossil evidence indicates that they have been in existence for at least 270 million years and over 10,000 fossil species have been described of which the largest was a dragonfly-like creature with a wing span of 3/4 m (10 ft). Over this great time-span, insects have become extremely well adapted to the great variety of habitats which they now occupy. They can be found in all environments except the sea. Various species are adapted to live in fresh and brackish water, but the majority are terrestrial, and live in soil, on and around animals and plants, and even inside some animals and plants.

CHARACTERISTICS

Insects belong to a large subdivision of the animal kingdom known as the Invertebrata, which means that they do not possess a vertebral column (backbone) as do vertebrates such as fish, reptiles and mammals. Most invertebrates exist either in water or in damp areas, whereas insects can live very successfully in dry environments thus giving them a great advantage over the other invertebrates. Probably more important however is their ability to fly, and this enables them to cover large areas in search of food, and also provides an ideal way of escaping from enemies. Although present in great numbers throughout the warmer regions of the world, their very small size makes them much less conspicuous than they might otherwise be. Most insects are little more than a centimetre

($\frac{1}{2}$ in) long and many measure only a few millimetres ($\frac{1}{8}$ in). The largest are the Rhinoceros and Hercules beetles which can grow to a length of 15 cm (6 in), whilst some of the large tropical butterflies and moths, such as the Bird-winged swallowtail and Atlas moth, have wing spans of up to 20 cm (8 in). These are, of course, exceptional and the vast majority of insects, due to their small size, go almost unnoticed.

Some insects, such as silverfish, bristle-tails and spring-tails are wingless and belong to the subclass Apterygota, but the majority are winged, possessing either one or two pairs. Other characteristics which distinguish insects from other classes of animals are the division of the body into a head, thorax, and abdomen, the possession of mouth-parts (modified for chewing, piercing or sucking), and the presence of three pairs of jointed legs, one pair of antennae and typically two pairs of wings. Breathing is through air tubes called tracheae, which form a network inside the body and terminate at small paired openings (spiracles) on the sides of the thorax and abdomen. The body is covered with a normally hard skin (exoskeleton) which is moulted at regular intervals to allow growth to take place.

There are some 26 orders of insects, many of which are little known and are of no interest to the nature photographer, whilst other orders are very well known and have fascinated entomologists for many centuries. Some of the more common orders include the Odonata – dragonflies; Ephemeroptera – mayflies; Homoptera – aphids, whitefly, scale insects; Trichoptera – caddis-flies; Lepidoptera – butterflies and moths; Diptera – horse-flies, common flies, midges; Coleoptera – beetles, weevils; and Hymenoptera – bees, wasps, ants.

Although spiders are not insects they do bear a superficial resemblance to them and they are found

in similar habitats. Spiders are readily distinguishable from insects by the possession of four pairs of legs in contrast to the insect's three pairs, and by the absence of wings. Also, unlike insects, they have simple eyes instead of large compound eyes, and the head and thorax are fused into one unit, the cephalo-thorax. Included in the same class as the spiders are scorpions, harvestmen, mites and ticks.

LIFE-CYCLES

Many insects have a fascinating life-cycle and much of their interest to nature photographers lies in studying and photographing various aspect of the life-cycle. Insects such as butterflies and moths undergo a complete metamorphosis, ie their life-cycle consists of four distinct stages culminating in the adult: egg, larva (caterpillar), pupa (chrysalis), imago (adult). Some of these life-cycles are extremely interesting to observe and photograph, and the highlight is often the splitting of the pupa case and the emergence of the imago.

Other insects, such as grasshoppers, cockroaches and dragonflies undergo an incomplete metamorphosis, in which the life-cycle consists of only three stages, again culminating in the adult: egg, nymph, adult.

These life-cycles are not as interesting as the first group, and the nymph often resembles the adult, the growth progressing through a series of moults. There are one or two notable exceptions, for example, dragonflies and mayflies have aquatic nymphs which in no way resemble the adults. At the appropriate time, the nymph leaves the water by climbing up a plant stem and after a short resting period the skin of the nymph splits open and a beautiful dragonfly emerges, leaving behind a perfect nymph skin still attached to the plant.

SUGGESTED APPROACH

Insects are an exciting group of animals to study and photograph and there are many different approaches to the subject. The choice depends to some extent on whether the photographer favours the artistic approach and hopes to produce, under controlled conditions, attractive portraits of adult insects, or whether his interest lies mainly in field ecology, when photography in the natural environment will appeal more to him. The following suggestions will serve to bring to a focus the main interests in insect photography.

1 Portraits of adult insects photographed under controlled conditions. The more attractive butterflies and moths can be collected in the field, or purchased as eggs or pupae from livestock suppliers (Fig. 8.1).

2 A study of mouthparts and feeding methods. Insects exhibit a wide range of feeding habits, and a series of photographs illustrating this would be a difficult but rewarding task.

3 A set of photographs illustrating the main stages in the life-cycle of a selected species. This could show the structure and arrangement of the eggs, the development of the caterpillars, the structure of the chrysalis and the beauty of the fully-formed adult. If one is lucky enough to be able to photograph the actual emergence from the pupa or chrysalis, one would certainly have an exciting set of photographs.

4 A survey of insect flight. Any photographer tackling this topic must have infinite patience and be prepared for numerous disappointments and setbacks. The problems are great but so are the rewards, as can be seen by studying the exceptionally beautiful flight photographs produced by Stephen Dalton.

5 A study of camouflage techniques. Many insects fall prey to other insects, birds and animals, and one way of reducing this loss is by adopting protective coloration. Most of this type of work would be done in the field where the insect is in its natural environment.

6 Mimicry is another interesting aspect of insect ecology. Some insects survive in the wild either by imitating natural inanimate objects, such as twigs (stick insects), leaves (lappet moths and leaf insects) and thorns (tree hoppers), or by mimicking harmful insects, such as wasps (wasp beetle) or bees (hoverflies). Again this study would be carried out in the field during the summer months when the insects are available, and the ambient temperatures are high enough to keep them active.

CHOICE OF EQUIPMENT

Because insects are so small, most photographic work will have to be done close to the specimens. Any camera which permits this, and also allows accurate framing and focusing would be quite satisfactory for insect photography. Rangefinder cameras have separate viewing and taking systems and the problem of parallax eliminates them from being acceptable for this task. TLR cameras suffer in the same way and although valiant attempts have been made to solve these problems (see Chapter 1) they cannot be recommended for this type of work.

expensive. In recent years some photographers have been using enlarging lenses for close-up work, and although the diaphragm is manually operated, and therefore a great disadvantage when photographing moving insects, the lens is specially designed for use at the object-to-image ratios with which we are dealing in insect photography. In order to move in closer than the standard lens will allow, one must either include a bellows unit or extension tubes, or adopt the cheaper but slightly less effective (optically) alternative of using close-up lenses. The photograph of the Chinese oak (Assam) silkmoth (Fig. 8.2) was taken using a 75 mm (3 in) Komuranon E enlarging lens mounted on a bellows unit.

Two other items will complete the basic requirements for this type of photography. The first is a firm tripod, which on some occasions will be indispensable, and the second is a small electronic-flash unit (two, if finances allow it), which will be used frequently, both in the field and in the studio.

PHOTOGRAPHY IN THE FIELD

Photographing insects in their native environment will be of prime importance to the photographer whose main interest is natural history. Insects tend to be restricted to specific habitats – for example, dragonflies and caddis flies are usually found near water, grasshoppers and crickets prefer dry grassy areas, and bees of various types are attracted to nectar and pollen-bearing flowers. If specific insects are to be photographed, a good knowledge of their natural history and ecology is necessary if one is to avoid wasting many hours in abortive searches. Photographs produced by the naturalist photographer should show not only the insect, but sufficient of the surrounding area to make the latter easily recognisable.

Stalking insects

Photography in the field is usually undertaken by the stalking method, which involves selecting a habitat – for example a hedgerow – and systematically working along it, in an attempt to find a particular species of insect. The advantage of this

8.1 A preying mantis, *Hierodula membranacea*, as an example of an insect portrait, taken indoors under controlled conditions. Two electronic-flash units were used

The best choice is obviously an SLR camera and the typical 35 mm version will form an excellent foundation on which to build a useful outfit. A 6 × 6 cm (2¼ × 2¼ in) SLR camera will produce a much larger negative area but the greatly increased cost of the camera and accessories militates against it.

A useful additional lens would be a medium telephoto lens with a focal length of 105 or 135 mm (4⅛ or 5¼ in); 150 mm (6 in) focal length is ideal for a 6 × 6 cm (2¼ × 2¼ in) format camera. One of the specially computed macro-lenses is excellent for this type of work, but they tend to be very

8.2 A Chinese oak (Assam) silkmoth, *Antheraea pernyi*, photographed indoors using a 75 mm Komuranon enlarging lens mounted on a bellows unit. The large compound eyes are just visible below the base of the antennae

method is that one can cover a lot of ground, but the disadvantage is that movements usually disturb the insect population and the chance of taking a photograph may well be lost. Before commencing a search, the camera should be made ready for instant use and this will require attention to the lens, exposure and shutter speed.

The standard lens is not satisfactory for this type of work because the distances are so small that one would have to be within a few centimetres of the insect to obtain a reasonably large image on the negative. A medium telephoto lens and a suitable bellows unit or extension tubes should be used. It would be a great advantage if both the telephoto lens and the extension tubes were fully automatic so that focusing could be done with the lens diaphragm fully open, thus ensuring maximum brightness on the focusing screen.

A meter reading, typical of the area, should be taken and the shutter speed/aperture combination set on the camera. Ideally, one requires a short exposure to combat camera shake and subject movement, and a small aperture to obtain maximum depth of field. A 135 mm ($5\frac{1}{4}$ in) lens can normally be hand-held at 1/135 sec (ie reciprocal of focal length) and longer exposures might show evidence of camera shake on the negative. Having decided on the shutter speed to be used, the meter will indicate the appropriate aperture for that particular shutter speed.

For subjects likely to be close to the ground, a waist-level viewfinder, or a right-angle attachment to the pentaprism eyepiece, are extremely useful, and the difficulty of getting low enough to see through the normal viewfinder is eliminated. A lens-hood should be used at all times as a matter of habit and although its effect is minimal with frontal lighting, it does become essential as the light source moves round to the back light position.

Having set the shutter speed and lens aperture one should then move slowly along the hedgerow looking for the insect to be photographed. On locating a suitable specimen, the slow continuous approach is preferable to the intermittent stop-start technique. Experience suggests that the former method causes much less disturbance to the insect than the intermittent approach. It is also important to make the first exposure as soon as the insect comes into focus on the viewfinder screen, regardless of the ambient light level or the state of the surrounding vegetation (Fig. 8.3). This should be followed by a slow steady withdrawal to a safe distance where the meter reading can be checked and the film wound on.

Having obtained a photograph one can now give some thought to background confusion, foreground distraction and angle of view. After removal of any unwanted highlights or conspicuous blobs of colour from the background, it is then worth observing the effect through the viewfinder with the lens stopped down to the taking aperture. A background which looks satisfactory at full aperture will often be quite unacceptable when it becomes sharper, on stopping down the lens. Several photographs can now be taken under more controlled conditions.

It is useful to have on hand a small electronic-flash unit and although under normal conditions one would use daylight, which is the natural lighting in the field, there might be occasions when flash would be of great value. If an insect is located on the shaded side of a hedge, or under the hedge

8.3 A Large White butterfly, *Pieris brassicae*, photographed using the 'stalking' method discussed in the text. Only one exposure was made before the butterfly took flight

where the light level is very low, or if the weather is dull and overcast, then flash should be used. To produce a natural effect the flash should come from the same direction as the sunlight, ie overhead, but if this necessitates separating the flash unit from the camera, then the extra movements are likely to disturb the insect and the principle should be abandoned. The flash unit should be attached to the camera and the combination can then function as one unit causing the minimum of disturbance to the insect.

An awareness of what one is trying to achieve will suggest a particular viewpoint and this should be considered before the insect is located. If, for example, one requires a photograph of a Large White butterfly to show the arrangement and shape of the wings, then a side view would be most appropriate as the butterfly tends to hold its wings vertically when at rest. On the other hand, most moths and several other species of butterflies hold their wings horizontally, almost in contact with the material on which they are resting, and are best photographed from above, ie at right-angles to the plane of the wings (Fig. 8.3).

When a photograph is designed to illustrate feeding methods, a frontal view should be considered and one must forgo sharpness in the regions behind the head in exchange for a dramatic head and mouthparts photograph. As a general rule a more interesting photograph will be produced if the insect is involved in some activity such as feeding, mating, or egg-laying, rather than just resting on a twig or flower. This is not easily obtained and requires skill and patience on the part of the photographer.

Interesting outdoor photographs can be obtained of spiders, for example, feeding on a small insect caught in the web. All spiders are beasts of prey and they exhibit many methods of catching food in addition to the use of webs. Some spiders lie in waiting and pounce on suitable prey as it passes by, others actively hunt their prey in the open, and one or two species actually swim under water to obtain their food. British spiders are rather small and difficult to photograph in the field, and therefore photographers tend to concentrate on the spider's web with or without its occupant.

Webs are extremely delicate structures which require a special technique to make them visible on a photograph. They must, of course, be photographed in the field *in situ* and this can present problems. A good time to photograph a spider's web is on a misty morning before the dew has had time to evaporate. The web will be laced with beadlets of water and should be photographed against a dark or black background and lit by fairly strong back or side lighting. This can be either natural sunlight or light from a flash unit. Dry webs can, of course, be sprayed with water from an atomiser but this technique should be restricted to outdoor webs, which would normally be covered with dew. To spray an indoor web is unnatural and misleading.

INSECTS IN THE STUDIO

The term 'studio' does not necessarily refer to an expensive purpose-built room complete with a multitude of lights and backgrounds, but more often to a shed, garage, attic or other small area equipped with a table and a mains power supply. If the area is warm and well lit, and if possible not used by other members of the family, it could be an ideal studio.

There are many reasons why insects are usually photographed indoors, but the main one is that of control. In the studio one can control the elements so that variations in light intensity, temperature and wind velocity do not occur, and the photographer can concentrate on photographing the insect in the best possible way. One can work at any time during the day or night and one is to some extent independent of the seasons. Insects are small and usually easy to handle, and simple habitats can be readily arranged in the studio. Most insects do not make any noise, or produce unpleasant smells; nor do they require expensive food or large complex accommodation. The camera, tripod and lighting equipment can be set up accurately without haste and can be left in position until the insect is ready to be photographed.

Collecting insects

The insects to be photographed can be obtained either from the natural environment or purchased from suppliers.

Collecting from the environment requires time, patience and some knowledge of insect ecology. In certain areas, such as nature reserves, collecting is not permitted, whilst in others — for example Forestry Commission plantations — it may be necessary to obtain permission. After the insects have been photographed, they should be returned to their original, or a similar, habitat.

Insects can be collected at any time in their life-

cycle, although most people tend to concentrate on the adult, partly because this tends to be the most conspicuous stage. However, certain eggs are quite easy to find, for example the Large White butterfly lays her eggs on the leaves of the cabbage family (cabbage, cauliflowers, broccoli) and many moth caterpillars feed on chickweed and dandelion leaves and their eggs are laid on these food plants. Trees such as hawthorn, oak and birch are worth searching for the eggs of the Large Thorn moth and Lackey moth, whilst the Puss moth favours poplar and willow trees.

Larvae are easier to locate than eggs because they are larger and mobile. They can be collected individually by hand, but a more successful method is that known as 'beating'. A sheet of plastic or paper is spread under a tree or bush, which is then struck with a stout stick. The caterpillars and some adult insects fall off onto the sheet and can then be collected. During June and July stinging-nettles are a likely source for the larvae of the small Tortoiseshell and Peacock butterflies, whilst the larvae of the Small Copper butterfly favour sorrel, dock and ragwort plants.

Pupae are not easy to locate because some have protective coloration and others may be buried in the ground. They can sometimes be found in leaf litter and soil at the base of trees on which the larvae have been feeding. They are often buried on the north-east side of the tree sheltered from the rain and sun, usually about 20 cm (8 in) from the trunk and 10–15 cm (4–6 in) deep. Pupae collected in the field can be carried home in a small tin can containing some damp moss, and stored in a cool place over the winter. Occasional damping of the moss will be necessary and the following spring the pupae should be transferred to a much larger cage containing twigs so that the emerging adults can hang from them whilst their wings are expanding.

Adult insects tend to be easier to locate than either larvae or pupae, but rather more difficult to capture. Most moths are active only at night and spend the daylight hours concealed out of sight of predators. However at night they are attracted to light, particularly ultra-violet (ie light beyond the blue end of the spectrum). The simplest method of collecting moths is to place a domestic lamp near to an open window, where after a few hours many moths and other nocturnal insects will have gathered.

A much better method is to use a large box (a tea chest is ideal), filled with cardboard egg-separators, which supports a metal container (such as a biscuit tin) with glass sides and top containing a lamp to attract the moths. A 40-watt domestic tungsten filament lamp is satisfactory, but a mercury-vapour lamp is much more effective because it emits more of the ultra-violet light, which is particularly attractive to moths. They fly towards the light, strike the glass sides and fall into the box. The following morning they can be collected from the cavities between the egg separators.

Commercial units such as the Watkins and Doncaster trap (see the List of Suppliers) are sold complete with ultra-violet light and moth trap. The moths should be removed from the trap as soon as possible to avoid unnecessary damage to their wings.

Butterflies are best collected with a large net during the day. Cotton nets tend to be softer than synthetic fibre nets and less damaging to the butterfly. Again great care should be exercised when removing them, as their wings are very fragile and easily damaged. Small insects which are often difficult to pick up by hand can be collected using a pooter, a simple suction bottle familiar to all field biologists. It consists of a small bottle or tube fitted with a rubber bung through which two tubes are inserted as shown in Fig. 8.4. The photographer sucks on the mouth piece and air is drawn in through the inlet tube carrying the insect with it. The gauze filter fixed over the end of the mouthpiece tube prevents the captured insect from being sucked into one's mouth. There is little chance of this actually happening but the thought is not a pleasant one!

If one is particularly interested in photographing examples of the Diptera then a readily available supply of blowflies would be the maggots used by anglers. These maggots can be bought cheaply from fishing-tackle shops; after a few days they pupate, and this stage is followed fairly quickly by the emergence of the adults. The whole sequence can take place in a small tin can or jar, and the adults can be removed as they emerge.

There are one or two specialist suppliers (such as Worldwide Butterflies Ltd, and Griffin Gerrard) who can provide species not native to one's own country. Tropical silkmoths and butterflies, stick insects and desert locusts, for example, are supplied as eggs, pupae or nymphs, depending on the species and the time of year.

Photographing insects

The task of photographing insects can range from

INLET

TO MOUTH

8.4 A pooter for collecting small insects

the consummate ease of working with completely static material (eggs and most pupae) to the extreme difficulties of photographing insects in full flight. The requirements for the work, in addition to the camera equipment described earlier, are a few pieces of plant material appropriate to the insect being studied, and some means of illuminating the specimen.

Photoflood lighting, although inexpensive and convenient to use, produces too much heat, and in this respect electronic flash in conjunction with a low-intensity modelling light is preferable. If these can be combined into one unit, as in the Courtenay Colorflash 100 or the more compact Photax Interfit Studio Flash unit, so much the better, otherwise some ad hoc arrangement will have to be made.

The modelling light is important because it will show up any unwanted shadows and, when two units are being used, an accurate indication is given of light balance and modelling effects. A good basic lighting arrangement, which can be used for most insect photography, is to place one light in the 45° frontal position and to use a second light almost as a back light to highlight certain areas on the insect and to produce good separation from the background.

Eggs and pupae are relatively easy to photograph as there is no movement to complicate the task (Fig. 8.5). They are best photographed on or near the host plant associated with that particular stage of the life-cycle and should be set up at table-top level and illuminated as indicated above, to show the surface texture and to produce good

modelling. Eggs and pupae are usually rather small and, to obtain a reasonably large image, either extension tubes, or a bellows unit, will be required. The use of an 85 or 135 mm ($3\frac{1}{4}$ or $5\frac{1}{4}$ in) telephoto lens will allow the camera to be moved back from the specimen, thus eliminating the possibility of unwanted shadows. Framing and focusing is much easier when the camera is supported on a tripod, although from the standpoint of camera shake and subject movement, a tripod is not essential when electronic flash is being used.

Caterpillars are more difficult to photograph than eggs or pupae because of their elongated shape and general mobility. A caterpillar can be kept in focus only if it is moving parallel to the film plane, and as this does not happen fortuitously, it must be arranged before hand. A twig should be carefully set up parallel to the film plane, after which the caterpillar can be placed in position on the twig but out of the frame. As the caterpillar works its way along the twig it will come into the viewfinder and can then be photographed. A caterpillar chewing food will make a more interesting photograph than a wandering non-feeding specimen (Fig. 8.6).

The choice of background warrants some attention, as it has a profound effect on the visual impact of the final photograph. When working in black-and-white, it is useful to have three sheets (white, neutral grey and black) of 50×77 cm (20×30 in) cartridge paper available as backgrounds. The most appropriate one can be selected for the particular task in hand, on the principle that the background tone should comple-

a.

b.

c.

8.5 An assortment of pupae. Being static they are quite easy to photograph if attention is paid to their position with respect to the film plane, and to the tone of the background
(a) The pupa of *Loepa katinka* (India) concealed inside a folded leaf attached to a twig
(b) The chrysalis of the large white butterfly
(c) The pupa of the giant atlas moth, *Attacus atlas* (Thailand), partially concealed and protected in a folded leaf

ment that of the insect being photographed, ie a light-toned insect requires a dark background and vice versa.

Photographers with an artistic flair can spray in various cloud effects and these can look very effective and natural if not overdone. Coloured backgrounds are not recommended for black-and-white work because of the difficulty of assessing their tone in monochrome. However, when colour film is being used, coloured backgrounds would be appropriate, and one can easily simulate blue sky,

cloudy sky, or simply include a complementary colour to balance up the picture (Plate 2). If it is appropriate, one can also include leaves, flowers or twigs to add strength to the composition and make the final photograph more interesting.

In addition to developing a brilliant technique for photographing insects in free flight, Stephen Dalton also managed to produce, using coloured paper, paint sprays and natural objects such as flowers and twigs, photographs which are extremely well composed and visually stimulating (see the Bibliography).

Adult insects, particularly the active movers, are the most difficult to photograph. Many photo-

8.6 The eggs and caterpillars of the Chinese oak silkmoth. The eggs are quite tiny, measuring some 2 mm in diameter, and are laid in clusters or in lines. The emergent caterpillars feed and grow at a phenomenal rate until they reach a length approaching 10 cm

graphers tend to concentrate on the insect resting on its food plant, and with a little time and patience good photographs can usually be obtained. Insects are temperature sensitive, and chilling them in a domestic refrigerator will slow them down, thereby making them more manageable. This should not be overdone, otherwise the insect will become moribund and this tends to show on the photograph.

As in outdoor photography, one must first decide what the photograph is to illustrate and then work out the best camera position. For example, Fig. 8.7 of a locust was taken to show the general features of the whole body and was photographed from the side, so that the head, thorax and abdomen could all be kept in focus. Figure 8.2 is a head-on close-up of a female Assam silkmoth and was taken to show the details of the head, eyes and antennae, and the general hairiness of the insect. Again one would pay special attention to the 'props', ie twigs, flowers, etc and use only those which are appropriate to the insect being photographed. Backgrounds should be given careful consideration and some attempt made to combine these elements to produce a well-balanced photograph.

The three-parallel-face lens, described in Chapter 2, was used in Fig. 8.8 to photograph a locust's wings in action. This was not free flight, the insect being supported around its thorax by a loop of wire. This is a standard technique used when examining insects such as locusts, and does not harm the animal in any way. The equipment was arranged as described in Chapter 2 and two spotlights were used to provide the high level of illumination required to use a shutter speed of 1/1000 sec. Three consecutive images were obtained, each representing an exposure of 1/1000 sec (1 millisec) with a time separation of 1/500 sec (2 millisec) between each image.

From this information one can do some simple calculating concerning wing-movement rates. Using a series of multiple-image photographs one could work out the path taken by the two pairs of wings during a complete wing-movement cycle and, knowing the exposure time and the interval between each exposure, one could then quantify the whole wing-movement sequence.

To produce high-quality colour photographs of insects in free flight requires the highest degree of skill and patience, coupled with the ability to design and operate electronic and optical equipment. This task was tackled by biologist and photographer Stephen Dalton, ably assisted by electronics expert Ron Perkins of the Royal Aircraft Establishment, Farnborough. Ron

8.7 A side view of a locust, *Locusta migratoria migratorioides*, photographed to show the general structure of the body. One flash unit was used

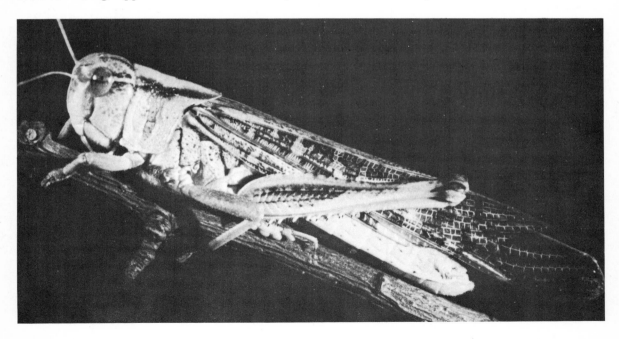

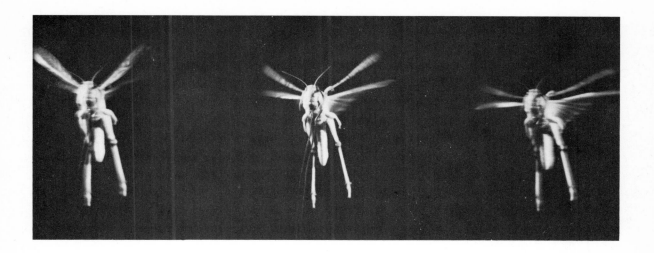

8.8 Locust flight sequence produced using the three-parallel-face lens described in Chapter 2. Each exposure is 1/1000 sec (1 millisec) with an interval of approximately 1/500 sec (2 millisec) between each exposure (see text for full discussion of this technique and its implications.)

Perkins spent over two years developing and perfecting an interrupted-light-beam switch and amplifier which was eventually made sufficiently sensitive to be triggered by a human hair moving through the light beam at high speed. Meanwhile, Stephen Dalton was trying to locate a flash tube which was powerful enough to produce sufficient light for use with 25ASA Kodachrome film, and which had a flash duration of not more than 1/25,000 sec. After many months of searching, both in Europe and America, he finally achieved his objectives, using an American capacitor and a British flash tube. With this equipment he took hundreds of photographs, and published 74 of these beautiful colour plates in *Borne on the Wind*. As an added bonus, he also solved the age-old problem of how a house fly manages to land on a ceiling.

Anyone interested in this approach to free-flight photography might well start with the rather simple equipment which I have designed and used with some success (Fig. 8.9). The interrupted-beam switching unit is the one described in Chapter 2, and when set up it responds to a pencil being moved rapidly through the beam: this is sufficiently sensitive to be triggered by the larger insects, such as bees and wasps.

The flight tunnel consists of a wooden-framed box 30 cm (12 in) square at the front and rising to 45 cm (18 in) high and 30 cm (12 in) wide at the rear. The unit is approximately 60 cm (24 in) long. Pieces of white card are cut to size and pinned inside the wooden frame to form the sides and roof, and a transparent acetate sheet is mounted in a cardboard frame to form the front. A selection of backgrounds (black, white, grey and blue) are cut to size, and the appropriate one is pinned to the rear end of the unit.

The light beam used is described in Chapter 2, and it is directed through a window in the side of the flight tunnel, onto a mirror located outside a similar window on the opposite side. The beam is reflected back to a second mirror which directs it onto the light-sensitive switching unit. The light beam traverses the flight tunnel three times before reaching the switch unit, thereby increasing by a factor of three the chances of an insect interrupting it.

In practice, it is best to direct the insect towards the food plant by constructing, in transparent polythene sheeting, extensions to the sides, top and bottom of the unit, and fixing them just behind the food plant (Fig. 8.10). The camera is focused on the plant material, and the light beam is located approximately 2 cm ($\frac{3}{4}$ in) behind it, on the premise that by the time the camera shutter has been released, the insect will be in line with the plant material and therefore in focus. This will depend on the delay time of the light-switching unit, and the speed of the flight of the insect.

A computer flash should be used, and in order to

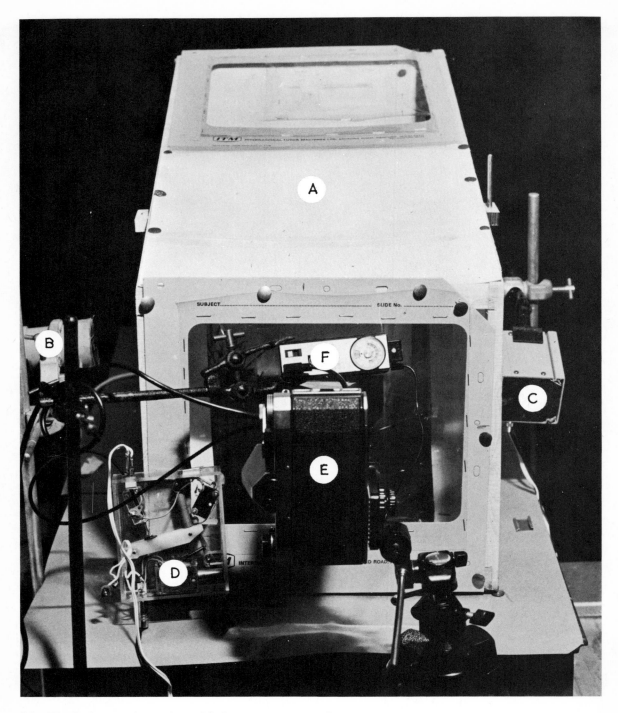

8.9 The flight tunnel complete with the accessory equipment
A – Wooden-framed flight tunnel
B – Light-beam unit
C – Light-switch unit
D – Solenoid-release apparatus
E – SLR camera supported on tripod
F – Computer flash

112

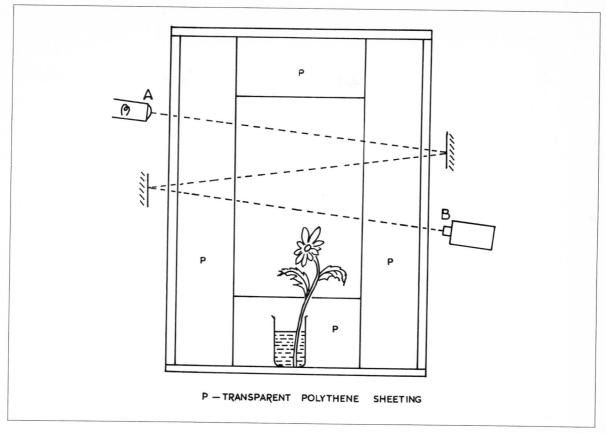

P — TRANSPARENT POLYTHENE SHEETING

8.10 The inside of the flight tunnel to show the path taken by the light beam from its source *A* to its destination *B*

8.11 (a) A honey bee (*Apis mellifera*) in free flight moving towards some clover flowers. As it interrupted the light beam, the camera shutter and flash were triggered. The exposure was made on HP5 film using a computer flash set up to give the shortest possible exposure, which may have been in the region of 1/10,000 sec – 1/20,000 sec

obtain a very short exposure, a fast film (HP5), rated at 400ASA, should be selected. The flash unit must be set up close to the transparent front, and just above camera level (Fig. 8.11).

HOUSING INSECTS
If one is interested in studying and photographing an insect through its complete life-cycle, one needs to house the insect adequately. Even when keeping adults for only a short time, a more permanent home than a jam jar will be required.

Eggs are best collected with a piece of the material on which they were laid, and placed in a small ventilated transparent container such as a sandwich box. Under normal conditions the eggs will hatch after two or three weeks and should be kept at room temperature and in the shade. However, eggs laid in the autumn may not hatch until the following spring, and are best left in a cool, frost-free place over the winter months.

Larvae can be housed with their food material in a well ventilated box. The food should be changed every day and apart from this the larvae require little attention. Transparent-plastic food boxes are ideal as rearing quarters and adequate ventilation can be achieved by cutting a hole in the lid and covering the aperture with a piece of perforated zinc sheet or nylon mesh (Fig. 8.12).

Larvae pupate in different ways, according to the species. For example, the Poplar Hawk moth and Peppered moth both form pupae under the soil, whilst the Kentish Glory and Garden Tiger use leaf litter. The Small Copper butterfly and the Green-veined White pupate on their food plant, whereas the Puss moth produces a hard woody cocoon cemented to a poplar or willow tree. Armed with this type of information, it is possible to provide the appropriate requirements for successful pupa formation, but when unknown species are involved then some soil, leaf litter and branches of a range of food plants should all be included in the hope of providing the correct environment.

Emergence from the pupa may occur after three or four weeks, but many pupae formed in the autumn do not complete their life-cycle until the following spring. They should be kept under the same conditions as the eggs mentioned earlier. The normal time for emergence can be found by referring to specialist texts and one would place the pupae in an emergence cage about three weeks before their suggested emergence time. The pupae should then be kept at room temperature and lightly sprayed with water each day to prevent desiccation. An emergence cage usually has nylon-mesh sides and is supplied with stout twigs so that the insect, after emergence, can climb up one of them and hang whilst its wings expand and dry

8.12 A larvae rearing box constructed from a plastic sandwich container, and a man-made drinking stand, with a butterfly drinking from one of the tubes containing sugar solution

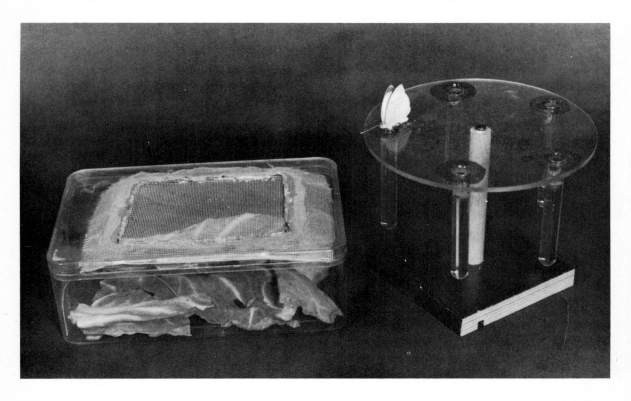

8.13 Two types of emergence cage. Both are easily constructed and are fully discussed in the text

(Fig. 8.13). The same cage can also be used to house adult insects and one can be constructed from a large lampshade frame covered with nylon mesh. The top and bottom can be made from stiff cardboard or hardboard.

Adult butterflies, moths, locusts and stick insects can also be housed in a cylindrical cage. This consists of a clear-plastic cylinder, made from a piece of acetate sheet, standing in a metal or plastic base (eg a plastic plant-pot container) and covered with a perforated lid. This type of cage is easily constructed and a range of sizes can be produced appropriate to the types of insects being housed (Fig. 8.13).

Adult butterflies do not survive for more than a week or two, but during this time they will feed on nectar provided it is made available to them. A few fresh flowers, preferably of the same species from which the insects were collected, should be placed in the cage at regular intervals. When flowers are not available, a 10 per cent solution of sugar or honey will serve as a good substitute. This can be placed in small tubes supported on a circular platform (Fig. 8.12). A blue ring around the mouth of each tube will help the butterflies to locate the sugar solution, and most butterflies will feed quite happily from these man-made drinking stands. If mating occurs during captivity, one should supply the female with the appropriate larval food plant so that she may lay her eggs on it.

Stick insects, although natives of the tropics, are easily reared in artificial conditions. They are of particular interest to the nature photographer who is studying mimicry, as they demonstrate the

8.14 Stick insects, *Carausius morosus*, on privet twigs. These insects exhibit mimicry to a fascinating degree. Can you spot the two insects in this photograph?

8.15 A locust chewing a piece of lettuce leaf. A standard lens mounted on an extension tube was used. Illumination was provided by one flash unit and a small reflector

phenomenon in a superb way (Fig. 8.14). In colour, shape and immobility they completely imitate the twigs on which they feed. Stick insects tend to be very inactive during the day, when their enemies are about, and feed during the comparative safety of the night. They are easily housed in one of the plastic cylinder cages described above and, apart from supplying the food plant regularly, they require no further attention. They do not even drink water except for a brief period at the beginning and at the end of their life. Stick insects breed readily, and as males are not required for reproduction, the female can lay fertile eggs without mating. The eggs are dark brown in colour, about 3 mm ($\frac{1}{8}$ in) long and resemble tiny seeds. There is a small lid at one end of the egg, through which the nymph emerges on hatching.

Another tropical insect which is very easy to house and rear is the locust. There are several species of locust but the two which are generally readily available are the African migratory locust and the desert locust. These insects are similar in appearance to grasshoppers, which is to be expected as they belong to the same order. Housing can be similar to that suggested for stick insects, and locusts will feed on almost any type of grass. During the winter, when grass might be in short supply, they will feed on Brussel sprouts and cabbage leaves and stems. They have chewing mouth parts, which include a sizeable pair of mandibles, so that fibrous stems do not present any problems (Fig. 8.15).

As tropical insects, they require an ambient temperature of approximately 32 °C (90 °F). This is most easily achieved by placing a 40–60-watt lamp in the top of the cage. The sexes mate readily but the females must be provided with sand-filled containers at least 8 cm (3 in) deep and sunk into the floor of the cage. The eggs are deposited deep in the damp sand and hatch in about two weeks, when the small nymphs wriggle to the surface and moult almost immediately to emerge as tiny grasshopper-like insects. The nymph gradually grows through five moults to produce the adult, which can be up to 7 cm ($2\frac{3}{4}$ in) long, complete with two pairs of wings. Locusts are useful insects for studying mouth parts and feeding methods and also for experimental work on flight.

117

9 Aquatic Organisms_____

The photography of aquatic life in general opens up vast areas of the animal and plant kingdoms, and includes such invertebrate groups as the coelenterates, echinoderms, molluscs and arthropods, and aquatic vertebrates such as fish and amphibians. Fully aquatic plants are mainly limited to the algae, as exemplified by the seaweeds of the rocky shore and the green filamentous algae found in most ponds and lakes. There are, however, several flowering plants which are aquatic, and one can readily bring to mind the water lily, with its floating leaves, the Canadian pondweed, trailing its long submerged stems, and the brooklime, with its vertically growing leafy stem and small azure-blue flowers.

SUGGESTED APPROACH

The seashore, and in particular the rocky shore, exhibits a great range of invertebrate animals and the nature photographer could develop an interest in any of the following ideas.

1 A collection of photographs illustrating the range of organisms found on the seashore. This could be all-embracing and would take several years to complete.

2 A study of a particular group of animals, for example, the molluscs (mussels, limpets, periwinkles, etc.) incorporating photographs of as many different species as possible.

3 A photo-study of seaweeds, concentrating on their form and habitat. Again this could be a comprehensive survey or limited to a particular group, for example, the brown algae (bladder wrack, serrated wrack, bootlace weed, flat wrack, knotted wrack).

4 Photographs illustrating ways in which animals and plants protect themselves from being damaged by wave action. Consideration would be given to body shape and hardness, position on the shore, and methods of attachment.

5 Most intertidal animals have to survive two periods of exposure to air during every 24-hour cycle. Marine animals are adapted in various ways to prevent desiccation. For example, the limpet clamps down on to the rock surface and survives on the oxygen present in the small volume of water trapped between its shell and the rock. Periwinkles, mussels, sea anemones and barnacles have different ways of avoiding death by desiccation, and all are of photographic interest.

6 A photo-study of the life-cycle of a plant, such as the bladder wrack, or an animal, such as the common mussel.

7 Marine animals exhibit a wide range of feeding methods. Limpets browse on the micro-algae which cover most rocks by using a flexible miniature file called a radula to rasp away the food material. They leave behind them a very distinct feeding trail. Sea anemones lie almost motionless, with their tentacles extended waiting for an unsuspecting victim, whilst fish, crabs and lobsters are active hunters and go in search of their prey. Consider the common mussel, which thrives near sewer outlet pipes, and like a miniature vacuum sweeper sucks water and organic debris across a special internal surface. Small useful particles are retained and the large pieces of unwanted material are pumped back into the water. Finally, the ubiquitous starfish, which is so widely featured in all paintings and murals depicting life on the seashore, has a feeding method as interesting as it is revolting. It slowly pulls open the two shells of a mussel and having only a small mouth and no teeth, it proceeds to push its stomach up through its mouth and turns it inside out on to the food, which it then digests and absorbs. These and other feeding methods represent a fertile area in which the nature photographer can produce some very unusual photographs.

Ponds and streams, although fascinating places in which to study aquatic organisms, are difficult habitats to photograph and one must be content to work mainly with surface-living organisms such as pond skaters and floating plants.

Indoor work with aquaria opens up new vistas and the nature photographer is in a position to explore in detail the shape and structure of aquatic organisms. The following suggestions for photographic work come readily to mind.

1 A photo-study of a small fish (tropical or cold-water) concentrating on shape, movement, and the use of the fins.

2 A series of photographs illustrating protective shape and colour in a range of pond animals.

3 Life-cycles of aquatic organisms can make an interesting photographic study. The various stages can be collected, carefully photographed and the pictures assembled into a complete life-cycle sequence.

4 There are many methods of extracting oxygen from the water in addition to the familiar gills of a fish. Of all the invertebrate groups, perhaps the aquatic insects show the greatest range of external breathing structures and they are worth studying and photographing.

EQUIPMENT

Most of the animals and plants to be photographed are relatively small and the photographer will require a camera which is suitable for close-up work. Again the SLR camera (35 mm or 6 × 6 cm) is the obvious choice, because the problems associated with focusing and framing are almost non-existent. TTL metering is also a great asset, particularly when a bellows unit or extension tubes are being used. A usefully large image of the specimen can be achieved with the previously mentioned accessories, although close-up lenses can be used as a cheaper alternative. A standard 50 mm lens would be quite satisfactory for most needs but a medium-length telephoto lens, 85–135 mm ($3\frac{1}{4}$–$5\frac{1}{4}$ in) enables one to obtain a large image without being too close to the specimen.

A waist-level viewfinder or a right-angle finder is also useful when working very near to the ground and these might also prevent wet trouser knees and subsequent arthritis! Two filters, an ultra-violet and a polariser, will both come into their own on the seashore. Finally, a flash unit and a small portable reflector would complete the equipment list.

THE SEASHORE

Britain is surrounded by approximately 6,000 miles of coastline and, even when living inland, one is always within 75 miles of coastal water, yet the seashore as an area of great photographic potential is grossly neglected.

The seashore is a unique environment consisting of a narrow band of land submerged by sea water twice daily. The majority of the plants are algae (ie seaweeds) and they are not found in any other environment, although a few species which can survive large variations in salinity may penetrate several miles up tidal rivers. Most of the invertebrate groups are represented on the seashore, and several organisms including sea urchins, starfish, sea-squirts, jellyfish, sea anemones and limpets are unique to this area.

A basic knowledge of tidal movements is very useful to the photographer, even if only to avoid being cut off by the tide! There is a high water and a low water twice every lunar day (24 hours 50 minutes) and the high-tide time moves back 25–45 minutes each 24-hour day. This is the daily rhythm and superimposed on this is a monthly rhythm. Every lunar month there are two runs of spring tides and two of neap tides. During spring tides the maximum tidal range occurs approximately two days after a new and full moon, whilst the alternating neap tides come after the first and third quarters of the moon.

Although tide heights vary enormously around the coastline, the average height (ie the vertical distance between high and low water) for a spring tide is 5 m (16 ft) and for a neap tide 3.5 m (11 ft). Superimposed on the monthly rhythm, there is a seasonal rhythm to contend with, consisting of large-range spring tides during the March and September equinoxes, with smaller range tides between them. The equinoxes are the times when the sun and the moon are directly in line with the earth, thus producing a maximum pull which results in the largest possible tidal movements.

Although the tidal range is very important, the slope of the shore also determines the area available for photographic work. A gently sloping shore will expose a large stretch of perhaps 250 m (800 ft) between high and low water, whereas a steeply sloping shore might have only a narrow 10 m (30 ft) band available for photographic work.

The area below extreme low water is referred to as the sublittoral zone and represents the beginning of the truly marine environment. Underwater photography is a rather specialised

field, and requires special clothing and equipment, eg subaqua wet suits and a waterproof housing for the camera.

Photography on the seashore

The ideal conditions for shore photography are a blue sky with a few wispy clouds, a clear bright sun, no wind, and a comfortable ambient temperature.

Most seaweeds can be readily photographed out of water, draped over rocks, and the only problem likely to arise is, perhaps ironically, the lack of water. The dried out fronds of most of the brown wracks present a very dark non-reflecting surface and to all intents and purposes look quite dead, whereas a wet specimen looks healthy and very attractive. Great care should be taken to avoid unwanted highlights caused by the sun reflecting from moisture on various parts of the wet frond. This is one reason why diffused sunlight (produced when wispy clouds pass over the sun) is ideal, as the light produced is neither too harsh and directional, nor too soft and diffuse. If the reflections are still too obvious, then a polarising filter over the camera lens could be the answer.

Seaweeds such as the bladder wrack, serrated wrack and oar-weeds are usually draped over the rocks to which they are attached, whilst the flat wracks and channelled wracks tend to be small and bushy. All of these plants can be successfully photographed, even under blustery conditions, because their fronds do not sway around in the manner of long-stemmed flowering plants (Fig. 9.1).

Seaweeds are divided into three groups, the Greens, Browns and Reds, based on the pigments they carry. All contain chlorophyll, the green pigment essential in the food-making process (photosynthesis), but in the brown and red algae the chlorophyll is masked by other pigments. As always, things are never quite as simple as they appear at first sight and several of the red algae may look more brown than red, whilst many of the brown algae tend to take on an olive-green hue. All dead seaweeds lose their pigments quite quickly and soon become almost white and translucent. Other changes occur in dead organisms and the photographer should never be tempted to try to pass them off as living material because the deception is spotted very quickly by any marine biologist.

A great variety of animals inhabit the rocky shore, although this may not be apparent at first glance. Barnacles and limpets are conspicuously

9.1 The egg wrack, *Ascophyllum nodosum*, photographed on the shore in bright diffused sunlight

abundant and when the tide is out the barnacles 'batten down the hatches', whilst the limpets pull their shells close to the rock surface. In both cases there is sufficient oxygen in the small volume of trapped water to satisfy their respiratory needs until they become submerged at the next high tide. When covered again by the incoming tide, the barnacle opens up its four opercular plates and begins to feed by waving its legs about in the water, catching food in the process. When covered with water, the limpet relaxes its tight grip on the rock and moves about rasping fine algae from the rock surface. As the tide comes in again, the limpet returns to its 'home' and settles down in exactly the same position as that occupied prior to the last tidal movement (Fig. 9.2). Limpets removed from their 'homes' and placed up to 2 m (6 ft) away will often return to their original positions within 24 hours. The feeding process can only be photographed when the animal is submerged and, although this can be attempted on the shore in a shallow rock pool, it is often best achieved in the controlled environment of an aquarium.

9.2 A common limpet, *Patella vulgaris*, attached firmly to the rock surface whilst the tide is out. To the right is an unoccupied 'home' consisting of a depression worn in the rock by the constant shuffling of the limpet as it settles down

Photographing barnacles and limpets on dry rock surfaces presents little difficulty but one must consider the angle of illumination. Frontal shadowless lighting tends to produce a rather flat effect and strongly oblique lighting often results in long dark shadows devoid of any detail. The angle of the sun should be such that only short shadows are formed, thereby giving the organism a three-dimensional appearance. This is easily achieved at almost any time of the day, since rock surfaces can be found at all angles and facing every direction, so that it is simply a matter of locating the appropriate rock surface to suit a particular sun position (Fig. 9.3). If the sun's rays are not slightly softened by light cloud, the shadows might be too dark and lacking in detail. A portable reflector (white card or crumpled aluminium foil) can be used to lighten the shadows, or the sunlight itself can be diffused by holding a stretched handkerchief between the sun and the rock face.

Many animals, in an attempt to reduce desiccation, or to escape from would-be predators, secrete themselves away in holes, cracks and crevices. As this is their natural habitat when the tide is out, they should be photographed in this position (Fig. 9.4). Organisms which favour a

9.3 Barnacles, *Balanus balanoides*, growing on limpets. Photographed in situ on the shore so that the shadows are just long enough to produce a three-dimensional effect. A directly overhead sun would produce flat shadowless lighting and the 3-D effect would be lost

9.4 Five barnacles and 30 periwinkles, *Littorina littorea*, taking refuge in a hole in the rock as a protection against desiccation and would-be predators. Note the total absence of animals on the surrounding rock

clearly illustrate shape and structure, then a little re-arranging has to be done. This should be kept to the minimum and sufficient material included in the photograph to make the background instantly recognisable.

When photographing small organisms, a set of extension tubes or a bellows unit are required to ensure a suitably large image on the negative. A fully automatic bellows unit is ideal as this produces magnifications from approximately 0.75 × to 2.5 × without losing the automatic diaphragm facility of the lens. Thus focusing can be done at maximum aperture and at full screen brightness. These units are, however, very expensive in the automatic form; a set of Panagor automatic extension tubes are a good substitute, as they are much less expensive, although, of course, less versatile. For work on the seashore, a No. 1 tube, 11 mm ($\frac{3}{8}$ in) coupled to a standard 50 mm (2 in) lens, or a No. 2 tube, 18 mm ($\frac{3}{4}$ in) on a 135 mm ($5\frac{1}{4}$ in) telephoto lens is adequate for most requirements.

The importance of focusing at full aperture cannot be overemphasised as the depth of field is very small, and any error in the initial focusing will be immediately apparent on the finished photograph (Fig. 9.5). When automatic extension rings are not available, high quality close-up lenses should be used, and if the camera lens is stopped down to a small aperture (ie only the central part of the close-up lens is used) the definition should not suffer appreciably.

Another attachment which is extremely useful when working near ground level, particularly in a wet environment, is a right-angle finder which can be attached to the camera eyepiece. This allows the photographer to look down onto the viewing screen, thus allowing the camera to be used comfortably from a very low position. A waist-level finder serves the same function, but there are very few cameras on the market which have the detachable pentaprism necessary for this type of viewing system to be used.

A very interesting animal group found only in marine environments is the Echinodermata. The word means 'hedgehog-skinned', and the group includes starfish, brittle-stars, sea-urchins, and the less well known sea-cucumbers and feather-stars. The interest in the group lies in the five-point radial symmetry (N.B. five radiating arms of the starfish) and the water-circulatory system which operates five rows of radially arranged suckers called 'tube-feet'.

sheltered niche include the three species of periwinkles, dog whelks, small tubed worms, crabs and the side-swimmer *Gammarus*. The light intensity in the crevices is often low, and flash illumination may be required. The latter also allows a very small lens aperture to be used, resulting in increased depth of field. The short flash duration arrests any movement in the organism being photographed. Overhanging rocky ledges are often inhabited by large numbers of beadlet anemones but the latter are best photographed in water when their tentacles are fully extended. When exposed to the air, anemones resemble uninteresting blobs of jelly.

Many small animals such as sea slaters, sand-hoppers, side-swimmers and small shore crabs are to be found amongst the brown algae, and in most instances they are extremely well camouflaged.

If the photographer is attempting to illustrate protective colouring, then the organisms can be photographed with minimum disturbance to the surroundings, but if the photograph is intended to

9.5 Chitons discovered on the undersurface of a piece of rock. These animals are very small (less than 1 cm long) and, when working very close with extension tubes, the depth of field is only a few millimetres. The rock surface should be parallel to the camera film plane

9.6 A tiny brittle star, *Ophiothrix fragilis*, approximately 2 cm in diameter photographed on the shore. It was found on the underside of a pebble taken from a rock pool, and after being photographed, the pebble and animal were returned to the rock pool. A standard 50 mm lens and two extension tubes were used

The brittle-stars, found under rocks, are usually tiny creatures no more than 4 cm (1½ in) across the outstretched arms and the name derives from the very fragile nature of these long slender arms. However, larger brittle-stars are found in considerable numbers below extreme low water and into the sublittoral zone, particularly on rocky coasts. I have seen specimens up to 15 cm (6 in) in diameter brought up from a depth of 10 m (30 ft) off the west coast of Scotland near Millport. Figure 9.6 shows a tiny brittle-star on a piece of rock collected in the mid-shore region and photographed there using a standard 50 mm (2 in) lens and an 18 mm (¾ in) automatic extension tube.

Starfish, which are very common on the lower shore and below extreme low water, have the ability to wedge themselves in cracks and crevices, twisting their bodies to fit the space available. They are quite static when uncovered by the outgoing tide and to study and photograph their movements, the photographer should transfer them to a shallow rock pool. An interesting photo-study can be made showing the changes in body shape and position which occur when a starfish is placed upside down in a shallow pool. One can observe the use made of the tube-feet as the animal rights itself (Fig. 9.7).

To many people the mention of 'sea-urchin' conjures up an image of a smooth polished shell – often complete with a small internal lamp – used as an attractive ornament. Yet, living, this animal is as prickly as a hedgehog, gaining complete protection from its multispined skin. The sea-urchin lives in cool water amongst the rocks and oar weeds in the

sublittoral zone below low water (Fig. 9.8). Without using subaqua equipment it can be found only by visiting a rocky shore at extreme low water of a spring tide, when one might be lucky enough to see one, or several of them, in the deeper rock pools and crevices. A photograph of the urchin should show its tube-feet extended and this can only be achieved by photographing the animal in water since once it is removed the tube-feet are withdrawn. Although the urchin has only a small mouth it does possess an interesting and very complex five-toothed apparatus called 'Aristotle's lantern' which it uses for browsing on encrusting vegetation and for assisting in slow locomotion.

The sandy shore is, by comparison with a rocky shore, quite barren of both animals and plants. Seaweeds need a firm rocky foundation on which to attach themselves and when this is absent the seaweed spores have nothing to adhere to and do not germinate. With no plant material to feed on,

9.7 A common starfish, *Asterias rubens*, righting itself after being placed upside down in a shallow rock pool. Note the position and the part played by the tube feet in the righting process

9.8 A sea urchin, *Echinus esculentus*, photographed near the surface of a deep rock pool at extreme low water of a spring tide. The rows of tube feet are just discernible between the spines

the herbivores such as limpets, periwinkles, and top-shells cannot survive and therefore the carnivores cannot find animal material to feed on. Life on a sandy shore is also difficult because the animals are exposed to direct wave action, there being no cracks, crevices or rocky outcrops to offer protection.

This sandy environment is left mainly to burrowing animals, some of which filter-feed on microscopic particles of animal and plant material, whilst others feed on the debris which accumulates on the surface of the sand. Typical sand dwellers are the burrowing cockles, razor shells, burrowing starfish, and a multitude of worms both tubed, as in the sandmasons, and untubed as in lugworms and ragworms. All these animals tend to burrow deep into the sand when the tide is out, and from a photographic viewpoint there is little of interest apart from the casts of lugworms. These are best photographed in strong direct sunlight, rather than in the more diffused light recommended for most of the shore photography, so that the sand in the worm cast will stand out from the sand in the background.

ROCK POOLS

Much of the interest in rocky shores is associated with the study of animal and plant life in rock pools. Here one can see a great abundance of organisms and the greatest problem facing most shore dwellers, that of desiccation, does not exist for the inhabitants of the rock pool. However it is not quite the pleasant haven it might appear to be, and the organisms do have special problems to overcome. For example, shallow upper shore pools tend to warm up quickly in the summer sun, to be followed by a dramatic fall in temperature when the tide comes in and the pool is flooded with cool sea water. Rock-pool inhabitants must therefore have the ability to withstand these temperature fluctuations.

Similarly changes in salinity occur as the sun evaporates the surface water, leaving the remainder much more concentrated. Shallow pools in the extreme upper shore region might not be flooded during several days of neap tides and their water can be concentrated up to five times that of normal sea water. When it rains, the pure rain water tends to lie on the surface of the more dense sea water, producing a situation where the surface water is fresh and the lower layers consist of very concentrated sea water. This is a difficult situation for any animal to cope with.

As one moves down the shore the fluctuations in temperature and salinity in the rock pools becomes less pronounced, until at the lowest level they almost cease to exist. However, the mid-shore rock pool is a good environment in which to study and photograph both animals and plants.

Rock-pool photography

The first barrier to photographing life in a rock pool is the actual surface of the water. On a fine sunny day it will exhibit the properties of a mirror, producing a perfect reflection of the cliffs, clouds and sky above it, whilst under less settled conditions it will distort the image of the organisms beneath it to such an extent that photography becomes impossible. Visual information about the reflections of clouds and sky, although sent to the brain via the optic nerves, tends to be ignored by us and we 'concentrate' our visual attention on the organisms in the rock pool. The camera, however, does not discriminate in this way and faithfully registers everything present in the field of view, often to the dismay of the photographer when the prints and transparencies have been processed and examined.

Surface reflections can be largely eliminated by selecting a particular viewpoint with respect to the position of the sun, and the effect can be readily observed in the viewfinder of the camera. One is likely to achieve the best results by holding the camera with its optical axis at right angles to the surface of the water, because most of the sunlight falling on the water does so at angles other than 90°, except around midday in midsummer when the sun is more overhead than at other times of the year. Figure 9.9 was taken under these conditions and does not show any surface reflections despite a very bright overhead sun.

If, however, for photographic reasons the camera must be tilted to say 30° below the horizontal, then surface reflections will become a nuisance and a polarising filter will be required. This should remove the unwanted reflections but at the expense of an exposure increase of up to two stops (ie up to 4 × normal exposure). Figure 9.10 illustrates the use of a polarising filter in rock-pool photography. Direct high-contrast sunlight penetrates the water more effectively than the softer more diffused light from an overcast sky and as rock pool photographs are often lacking in contrast (particularly noticeable on black-and-white film), the highly directional sunlight serves a dual function.

Rock pool photography should not therefore be attempted under hazy or overcast conditions. Whilst discussing filters it is worth remembering that a filter is quite inexpensive compared with a camera lens, and when working on the seashore the camera lens should always be protected from spray and salt-laden air by an ultra-violet filter. The fact that this filter can also be used to reduce haze is of secondary importance because most seashore photography is close-up work.

The wind can be a problem, as when the surface of the water is disturbed, the images of organims in the pool become distorted; under these conditions it is better to abandon all thought of rock pool

9.9 A typical coralline rock pool photographed by holding the camera film plane parallel to the surface of the water. No surface reflections are visible. The photograph is disappointing because the subtle shades of green and brown are indistinguishable on black-and-white film

photography and to concentrate on out-of-water organisms which are not unduly affected by the wind.

The general clarity of the water is an important consideration but fortunately most rock pools are crystal clear and present no problems. Sometimes, however, due to the inflow of silty fresh water, the clarity is lost, the image is degraded, and the contrast falls. Photography should not be attempted under these conditions.

The depth of water in the rock pool is significant and where possible shallow pools should be selected. Light is quickly absorbed as it passes through water and in North European coastal waters there is rapid extinction of both the red and blue wavelengths. At a depth of only 1 m (3 ft) most of the blue and about half of the red light has been absorbed, whilst the green has been reduced to approximately 60 per cent of its surface value. Under these conditions, organisms at the bottom of the pool are difficult to see and almost impossible to photograph.

Finally, the composition of the bottom of the rock pool will determine whether light will be reflected back up into the water or whether it will be absorbed. Fortunately most rock pools have a light sandy bottom which reflects light well and the occasional dark-bottomed pool should be avoided if possible (Fig. 9.11).

Black and white photographs of rock-pool life are often disappointing because at the time of actual exposure it is very difficult to imagine the world of colour in a series of grey tones. Figure 9.9 illustrates the point admirably. The scene looked very attractive in the viewfinder of the camera, with several periwinkles browsing on the green algae present. The colours were a mixture of greens and browns intermingled with the delicate pink of *Corallina officinalis*. In the final photograph the greens and brown are virtually indistinguishable, although the *Corallina* does give some tonal range to the photograph, which was printed on a hard grade of paper to produce a better range of tones. None of these problems arise when using colour film, although an 81A filter might be required to 'warm up' the scene a little.

PONDS AND STREAMS

From a photographic viewpoint, the possibilities offered by life in ponds and streams are strictly limited. Most aquatic animals are well camouflaged for protection and survival, and are therefore difficult to spot even by experienced biolo-

9.10 Rock-pool photography (a) without a polarizing filter (b) with a polarizing filter over the camera lens. The penalty for using the polarizing filter was a loss of two stops, requiring the lens aperture to be increased from f11 to f5·6 with the resultant loss in depth of field

gists, and when the image of the discovered animal is distorted by surface disturbances in the running water of streams and rivers, photography becomes very difficult or even impossible. In addition, many slow-flowing streams are silt-laden, making the water very murky. Most stream beds tend to

consist of dark non-reflecting silt or mud which cuts down the light intensity. The only type of stream which allows any serious photography is one which is clear, slow flowing, and has a light pebbled bed, but these are not very plentiful.

Ponds, although not suffering from surface disturbances, often contain water which is heavily laden with suspended silt and humus, and a dark non-reflecting bottom. However, any organisms found on the surface of the water or growing above it can be photographed, and if one is interested in, for example, frogs in the mating season, or a dragonfly adult emerging from its nymph case, or even a newt basking on an exposed stone, then there are few problems. But to photograph true aquatic life from ponds and streams it is preferable to collect the organisms and work with them in the controlled environment of an aquarium.

ANIMALS IN AQUARIA
Collection of material
Animals and plants can be collected from the seashore at any time of the year, although the

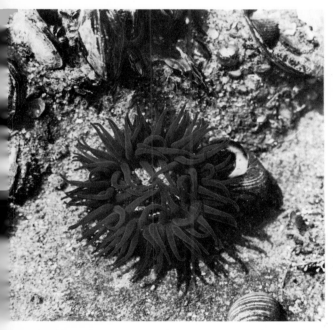

9.11 A sea anemone, *Actinia equina*, and several mussels, *Mytilus edulis*, are clearly visible in the rock pool, due in no small measure to the sandy light-reflecting bottom. The camera was again held parallel to the surface of the water and no polarizing filter was required

numbers of certain organisms do increase in the summer months. Knowledge of tide times is vital and one should choose a day when the maximum shore is available. Many organisms, such as limpets, barnacles, periwinkles, sea anemones, mussels, and dog whelks are very obvious and can be collected quite quickly. Others, such as crabs, chitons, hermit crabs and side-swimmers, are usually well concealed and must be searched for. Examination of the underside of loose rocks will reveal many animals, and care should be taken to replace the rock in approximately the same position after the organisms have been removed. Animals which are attached to the substratum should not be chipped away, as this invariably damages them, but they should be collected with a piece of the material on which they are growing. For example, the easiest way to acquire barnacles is to look for limpets with barnacles growing on their shells and collect the limpets (Fig. 9.3).

There is little point in uprooting the large brown algae; these are best photographed in their natural environment (Fig. 9.12). They also exude large quantities of slimy mucilage if kept out of water for any length of time. The green and red algae can be readily collected and will be very useful in a marine aquarium. Again, it is preferable to select specimens attached to small pebbles, so that plant and pebble can be collected as an entity. Animals and plants, together with a little sea water can be safely carried in polythene bags, particularly if the latter are supported in wicker-baskets or other rigid structures. Several litres of sea water should be bottled separately, as marine animals will die almost immediately if placed in fresh water. On returning to base, the sea-water aquarium can be set up and kept in a cool place. The water should be artificially aerated if possible, as most inhabitants of the rocky shore are accustomed to highly oxygenated water.

Collecting organisms from ponds and streams requires a rather different approach and on arrival at the site one should crouch as near to the water as possible and simply observe. It takes several minutes before one begins to notice the many small animals which inhabit the bottom of the pond. Slow movers, such as caddis-fly larvae, pond snails and freshwater winkles, can be picked out by hand, whereas fast-moving water beetles, sticklebacks, and newts need to be netted. A small fine-meshed fishing net is quite adequate for this purpose. A liberal supply of various pond weeds should be collected as they will not only oxygenate the water

9.12 Oar-weeds, *Laminaria digitata* and *L. hyperborea*, at extreme low water. These weeds are best photographed in their natural environment rather than in the laboratory

in the aquarium, but have a variety of small interesting animals, including pond snails, flatworms and insect larvae, associated with them. Again, several litres of water should be collected as this is preferable to tap water, although the latter can be used for topping-up purposes if it has been allowed to stand for 24 hours to dechlorinate. On returning to base the carnivores (dragonfly larvae, water boatmen, diving beetles, etc) should be separated from the quiet herbivores (pond snails, caddis larvae and so on).

Setting up an aquarium

An aquarium is simply a water-filled container for housing aquatic organisms, and it can range from a small glass jar containing pond water and a few tadpoles, to a 2 m (6 ft) long rectangular glass tank full of sea water and containing a variety of interesting marine organisms. The former is really too small, and holds an insufficient volume of water to prevent dangerous fluctuations in temperature, carbon dioxide and oxygen levels. In general terms the larger the aquarium the more satisfactory it is likely to be. Shape is not really important, although a fish bowl does tend to act like a magnifying glass, and results in overheating of the water to the detriment of the animals inside, whilst the curved surface produces too much image distortion for it to be of much value to the photographer. Glass aquaria are preferable, in the long term, to the less expensive plastic ones, as the latter scratch easily and thus lose their transparency. This is particularly important to the photographer, who must try to avoid such scratches and blemishes at all costs.

The aquarium should be set up to replicate, as closely as possible, the natural environment, although it is normal practice to use washed pebbles and gravel, rather than the silt or mud which was probably present in the original pond. The various pond weeds should be sorted out and the fresh looking specimens carefully washed free of silt. Each piece should then be attached with cotton to a suitable pebble, and placed in the bottom of the aquarium.

If the aquarium is to be used for photographic purposes, it is a wise precaution to filter the water before pouring it into the aquarium. When this is not done, the fine particles of debris show up as distracting points of light, this being particularly obvious when small organisms are being photographed against a black background.

A useful filter can easily be made by placing a piece of a fine-mesh nylon stocking inside a colander or sieve. The water can then be gently poured through the filter into the aquarium, causing as little disturbance as possible. Even filtered water will not remain clear for very long, because food given to the animals and the faeces produced by the animals tend to foul the water. Even if the latter could be prevented, the water very soon starts to take on a green hue as several species of unicellular green algae begin to grow and reproduce. This is particularly obvious in an aquarium kept in bright sunlight.

The water can be continuously filtered by passing it through a specially designed filtering

unit attached to the outside of the aquarium, and for long-term work this extra piece of equipment is highly recommended. Keeping the glass sides free from the green algae is a difficult task and a good supply of water snails certainly helps, although the glass should always be cleaned before any photographs are taken. The aquarium should be covered with either a commercially-made top or a sheet of glass supported on four corks. The cover prevents dust from settling on the surface of the water and also reduces evaporation.

A marine aquarium can be set up in much the same way as the freshwater variety, but special attention should be paid to the aeration of the water. Many seashore animals prefer well oxygenated water and although illumination of the algae will produce bubbles of oxygen, an extra aerator in the water is usually beneficial. Marine organisms seem to thrive in cooler rather than warmer water, so the aquarium should be sited in a cool basement or in some other shaded area.

Photography through the front of the aquarium

Free-swimming animals are not easy to photograph. The main problems are keeping the animals in focus, the avoidance of reflections from the glass of the aquarium, and finally, obtaining an adequate tone range when using black and white film.

To produce an acceptable image size on the negative, one needs to work close to the organism and therefore the depth of field will be very small indeed. Some means of keeping the organism in

the plane of focus must be devised, and for free-swimming animals of gold-fish size this is best achieved by placing a sheet of glass or perspex, of approximately the same length and height as the aquarium, in the water about 5 cm (2 in) from the front (Fig. 9.13). This allows the fish complete freedom of movement in two dimensions but severely limits it in the third dimension. The distance between the glass sheet and the front of the aquarium will vary according to the size of the animals being photographed, and might be as little as 2 cm ($\frac{3}{4}$ in) when small tropical fish are involved.

It is worth remembering that, as the volume of water in front of the glass sheet is rather small, it will soon become depleted of oxygen if several active fish are present, and the sheet should therefore be removed, or at least tilted backwards after the exposures have been made. If the dimensions of the aquarium are large in proportion to the size of the animals being photographed, it may be necessary to further restrict their freedom by fixing vertical and/or horizontal lengths of wood between the glass sheet and the front of the aquarium.

Another useful method of limiting the freedom of the animals is to place them in a small rectangular perspex specimen case measuring approximately $15 \times 10 \times 3$ cm ($6 \times 4 \times 1\frac{1}{8}$ in) and suspending it at the top of the water, or alter-

9.13 Photographing animals in an aquarium. Note the positions of the glass-sheet insert and the supported background

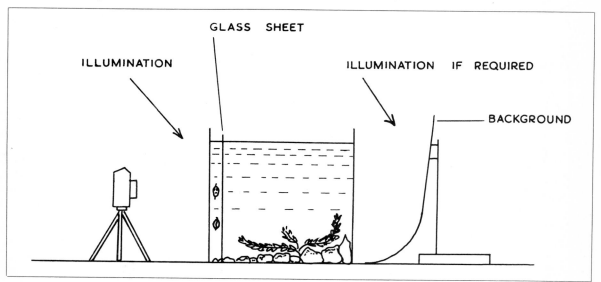

GLASS SHEET

ILLUMINATION

ILLUMINATION IF REQUIRED

BACKGROUND

natively attach it to the front of the aquarium. The latter technique allows the photographer to select a background appropriate to the animal being photographed and it is also of particular value when very small or rare organisms are being studied as this will eliminate the possibility of them being lost in the large aquarium.

An easily made alternative to the small specimen case consists of a length of rubber tubing, approximately 20 cm (8 in), flexed into a U shape and sandwiched between two small sheets of glass. Cells of various thickness can be produced by using different diameter tubing, and the whole

unit can be held together with strong rubber bands.

Unwanted reflections in the front panel of the aquarium arise from three main sources, the immediate surroundings (windows and glass-panelled doors); the camera itself; and the actual source of illumination for the photograph. The

9.14 Goldfish feeding on small particles on the bottom of an aquarium. Two flash units were used, one at each end of the aquarium. Movement was restricted by placing a glass sheet in the water some 5 cm behind the front of the aquarium

window problem can be solved by appropriate blacking out, and its effectiveness can be checked in the viewfinder of the camera. The use of a polarising filter to reduce unwanted reflections is often suggested, but I have rarely found this to be necessary.

If reflections from the camera itself become a nuisance, a neat solution is to attach a piece of card, approximately 25 cm (10 in) square and painted matt black, to the lens barrel of the camera. The advantage of this over a fixed screen is that it allows the camera sufficient freedom of movement to view the organism swimming around in the aquarium. Reflections from the light source should not occur if the light is positioned above and slightly in front of the aquarium. This will produce an illumination similar to that found in the natural environment. This simple overhead lighting, although intended to simulate sunlight, often produces rather flat low-contrast photographs. Two or more lights will result in more effective illumination and, if the aquarium has accessible glass sides, a light can be directed through each end, producing a pleasant modelling effect (Fig. 9.14). When the animals are translucent or have delicate transparent tentacles or tube-feet, a powerful back light and a less

powerful frontal fill-in light would be invaluable, particularly against a dark or even a black background (Fig. 9.15).

Continuous lighting (eg photofloods or spotlights) can be used but the exposures might not be short enough to prevent blurring of the image in moving organisms, and the heat generated would soon affect the temperature of the water, particularly if the aquarium were fairly small. The ideal form of illumination is an electric flash unit coupled to a modelling light. Although the latter is of low intensity, it does give an accurate indication of the direction of the illumination and any unwanted reflections are immediately apparent. If two or more such units are available, then the best combination of position and distance can be quickly established. The flash also provides a high level of illumination and a very short exposure time, both characteristics being of the utmost importance in this type of work (Fig. 9.16).

9.15 A small sea urchin, *Psammechinus miliaris*, photographed against a dark background to highlight the extended tube feet. Two flash units were used, one at each end of a small glass trough

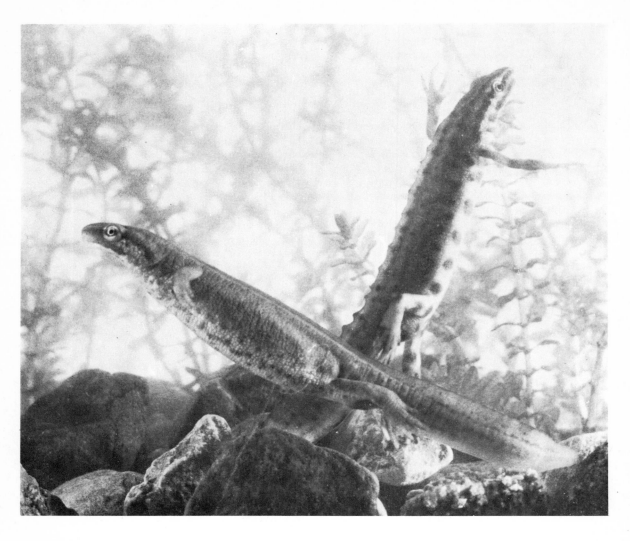

9.16 Smooth newts, *Trituris vulgaris*, in an aquarium. Set-up and lighting as for Fig. 9.14

Fibre-optics illumination is just beginning to be applied to nature photography and no doubt its use will increase in the coming years. Basically, light is transmitted by total internal reflection down a fine glass fibre. Several thousand fibres can be bound together to form a glass-fibre string or rope, along which light can be transmitted. If one end is illuminated by a powerful lamp, the other end can be safely placed inside the aquarium to illuminate small organisms which might be difficult to light by more conventional methods. There is little or no transfer of heat – an obvious advantage – and although at the moment continuous lighting is

normally used, there seems to be no theoretical reason why a focusing electronic-flash unit should not provide the illumination.

Finally there is the difficulty of producing an adequate tone range on the photograph. This applies mainly to black and white work, because with colour any deficiencies in the tonal range are overshadowed by the presence of the various colours. One has to imagine the browns and greens as different shades of grey on the final print and it is

9.17 A smooth newt with its hindlegs clasped around some pondweed leaves, depositing eggs. Two newly laid eggs are clearly visible to the right of the hind limbs. A white background was used to produce a tonal range on the photograph

only too easy to produce an overall grey print concealing a well-camouflaged, grey-looking fish. This problem can be solved by paying special attention to the lighting and to the background. It is useful to have sheets of black, middle grey, and white paper available and to position the appropriate one some distance behind the aquarium, illuminating it if necessary (Fig. 9.17).

The photographs in this section were all taken using electronic flash (usually two units) linked by a 2 m (6 ft 6 in) flash lead to a hand-held camera. By not using a tripod, I had the advantage of being able to follow the organisms around the aquarium, making an exposure at the appropriate moment.

Photography through the surface of the water
It is possible to photograph sessile organisms by setting up the camera above the aquarium, looking down onto the surface of the water. This presents difficulties with a normal aquarium because one has to photograph through the whole depth of the water. One solution is to transfer the animals to a shallow container, but time is required for them to settle down again. Another solution is to use a viewing tube, which effectively reduces the amount of water above the specimen, thereby giving a sharper, higher-contrast image. The apparatus consists of a metal or perspex tube with a piece of plain glass cemented over one end. The tube is then lowered into the water and supported over the specimen.

I have used both metal and perspex tubes and the urchin shown in Fig. 9.15 was photographed using a perspex tube 10 cm (4 in) in diameter and 20 cm (8 in) long with a 10 cm (4 in)-square piece of plain glass cemented over the open end. The tube need not be set up in the vertical position – in fact the urchin photograph was taken with the tube inclined at about 35° to the vertical. When photographing smaller organisms in a more confined space, it is appropriate to use a smaller tube.

The position of the illumination is very important and, to prevent shadows being cast by the tube itself, the illumination should be set at a low angle. This produces a deep long shadow on the unlit side of the specimen, which can be eliminated by using a second light or a good reflector. Any form of tungsten lighting can be considered and electronic flash can also be used, provided one is careful to avoid unwanted reflections. A typical example of the set-up is shown in Fig. 9.18.

Photographing living animals in a well-stocked aquarium requires time and patience, but the satisfaction of producing a set of clearly defined, well-composed photographs illustrating some facets of animal life amply justifies all the time and effort involved.

9.18 The use of a viewing tube to photograph sessile aquatic organisms

ILLUMINATION

PERSPEX CYLINDER

ILLUMINATION

10 Amphibians and Reptiles

For about 150 million years reptiles dominated the land, sea and air but at the end of the Cretaceous period (approximately 135 million years ago) their rule came to an end. It is fascinating, to contemplate how, from absolute unquestioned dominance, the reptiles have declined to their present lowly position, particularly in temperate regions such as the British Isles. (The amphibians have not fared much better considering that they were the first inhabitants of dry land and for a while were the dominant animal group.) What caused the catastrophic decline of the reptiles? It is a long interesting story, based on speculation, theory and a few hard facts, but it is generally accepted that changes in climate and terrain produced a situation in which the reptiles, being cold-blooded animals, could not survive. Many became extinct and those which did remain favoured the warmer climates. Amphibians and reptiles are reasonably abundant on the continent of Europe but, after the Ice Age, Britain became an island before many of them had had time to establish themselves.

These two groups of animals hold much interest for the naturalist, and photographic work can range from head and shoulder portraits and life-cycle sequences, to skin texture and feeding methods.

Biologically, amphibians and reptiles are quite separate, and have distinct characteristics, although from an evolutionary point of view they are close to each other, in that the reptiles evolved from early amphibian stock.

CHARACTERISTICS OF AMPHIBIANS

Amphibians are poikilothermic (cold-blooded) animals with a delicate moist skin. Poikilothermic means that their body temperature fluctuates with the environmental temperature, so that as the outside temperature falls, their body temperature follows suit. In temperate regions the ambient temperature is nearly always much lower than human body temperature, and therefore amphibians feel cold to the touch – hence the term 'cold-blooded'. For exactly the same reason, a fish feels cold to us and is therefore poikilothermic. In tropical regions, where the ambient temperature is high, the term 'cold-blooded' is not quite so apt, although the water, if not the air, is cooler than human bodies and so the term is again applicable.

In very cold weather amphibians have to hibernate, usually underground, to avoid freezing to death, whilst in tropical regions they aestivate to prevent death from overheating.

The skin of amphibians is very delicate and is well supplied with blood vessels. Great care should be taken when handling these animals because skin haemorrhages occur very readily. This liberal blood supply allows the skin to function as a respiratory surface and, although the frog does have a pair of small lungs, it can survive quite happily totally submerged in water. It also spends much of its time on land, hence the name 'amphibian' (from the Greek *amphi* and *bios*, living in both elements). However, they are tied to the water during the early part of their life-cycle and each year towards the end of March they return to the pond to lay their eggs. For the subsequent few months the eggs, tadpoles and developing adults are totally dependent on water for survival.

DISTRIBUTION OF AMPHIBIANS

In the British Isles the amphibian population consists of three species of newts, two species of toads and only one species of frog. The latter is the common frog, *Rana temporaria* (Fig. 10.1), and, although it has been extremely common in the past it is now becoming rather rare because of the drainage and utilisation of wet marshy ground which is its natural habitat. Two other species, the edible frog, *Rana esculenta*, and the marsh frog,

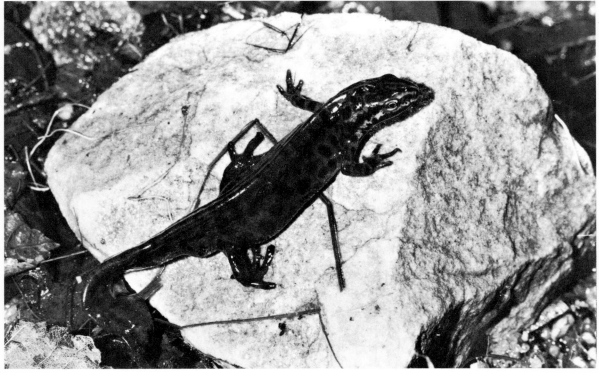

10.1 A common frog, *Rana temporaria*, amongst natural surroundings in a vivarium. Electronic flash was used

10.2 A common (smooth) newt, *Triturus vulgaris*, photographed in the same vivarium as the common frog. Electronic flash was again used

Rana ridibunda, have been imported from Europe. The former was introduced into Cambridgeshire about 200 years ago and is today limited to the south east of England. The marsh frog was introduced in 1935, a thriving colony still existing in the Romney Marshes of Kent.

There are two species of British toads, the common toad, *Bufo bufo*, and the natterjack, *Bufo calamita*. The common toad is larger than the natterjack and is widely distributed in England, Scotland and Wales. The natterjack is more localised but does occur in Ireland. Toads can be distinguished from frogs by their rough warty skin and their crawling movements. They hibernate, usually under stones or in heaps of vegetation, from October to April.

There are three species of newts native to Great Britain. The smallest is the palmate newt, *Triturus helveticus*, which is about 8 cm ($3\frac{1}{8}$ in) long. It can be distinguished from the other two species by its fibrillate tail and the slight webbing between the toes. The next in size is the common or smooth newt, *Triturus vulgaris* (Fig. 10.2), which is about 10 cm (4 in) long, smooth in texture and olive brown in colour. The male has an orange-yellow belly and is dappled. The largest of the three species, the great crested newt, *Triturus cristatus*, is about 15 cm (6 in) long and has a warty skin. Its name derives from the exceptionally large crest present on the male in the breeding season. Newts prefer an aquatic life during the warmer months, including the breeding season, and a terrestial life for the remainder of the year.

Many more species of amphibians are to be found on the Continent of Europe than occur in Britain. There are many species of frogs, newts and toads, and salamanders which are fairly widespread in the warmer regions of central and southern Europe (Fig. 10.3).

Finally, there is a rather odd group of amphibians called the caecilians, which are limbless serpentine animals, looking rather like earthworms. They are dark in colour and live in burrows in the ground. They feed on worms, termites and other small animals and are widespread in the tropics, with the exception of Australia and Madagascar.

HOUSING AMPHIBIANS

The principle involved in housing an organism is to try to replicate its natural environment as closely as possible. Thus, for amphibians, two types of accommodation are required. The first is based on an aquarium and fulfils the needs of the spawn laying and tadpole stage, whilst the second is a vivarium, which houses the animals when they are not breeding. A typical frog-breeding aquarium should have about 2 cm ($\frac{3}{4}$ in) of washed gravel on the bottom, into which a selection of water plants are anchored (see Chapter 9 for a detailed discussion of aquaria).

Several stones are piled up at one side and the aquarium is carefully filled with pond water to a depth of approximately 25 cm (10 in.). Some of the stones should project above the level of the water to allow the frogs to leave the water from time to time. A mature environment (ie one which has been set up for a few weeks) is very useful because it will contain plenty of green algae and other soft plant material on which the tadpoles can feed. The open top should be covered with either a purpose-built aquarium cover, or a piece of glass supported on four corks. The cover prevents rapid evaporation of the water, keeps out the dust, and prevents the frogs from escaping. Fig. 10.4 illustrates a typical arrangement.

Adult frogs are best kept in a vivarium. This consists of an enclosed perforated box, preferably with a sliding glass front. The floor should be covered with peat or loamy soil and some sphagnum moss, leaf mould, or pieces of bark placed here and there to provide useful cover. A few stones and one or two plants will complete the main area. A glazed dish sunk into the peat will make a suitable pool and the water should be changed weekly. An alternative arrangement is to construct a gently sloping bank of sand or gravel leading down to the water. Again leaf mould, pieces of bark, stones and plants should then be added. The completed vivarium is shown in Fig. 10.5. In the wild, non-breeding frogs tend to live in damp, shady places and this is the type of environment which is provided in the vivarium.

Adult frogs and toads are attracted only to moving food and they feed readily on pieces of earthworm, mealworms, maggots and flies. The tongue is very long and is attached to the front of the mouth, rather than at the back, as in humans. When flicked out, it can therefore cover a considerable distance and the speed of movement of the tongue tip is almost too rapid to see. Dead

organisms are of no interest to the frogs and should be removed before they sour the water.

Young tadpoles are vegetarians and feed on the green algae in the water but as they grow older they become carnivorous and should be supplied with insect larvae, water fleas, or small pieces of raw meat. Newts have a sense of smell and will feed on small pieces of raw meat during the aquatic breeding phase, whilst on land they will eat earthworms and maggots. Salamanders eat slugs, earthworms and slow-moving insects, and can be trained to accept raw meat from the fingers.

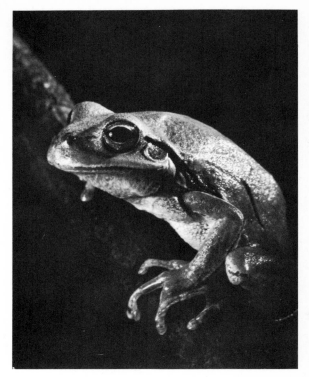

10.3 Two amphibians not found in the British Isles but common on the continent of Europe.
(a) The European Green Treefrog, *Hyla arborea*, is bright green in colour when amongst green vegetation. The adhesive pads on the ends of the digits are clearly visible. Two electronic-flash units were used
(b) The Spotted Salamander, *Salamandra salamandra*. Poisonous secretions are produced from the skin glands, particularly the large ones behind the eyes. These secretions irritate the skin of man and can be lethal to small animals

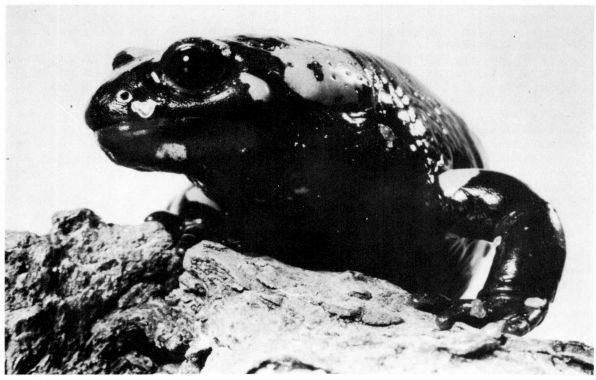

10.4 A typical aquarium suitable for frogs in the breeding season. Note the adequate volume of water, the liberal supply of plant materials, and stones to allow the frogs to leave the water

CHARACTERISTICS OF REPTILES

Reptiles are poikilothermic and therefore, like amphibians, their body temperature fluctuates with the environmental temperature. They thrive in tropical and subtropical regions where ambient temperatures are high enough to keep them active and they endeavour to maintain their body temperature in the 20°C–35°C (68°–95°F) range. Basking in the sun will quickly raise the temperature of a chilled body and, should overheating occur, the animal will quickly seek shelter under vegetation or in water.

Reptiles are covered with dead horny scales and in the tortoise group the scales become the horny plates of the shell. The scales are protective, but being composed of dead material they cannot have any respiratory function like that of the delicate living skin of amphibians. Reptiles are lung breathers at all stages of their life and, unlike most amphibians, do not have a gill-breathing tadpole stage. Their eggs are fertilised internally and laid on land, even by aquatic species such as turtles. The eggs are usually lightly buried in sand but otherwise they are not protected, guarded or cared for in any way by the parents. A few reptiles, such as slow worms, are viviparous and give birth to live young, instead of laying eggs.

DISTRIBUTION OF REPTILES

There are only three species of lizards and three species of snakes native to the British Isles. The lizards include the common lizard *Lacerta vivapara*, the sand lizard *Lacerta agilis*, and the slow-worm, *Anguis fragilis*. The common lizard is 10–15 cm (4–6 in) long, variable in colour but typically dark brown and lives on moors, meadows and along the edges of woods. It hibernates from November to March and produces 5 to 12 black young during August. The sand lizard is slightly larger than the common lizard, being about 17–20 cm (6¾–8 in) in length. It is restricted to the south of England and to a few sand-dune areas in the north west. It is fairly common in central Europe through to Russia and southern Siberia. It

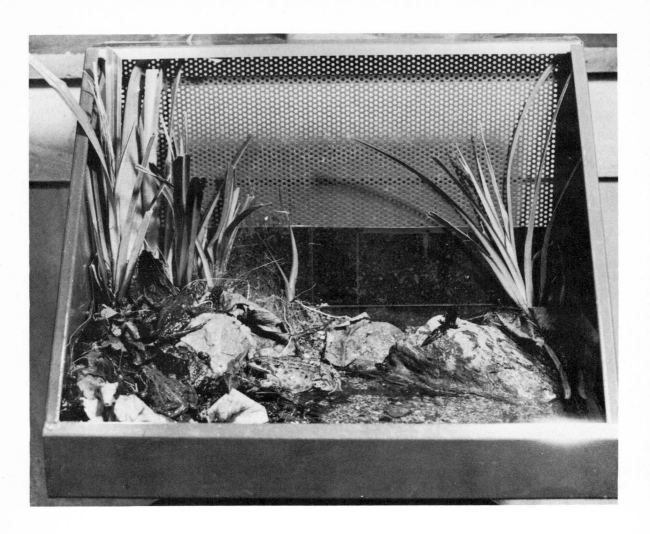

10.5 A vivarium suitable for amphibia. Note the plants, stones, and leaf mould on the left and the area of shallow water near the front right. A sliding-glass front completes the vivarium

has a very long tail, accounting for over half of its length, and the claws are longer at the front than at the back. The colour varies according to sex, age and habitat. It hibernates from October to April and produces 5 to 14 young during August.

The slow-worm is snake-like in appearance and is usually between 25 cm (10 in) and 45 cm (17¾ in) long. It is fairly widespread in Britain and occurs over most of Europe. It is a limbless animal covered with small shiny scales which may be steel grey or bronze in colour. Although serpentine in appearance, the slow-worm has a tail which is much longer than the rest of the body and if the tail is broken off only a short stump grows in its place.

In addition to these three species there are two more which are native to the Channel Islands: the green lizard, *Lacerta viridis*, in which the tail accounts for about two-thirds of the total length, and the wall lizard, *Lacerta muralis*, which is grey and brown in colour and an excellent climber.

It is quite true that in many species of lizard the tail can be broken off without causing the death of the animal. This is of great survival value in that when a predator is wrestling with the detached tail, the body and head can slip quietly away. The muscles and blood supply in the region of the break are arranged to cause the minimum of damage to the animal when a break does occur.

However, the new tail seldom attains the full length of the original.

The three species of snakes which are native to Great Britain are the adder (viper), the grass snake, and the smooth snake. The adder, *Viperus berus*, is 50 cm – 60 cm (20–24 in) long and is the only venomous species. It lives on moorland, heath, and along the edges of woods and is active mainly in the early morning. The colour is variable but typically the male is greyish, and the female brownish in colour and both have a dark zigzag stripe along the back. Adders feed on mice, slow-worms, frogs and lizards, which they paralyse by pumping venom into the skin punctures made by the fangs. Adders hibernate from November to April, mate in early May and produce 5 to 18 young in August. The adder bite can be dangerous to man but is seldom lethal. The treatment in severe cases consists of injecting adder antivenene into the patient as soon as possible after he has been bitten. Adders have the widest distribution of all land snakes.

The grass snake, *Natrix natrix*, is Britain's commonest snake. The female is 60 cm – 100 cm (24–39 in) long, while the male is a little shorter. Again colour is variable but is typically bluish-green. There is usually a prominent yellow or white collar behind the head, consisting of the two fused neck spots. Grass snakes live near marshes, lakes and ditches, but may also be found in gardens, sheds and stables. They are good swimmers and feed on frogs and small fish which they eat alive. When handled, they often expel a foul-smelling secretion from the anal glands. Grass snakes hibernate in stone walls, under tree roots and in compost heaps, from October to April. In July to August they mate, and lay 10 to 20 eggs which hatch in early September. They are found in most European countries and as far eastwards as central Asia.

The third type of snake found in the British Isles is the smooth snake, *Coronella austriaca*, but it is fairly rare and occurs only in a few places in the south of the country. It is, however, quite widespread in most areas of Europe. Being about the same size as the adder, it is sometimes mistaken for it, and although the characteristic zigzag of the adder is absent, several dark spots may have fused together to give a somewhat similar appearance. The smooth snake prefers dry conditions and lives on sandy heaths and scrub land where it feeds on lizards, slow-worms and small snakes. It hibernates from October to April and produces 3 to 5 young in September.

HOUSING REPTILES

Snakes and lizards can be kept in indoor vivaria, built to replicate the type of environment in which they are normally found. Most reptiles live in fairly dry environments, and enjoy basking in the sun but they also need a shaded area in which to take refuge when they are beginning to overheat. They also require a supply of water. The amphibian vivarium described in the earlier part of this chapter would form a good basis, although the area of water could well be reduced to that of a small dish. In captivity reptiles must either be kept at normal room temperature, around 15°C (59°F) and fed regularly, which is not easy, or be allowed to hibernate in a cold but frost-free place. No middle course is possible. Snakes can also be housed in a specially built snake pit, and for information on constructing this, the reader is referred to the specialist books listed in the Bibliography.

EQUIPMENT

An SLR camera with close-up facilities and a medium-length telephoto lens would be the basic equipment for photographing amphibians and reptiles. A TLR camera could be used but problems of parallax would arise when photographing small organisms such as newts and frogs. Additional equipment, which would be used from time to time, would be one or more electronic-flash units, some photoflood lighting, a polarising filter, and, of course, a tripod.

PHOTOGRAPHING AMPHIBIANS AND REPTILES IN THE FIELD

During the non-breeding periods of their life, amphibians are seldom seen. They are sometimes discovered by chance, rather than by making a conscious search for them. Frogs, toads and newts are all able to merge into the background, so they are extremely difficult to see. Figure 10.6 is an enlargement of part of a vivarium and includes three frogs and one newt, which at first glance are almost impossible to see. The areas of pigmentation in the frog's skin can increase or decrease according to the tone of the background, so that the frog can literally change colour to match its background. Unless one is trying to illustrate animal camouflage, there is little need to photograph amphibians in the field. The one exception to this is during the breeding season, when their presence is much more apparent and their acti-

10.6 An enlargement of the vivarium shown in the previous photograph. Can you spot three frogs and one newt? Two photofloods were used for illumination

vities rather special and worth photographing in the natural environment.

Towards the end of March, or a few weeks later if the weather is very cold, frogs begin to return to their pond to start the breeding cycle. The male develops a nuptial pad on the first digit of each forelimb in preparation for gripping the egg-laden female. When a large female arrives in the pond, the male climbs onto her back grasping her tightly with his forelimbs. The pond, which might have been still and quiet on the previous day, will suddenly become alive with pairs of leaping, croaking frogs. The timing for photographing frogs in amplexus (paired) is rather critical, since they rarely stay together for more than one day. The eggs are released by the female and immediately fertilised, by the male shedding sperm over them, after which the frogs separate.

Figure 10.7 shows a typical frog breeding pond containing a pair of frogs actively moving about and causing quite a disturbance in the water. It was photographed using a 135 mm (5¼ in) telephoto lens at an exposure of 1/125 sec at f5.6. In contrast, Fig. 10.8 shows four frog eyes belonging to a pair of frogs in amplexus. Their bodies are completely submerged and the area is surrounded by floating twigs and duckweed, making the heads very difficult to see. This photograph was taken from the same position as the previous one, but with a 300 mm (12 in) telephoto lens. Reflections of clouds in the water can cause problems and the ideal sky is a bright, cloudless one. A polarising filter can often be useful in reducing surface reflections in the water, particularly when the animal being photographed is partly submerged.

Newts begin breeding about two months later than frogs, and because newts spend most of their time under water, coming to the surface only occasionally to refill their lungs with air, they are very difficult – if not impossible – to photograph in the field. Apart from the brief period when

10.7 Paired frogs in the breeding season. This pond, complete with floating debris and a covering of duckweed, is visited each year by dozens of pairs of frogs. Natural lighting. Exposure 1/50 sec at f5·6 using a 135 mm telephoto lens

10.8 'Four eyes' – two frogs in amplexus. The pair remain together for less than 24 hours during which time the eggs are shed by the female and immediately fertilised by the male. Exposure 1/50 sec at f5·6 using a 135 mm lens coupled to a 2× converter

amphibians are pairing and mating in the pond, all other work can best be done under controlled conditions in the laboratory or studio.

Snakes and lizards are poikilothermic and need to sun themselves to maintain their body temperature. They can sometimes be found basking in the sun in sheltered areas away from the wind and, if approached cautiously, can be photographed fairly easily with a 135 mm (5¼ in) telephoto lens. On particularly hot days they become quite active and when disturbed will move rapidly to a shaded area. If one is seriously interested in studying and photographing reptiles in the wild, the warmer climate of Spain and the Mediterranean countries

10.9 Frog on stone. A low-key 'artistic' portrait rather than a biological record

10.10 Developing frog's spawn photographed indoors, using the set-up illustrated in Fig. 10.11
(A) Less than 24 hours old. The black spherical embryos are surrounded by gelatinous spheres which have not yet reached full size
(B) 7 days old. The head, body and stubby tail are visible in each developing embryo. Gelatinous spheres have reached full size
(C) 10 days old. The process of elongation continues with the tails becoming larger. The external gills are clearly visible and the 'jelly' is beginning to disintegrate
(D) 15 days old. The tails are wide and blade-like and the tadpoles have just freed themselves from the remains of the 'jelly'

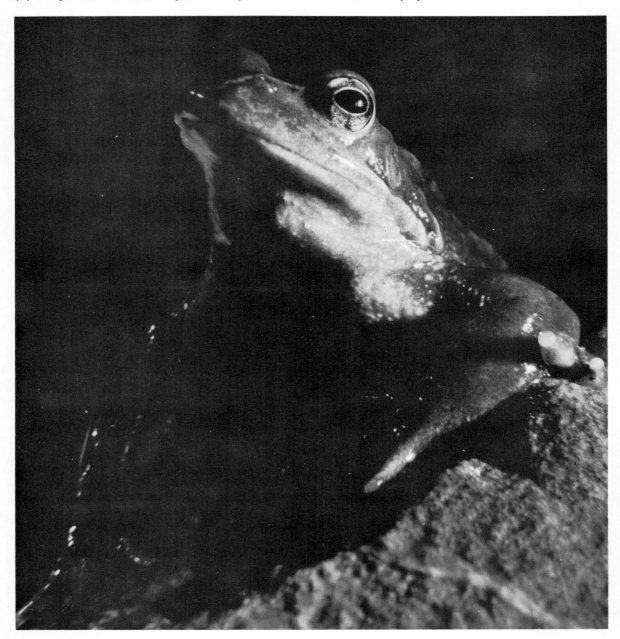

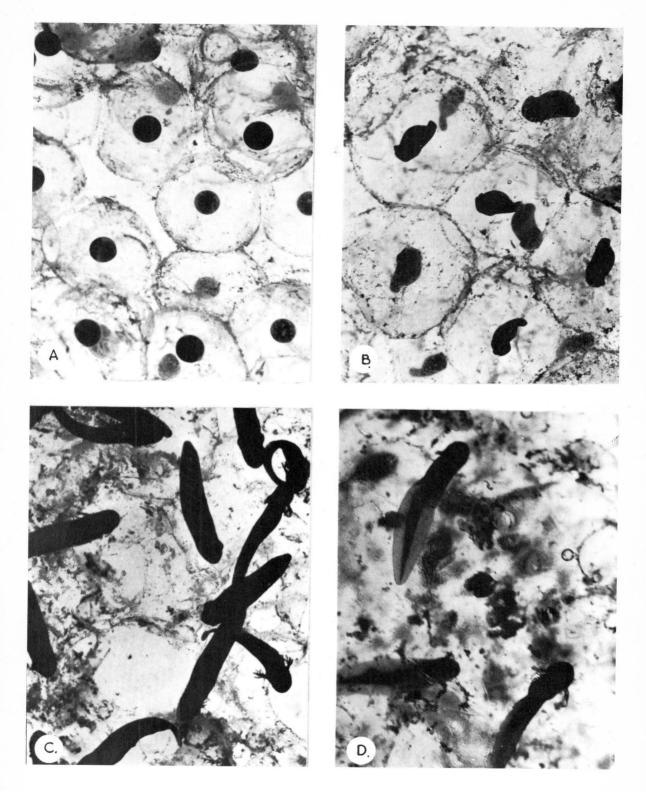

147

provide many naturally occurring species including water snakes, terrapins, geckos, chameleons and several types of lizard. Another method is to visit a reptile house and photograph the animals through glass. This technique is described towards the end of this chapter.

PHOTOGRAPHING AMPHIBIANS AND REPTILES IN THE LABORATORY OR STUDIO

Photographs of amphibians and reptiles are often best taken in the controlled environment of the laboratory or studio. The lighting can be arranged as required and one is not limited by the uncertainties of natural sunlight, which can vary both in colour temperature and intensity. The environment, whether it is an aquarium or a vivarium, can be readily controlled and the animals, being in a relatively small space, are easy to handle and arrange for photographs.

As these animals are poikilothermic, the heat from photoflood lamps soon makes them hyper-

active and rather difficult to control. A useful method is to chill them first, by putting them in a domestic refrigerator for about half an hour; this merely slows them down and does not produce a lifeless moribund body, which would be rather obvious in a photograph. If the work can be done fairly quickly the animal should remain docile, but for long photographic sessions electronic flash should be used. This does not produce any detectable heat and if a low-power modelling light is positioned next to the flash unit then the direction of the flash can be studied and very good results obtained. Excellent use can be made of a vivarium similar to the one described in the earlier section, and Figs. 10.1 and 10.2, showing the common frog and the smooth newt respectively, were both taken in a vivarium using electronic flash. If one is more interested in the artistic approach, Fig. 10.9 might be a more appealing

10.11 Set-up used to photograph the frog's spawn

10.12 The underside of a tree frog photographed through a sheet of glass as illustrated in Fig. 10.13. The adhesive pads on the digits are clearly visible

TRANSLUCENT TYPING PAPER

GLASS SHEET

L

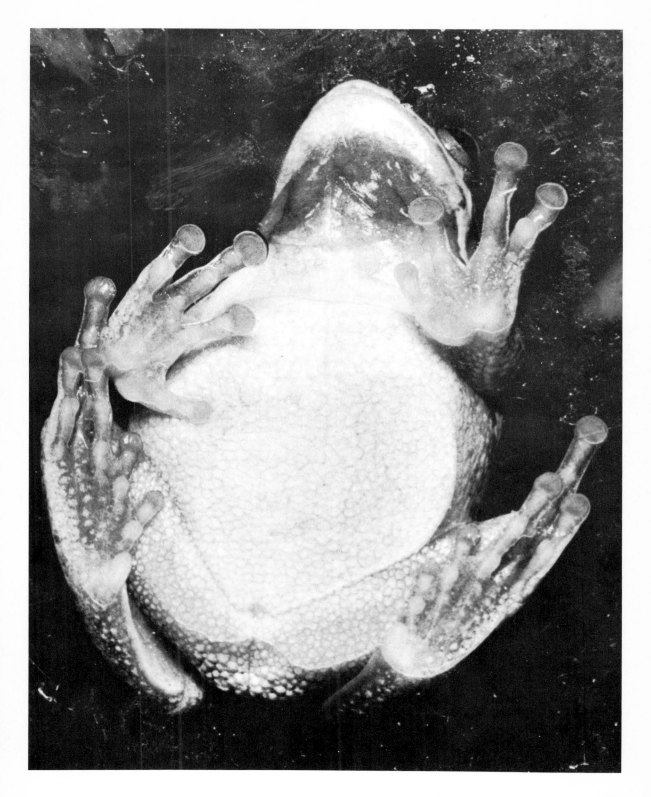

picture. This was taken outside the vivarium with the frog posed on a large stone. A dark background was used to heighten the dramatic effect and to concentrate attention on the frog.

Figure 10.10 illustrates some of the interesting stages in the development of frog's spawn, beginning with the beautifully symmetrical eggs in the one-day-old spawn and ending with the almost free-living tadpoles at day 15. All sizes are comparable because both the working distance and the degree of enlargement were the same in all cases. The set-up used for the photographs is illustrated in Fig. 10.11. Most of the water was removed just prior to taking the photographs, so that the spawn lay in a fairly thin layer on the bottom of the dish. This allowed most of the eggs and tadpoles to be seen without too much overlap

10.13 Arrangement for photographing the underside of animals

and also allowed them to be kept in focus. The camera was firmly fixed in the position shown in the diagram. After taking the photograph, the water was returned to the vessel again.

The underside of animals, although normally in contact with the ground, are sometimes worth studying. For example a photograph of the ventral surface of a tree frog will show very clearly the adhesive pads at the ends of the digits. This type of photograph can be obtained by arranging a piece of

10.14 The Puff Adder, *Bitis arietans*, is common in Africa, south of the Sahara, except in the tropical rain forest. When provoked, it hisses loudly and inflates its head to almost double its normal size. Photographed through glass using electronic flash

10.15 The Common Iguana, *Iguana iguana*, is widespread in South America. In this photograph, taken through glass, the iguana is hanging from a branch and eating lettuce

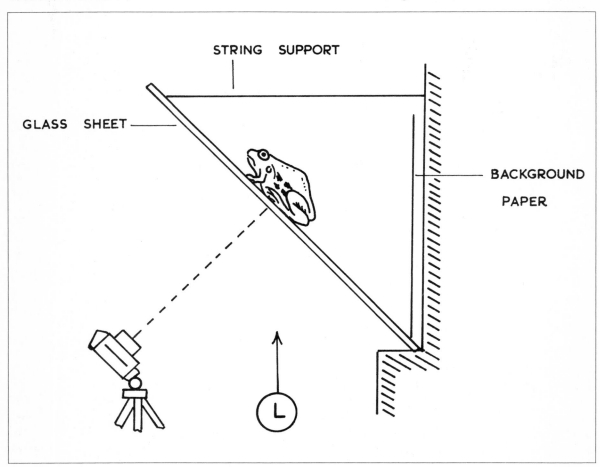

STRING SUPPORT

GLASS SHEET

BACKGROUND

PAPER

L

10.16 The Mississippi aligator, *Alligator mississippiensis*, grows to about 3 m in length. Photographed through glass using electronic flash and a 135 mm telephoto lens

glass at about 45° and photographing the animal from below the glass. The arrangement is shown in Fig. 10.13. The tone of the background paper should be selected to complement the general tone of the organism. Figure 10.12 was produced using this set-up.

PHOTOGRAPHY IN THE REPTILE HOUSE

There are so few reptiles occurring naturally in the British Isles, that anyone seriously interested in photographing them might well be advised to visit a reptile house in a zoo. Most reptiles, with the exception of tortoises and terrapins, tend to be kept behind glass and the main problem is that of photographing animals through a sheet of glass.

Figures 10.14 to 10.16 were all taken through glass and in only one of them, the puff adder, could any scratches be detected and even these disappeared when the photograph was printed. The reason why the scratches were visible at all was that the adder's head was almost in contact with the glass. An electronic flash provided the lighting and the unit was held at approximately 45°, and about 2 m (6 ft 6 in) above the camera. An increase in exposure of one stop was again given to compensate for some of the light being reflected from the glass.

In all cases, a 135 mm ($5\frac{1}{4}$ in) telephoto lens was used which, compared with the standard 50 mm (2 in) lens, shortened the depth of field and helped to throw out of focus any scratches or blemishes on the glass. It also produced a large useful image on the negative. The general principle is to have the glass as near to the camera as possible and the animal as far away from the glass as possible. If this can be achieved, the glass is unlikely to cause any serious problems. One must, however, be aware of the possibility of reflections of the camera and photographer appearing in the glass, but these are readily visible in the camera viewfinder and can usually be eliminated by a change of position.

In the reptile house in which the photographs were taken there was very little light from the windows and a black card to cover the camera and the photographer's face (see Chapter 9) was not required. A polarising filter can often be useful in reducing surface reflections and once again its effectiveness or otherwise is visible in the camera's viewfinder.

11 Birds

Bird ancestry can be traced back to the reptiles, and fossil evidence indicates that birds evolved in the Jurassic Period about 180 million years ago. Archaeopteryx is regarded as one of the first birds and it possessed many characteristics, such as a long bony tail, peg-like teeth and three claws on each wing, alongside the obvious bird characteristics (Fig. 11.1b). The pterosaurs, for example Pterodactyl, belong to another group of reptiles which took to the air but they remained basically reptilian in character and the group became extinct about 70 million years ago (Fig. 11.1a). The birds have, therefore, been in existence for a very long time, and can be regarded as a very successful class of animals.

There are about 9,000 species of living birds, distributed from the equator to the poles. Wing spans can range from 3 m (10 ft) to 5 cm (2 in) and their body weight from 9 kg (20 lb) to 3 or 4 grams (0.1 oz). Some birds, such as chaffinches, migrate only a few kilometres (or miles) from oakwoods to farmland, whilst others, such as the American Golden Plover, migrate between Alaska and Patagonia, a distance of about 35,000 km (22,000 miles). A large sea bird such as the albatross might beat its wings only once in half an hour, whilst the tiny humming bird beats its wings 200 times a second. Many birds display fascinating pre-mating behaviour characteristics and others indulge in exquisite bird song. Some birds are experts in the art of nest building, whilst others will work themselves almost to the point of collapse in caring for their offspring.

It is therefore not really surprising that so many people are interested in birds and it has been said that more people watch and study birds, than study any other group of wild animals. Similarly, more books have been written on bird photography than on any other aspect of nature photography, and readers who would like to make a serious study of this subject should read the publications of people such as Eric Hosking, John Gooders and John Warham.

CHARACTERISTICS OF BIRDS

Feathers evolved from reptilian scales and, whilst some feathers are light and stiff and are used for flight, others are fluffy and have good insulating properties. Flight is a very complex process and most birds have developed the art to a fine degree. There are, of course, different styles of flight and a range of take-off and landing techniques, and some bird watchers and photographers are primarily interested in this aspect of bird study.

Because birds are homeothermic (ie have a high fixed body temperature), they need to be kept warm, and this is achieved by the fluffy down feathers. Much air is trapped in these feathers, which lie underneath the outer feathers and next to the skin. This form of insulation is comparable with the fur and wool of mammals. In very cold weather birds fluff out these feathers, so increasing the amount of air trapped around them. Birds also do this in sunny weather to prevent the radiant heat from the sun from reaching their bodies and, whilst the temperature on the surface of the feathers might rise by 5°C (9°F), the skin temperature changes very little.

Another important characteristic of birds is the laying of eggs in a nest. Virtually all birds do this, although the emperor and king penguins carry their eggs around on their feet rather than use a nest. Nests vary tremendously in size, general tidiness, method of construction and degrees of protection afforded to the eggs. The simplest nest is a mere scrape on the ground, without any additional material being added to it and this is characteristic of ostriches and nightjars. A bare cliff ledge is sufficient nest for auks such as razorbills and guillemots (Fig. 11.2).

There are the scrappy untidy nests of gannets, made from a heap of seaweed and flotsam, whilst at the other extreme are to be found nests of great complexity as seen in the old world weavers, which use vegetable materials woven into a form of cloth. Other birds, such as leaf-warblers, long-tailed tits and certain wrens, build domed nests with the entrance at one side. Swifts use a plastic material, made from vegetable matter, feathers and saliva, for nest building; house martins and swallows use wet mud as the main building material. Types of nests and nest-building techniques is a fascinating branch of bird study which attracts a large number of devoted enthusiasts.

Another interesting characteristic of birds is their ability to make sounds. These range from the drumming of woodpeckers (usually referred to as a song-substitute) to the singing of the robin or

11.1a Pterodactyl. An early attempt at flight in reptiles. This group evolved in the Jurassic period and became extinct at the end of the Cretaceous period (about 140 million years ago)

11.1b Archeopteryx. An artist's impression of the earliest type of bird, based on fossil remains. This bird-like creature was approximately the size of a large pigeon and lived in the Jurassic period about 180 million years ago

11.2 Sea birds nesting on a vertical cliff face. The kittiwakes' nests are made from seaweeds and other local materials, whereas the guillemots lay their single egg on a bare rocky ledge

skylark. Bird song is particularly obvious during the breeding season and is associated with pair formation. It is also linked to the holding of territory and it is the male bird's way of saying, 'This is my patch, keep off!'. Some females sing where they hold a winter territory (eg the robin) and both sexes sing in certain tropical species. The tape recording of bird song in conjunction with photography is yet another branch of bird study which attracts its own following of devotees.

Sense organs

Some knowledge and understanding of birds' sense organs is very useful to the bird photographer. It is generally agreed that birds have taste buds on their tongue very similar to our own.

Some birds, such as tits, seem to have a reasonably well-developed sense of taste, whereas fowls and pigeons, which feed mainly on grain and swallow it whole, make little use of taste.

Birds also have a sense of smell, although until fairly recently, many people did not think so, despite the assertions of wildfowlers, made nearly a century ago, that one needs to stand downwind of ducks and geese if they are not to become aware of one's presence. However, compared with that of a dog, the bird's sense of smell is very poorly developed.

Birds obviously have a sense of hearing, otherwise bird song would be rather pointless. Experimental evidence indicates that their hearing is good and comparable with that of mammals. Most birds are sensitive to frequencies ranging from a few hundred Hertz to about 10,000 Hz, whereas man can hear frequencies up to about 17,000 Hz, although this level falls with advancing age to about 10,000 Hz. There is also abundant evidence that night predators such as owls have an upper limit of about 18,000 Hz, which enables them to hear the high-pitched squeaks of mice inaudible to most other birds and to many humans.

Where birds really do score is in their extremely well-developed eyesight and photographers should always be aware of this when stalking, observing, or setting up hides and camera equipment. Birds' eyes are built on a similar pattern to our own but they tend to be more conspicuous because they are larger relative to the size of the head than are human eyes. They are usually located on the sides of the head and therefore face sideways rather than forward. This has important implications which are discussed later in this section.

When the human eye focuses on an object, the image falls on the yellow spot of the retina (the retina is equivalent to the film in the camera), where the sharpest possible image is produced. The rest of the visual field is rather blurred. This is why one cannot take in the details of a view or picture unless one moves the eyes and scans the area so that each section in turn falls on the yellow spot for a short time and the detail is seen clearly at this point, (ie one 'concentrates' on a particular part of the visual field at the expense of the rest of the field). Due to the arrangement of nerve cells in the retina, birds have the ability to pick up fine detail over the entire visual field. Therefore they see the whole picture as clearly as we see the small areas on which we concentrate. The bird does not

need to move its eyes to pick up fine detail and, as most people know, birds move their eyes little or not at all.

A different field of view is obtained when the bird moves its head on its long flexible neck. Birds' eyes also have a yellow spot where the discrimination or visual sharpness is approximately three times greater than man can achieve, so that when a bird does concentrate on a small area, not only is the whole visual field very sharp but the small area being concentrated on is critically sharp. These retinal differences, coupled with an eyeball shape which greatly reduces spherical aberration, produce a sharpness of vision which is in a different class from our own.

The diagrams in Fig. 11.3 show the visual fields of two birds; a predator, such as an owl, and a non-predatory grain-eater such as a pigeon. Due to the forward position of the eyes, the owl has a fairly restricted total visual field but a large overlap field of binocular vision. This is an area of three-dimensional vision allowing the owl to judge distances accurately, and it is extremely important when catching moving prey such as mice and rats. The pigeon, on the other hand, has a total visual field of 340° (almost all-round vision) but its binocular vision extends over a mere 24°. This is in keeping with its life-style, as the pigeon does not need three-dimensional vision to peck at static food, but does benefit from almost all-round vision

in that it can see enemies approaching from virtually any point of the compass. The ultimate in all-round vision is seen in the woodcock where the eyes are placed high on the head and well to the back, giving it a full 360° visual field with a small overlap of fields in front and behind the head. It can therefore see all round itself, including directly behind, and it is impossible for anyone or anything to approach it unobserved. Birds, together with primates, lizards, salamanders and bony fish, possess colour vision, although in all except birds (so far as we know) there are many colour-blind species.

The above points have many implications for the bird photographer. When a bird is flying, it can see everything in great detail on the ground below, including the photographer and his equipment, and when the bird really concentrates on an area it can pick up fine detail from a great distance. When one goes behind a bird to, hopefully, get out of sight, it could be watching one's every movement. If these observations are linked to the fact that most birds are very wary of humans, then it should be clear why bird photography is so difficult and calls for a high degree of skill, a lot of knowledge and endless patience on the part of the photographer.

11.3 Visual fields of an owl and a pigeon (based on *Book of British Birds*, an AA publication)

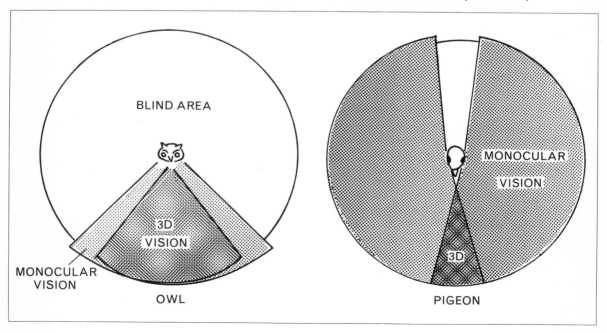

156

EQUIPMENT

Cameras

In theory any type of camera with interchangeable-lens facility is suitable for bird photography but in practice the choice is limited to one or two types. Formerly, when working at the nest was the main interest of bird photographers, 12 × 10 cm (5 × 4 in) plate cameras were usually used and the results were excellent. The cameras were, unfortunately, heavy, cumbersome and rather slow in operation and would be quite unsatisfactory for today's photographer, who is also interested in stalking techniques and in-flight work. One can therefore assume that most photographers will be using either 35 mm or 6 × 6 cm (2¼ × 2¼ in) format cameras.

The SLR has the obvious advantage that, whatever focal length of lens is being used, the view through the eyepiece is correct and, when using a standard screen of the ground glass or micro-prism type, the focusing is quick and accurate. The main disadvantage of the SLR camera is the noise from the focal-plane shutter and the instant-return mirror, which is often obtrusive enough to scatter the birds after the first exposure. If the camera can be prefocused on, say, the nest, and the limits of the field are kept in mind, then the mirror can be 'locked up', so reducing the noise considerably. One or two of the larger format SLR cameras, such as the Hasselblad, Kowa Super 66 and Mamiya RB67 have leaf-blade shutters which are very quiet in operation; unfortunately in these cameras the mirror and light baffle cannot by locked up.

Most SLR cameras have an eye-level prism viewfinder which is ideal for bird photography, particularly when photographing birds in flight. A waist-level viewfinder is satisfactory for slow-moving birds at ground level, but it is not ideal for fast-flying birds. It is very difficult to follow a fast-flying bird in a waist-level screen because the image moves in the opposite direction to the subject and one must go against one's natural instincts so that, if the bird moves to the left in the viewfinder screen, the camera must be swung to the right to keep up with it. To achieve this, and to focus the lens at the same time, is an extremely difficult task. Most 35 mm SLR cameras have an eye-level prism viewfinder as standard whereas the majority of 6 × 6 cm (2¼ × 2¼ in) SLR cameras have a waist-level viewfinder as standard and the eye-level finder is an expensive accessory.

Lenses

The lenses required for bird photography should be of the telephoto type with a minimum focal length of 135 mm (5¼ in). This, fortunately, is the most popular all-purpose telephoto lens and is usually the first, and often the only, long-focus lens bought by most photographers. It is useful for photographing large birds in flight and for working at the nest, and since most are fully automatic, they are easy and quick to operate.

There are, however, many occasions when a longer focal length lens is required, particularly when photographing small birds and when adopting stalking techniques. A 300 mm (12 in) lens gives a magnification of 6 × that produced by a standard 50 mm (2 in) lens and this means a six-fold increase in the size of the image on the negative. A good-quality 300 mm (12 in) lens will focus down to approximately 6 m (20 ft) and is therefore useful when photographing birds at close quarters. By using extension tubes or bellows this distance can be shortened slightly, although the gain is small and probably not worth the effort involved, particularly if the fully automatic diaphragm facility is lost in the process. A longer focal length would produce a larger image but the depth of the field becomes very small and critically accurate focusing is necessary.

Camera shake becomes an ever-increasing problem, calling for special supports in the form of either a tripod or a shoulder support. A 300 mm (12 in) lens can be hand-held if a short exposure (eg 1/300 sec) is given and the lens is sufficiently compact to be carried at the ready when the stalking technique is being used. A fully automatic lens is more satisfactory than the pre-set type, because one often has no time to rotate the aperture ring to the stop-down position after the bird has been brought into focus at full aperture. Longer focal length lenses of the mirror type, 500 mm (20 in) and 1,000 mm (39 in) are short and easy to handle but they require a separate support to avoid camera shake and their fixed aperture of approximately f8 presents problems.

A piece of equipment which initially fell into disrepute very early in its life was the 2 × tele-converter. Its optical performance was generally very poor and much sharper results could be obtained by selective enlargements from the negatives produced by the unaided telephoto lens. However, many modern tele-converters – for example, the Telemore 95 range – have an excellent optical performance and can be very

useful if lighting conditions are favourable. This simple optical system fits between the lens and the camera, and immediately doubles the focal length of the lens. However, as the diameter of the telephoto lens elements is not increased, the f number of the combination must decrease and the final light loss is equivalent to two stops. For example, a 135 mm ($5\frac{1}{4}$ in) telephoto lens with an aperture of f2.8 is converted into a 270 mm ($10\frac{5}{8}$ in) lens with an aperture of f5.6.

Other equipment

With a motor-drive unit, a series of photographs illustrating an interesting event, such as Canada geese landing on water, can be photographed with relative ease. Some photographers tend to use the motor drive like a machine-gun, hoping that, in a series of photographs, one might turn out to be quite superb. The motor-drive unit for the Olympus OM-2 can be set for single-frame operation or for filming up to five frames per sec, whereas without a motor drive a competent photographer can probably manage about one frame per sec.

Other pieces of necessary equipment are two electronic-flash units, a hide, and a range of remote-control devices. Of the latter, a pneumatic or an electro-magnetic remote control would probably be used quite often, whereas the electronic beam interrupting switch would be required less frequently. (This equipment was described in some detail in Chapter 2.)

APPROACH

What should be one's approach to bird photography? Many people's interest in photography ebbs and flows and one possible reason for this is the lack of aims and goals. One should decide on a definite aim and try to fulfil it to the best of one's ability. Some aims in bird photography could be:

1 Portraits of a selected bird. The photographs should be of high quality and show the bird in its natural surroundings.
2 A series of photographs illustrating flight characteristics. This could be limited to one species and include a study of take-off and landing, the use of the tail and feet, different flight styles, etc. If one studies the theory of flight and gliding in aeroplanes and gliders, examples soon come to mind of how man has finally and often laboriously arrived at the solution to a particular problem which birds solved several million years earlier. Some obvious examples are the Handley Page

Slots used as antistalling devices, the retractable undercarriage, and the swing-wing principle.
3 A study of the flight styles of selected birds.
4 A study of the reproductive cycle of a selected species, including aspects such as courting displays, nest building, egg incubation, the hatching process, the feeding of the young, and the first flight of the fledglings. A series of photographs illustrating these characteristics would require considerable photographic expertise and would spread over several seasons.
5 A study of social behaviour in colonies of birds. This would be particularly rewarding during the breeding season and much can be learned about social behaviour by observing the birds in the field, in conjunction with notes made at the time the photographs were taken.

BIRDS IN THE GARDEN

The garden is probably the best place to begin photographing birds. One can ensure quietness and privacy, techniques can be tried and modified, and equipment can be left *in situ* with little fear of it being disturbed. Sparrows, finches, tits, starlings, thrushes, robins and blackbirds are usually fairly common in urban gardens and much can be learned from working with these species. Most birds are timid or afraid of humans, and to overcome this problem, a typical garden set-up (illustrated in Fig. 11.4) should consist of a hide for the photographer and his equipment, and a special platform to which birds will be attracted.

The hide

The hide, or blind, enables the photographer and his equipment to get within 2 to 3 m (6 to 9 ft) of the bird, without being observed. Rather surprisingly most birds will come to accept, over a period of time, any shape or colour of hide and there is therefore no need to go to eleborate lengths to camouflage it or to make it resemble a bush or a tree. The first hides were devised by Richard and Cherry Kearton in the early part of this century, after they had observed that birds seem to be unaffected by the presence of sheep, cows or other domestic animals. The Keartons hid themselves in the mounted skin of a cow and on other occasions took to 'becoming' a sheep. Although they produced some superb photographs, it is now realized that such elaborate hides are not necessary.

A standard hide consists of a rectangular upright tent with a base approximately 1 m (3 ft) square and

11.4 A typical garden set-up. The hide is on the left and the bird table, complete with leafy twig, is in the centre. Two electronic-flash units and an artificial background board are also visible

a height of about 2 m (6 ft). This allows sufficient space to accommodate the photographer and his stool, the tripod and the camera. Best-quality hides are made of canvas, although heavy cotton is satisfactory as long as the photographer's silhouette cannot be seen through it. The framework usually consists of alloy tubing slotted together. There should be a hole for the camera lens and several peep-holes at an appropriate height to allow the photographer to see what is happening outside. The material should be securely fastened to prevent flapping, as this usually disturbs the birds.

Hides are available commercially (see the List of Suppliers). For the photographer who, initially,

does not want to invest money in a purpose-built hide, there are several alternatives. A toilet tent of the type used by campers and caravaners is a good substitute and with a minimum of modification can be made into a very effective hide. If it has to remain a dual-purpose tent, the front should be unzipped and refastened with safety pins, leaving a peep-hole near the top and a lens hole below it. These gaps can be held open by inserting either a circular wire frame or a furniture-polish tin from which the base has been removed.

A hide which is so obvious as to be almost overlooked is one's own home, and many excellent photographs can be taken from the living-room window. One or two precautions need to be observed, such as not allowing the camera to touch the glass because shutter noise will be greatly amplified. The window glass in front of the camera should be clean and free from flaws and scratches, and the curtains should be drawn to conceal any movement in the room. In much the same way, an outhouse or shed can make an ideal hide, for because of their permanence they have become accepted by the birds and can be used at any time.

Methods of attracting Birds

Having established the hide, the next problem is to attract birds to the area. This can be achieved in several ways, such as providing food, water and accommodation, or by call-back techniques.

Naturally occurring food readily attracts birds to the garden and they seem to know just what is available and where to find it. In the spring, they nibble young buds of fruit trees and early flowering plants such as crocuses. During the summer the birds feed on any available fruits and berries and this continues into the autumn when the hawthorn, rose and rowan berries ripen. Keen bird photographers will often plant specific shrubs in their garden to attract particular birds.

Another method of attracting birds is to provide food on a bird table. A typical one is illustrated in fig. 11.4 and consists of a flat piece of board approximately 30 cm × 20 cm (12 × 8 in) into which several different-sized holes have been drilled for the insertion of freshly cut twigs. Proprietary bird foods can be placed on the table regularly, and the birds soon come to accept it as a regular feeding place. A bird feeding from a flat piece of wood does not look very natural, hence the addition of the freshly cut twigs (Fig. 11.5a and b). The bird sees the food, but before picking it up, invariably perches on the nearest twig, surveys the

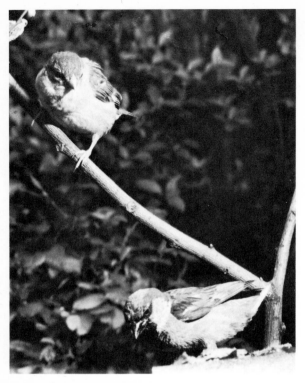

11.5a Bird table and leafy twig in use. One sparrow, *Prunella modularis*, is picking up the seed from the table whilst the other sparrow waits on the twig, ready to drop on to the table

11.5b A sparrow about to take-off from the bird-table twig. The flash has 'frozen' the wing movement and the flight feathers are clearly defined

area for potential enemies and then alights on the board. Peanuts form an attractive food for many birds, particularly tits, but if one wants something a little more authentic than tits hanging from an open-mesh bag of peanuts, a few nuts can be pushed into holes drilled on the far side of the twig. This will result result in attractive and very natural-looking photographs. Worms, dug up and placed on the table or draped around the twig, are very soon spotted by the birds and can form the basis of the 'thrush-eating-worm' photograph.

Although this if often forgotten, birds require water for drinking and bathing, and this can be quite an attraction, particularly in hot dry weather. A bird bath has the same unnatural appearance as a bird table, but a man-made drinking pool at ground level can be made to look natural. The classic method is to use an upturned dustbin lid, sunk into the ground and surrounded by plant material and soil. Birds, using their keen eyesight, soon notice this, and it becomes a regular place to visit. If one is prepared to go to the trouble of setting up a supply of water dripping into the pool, this really does attract birds and seems to be of particular interest to warblers. In addition to drinking it, birds use water to clean their feathers, after which they preen and oil them to keep them in first-class condition.

Accommodation can be provided for birds by using nesting boxes and, although not always very natural in appearance, they are often quite attractive and worth the attention of the bird photographer. Tits seem to prefer an enclosed box with a small hole at one end, whilst robins like a box with a large front opening. If one is lucky enough to have a permanent bird box, in which eggs have been laid, then interesting photographs can be obtained of the parent birds bringing food to the developing young.

A final method of attracting birds to the garden is by using the call-back technique. This involves setting up a tape-recorder and repeatedly playing the song of the bird to be photographed. In theory the bird responds to the call and quickly perches on a branch next to the play-back equipment. In

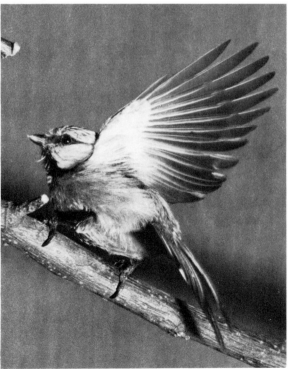

practice it is not as simple as that and much time must be spent in order to obtain good results. The response to call-back varies with the physiological condition of the bird, and is at its peak early in the breeding season when the males have arrived and are staking out their territory. At this time the response is often quick and dramatic with the bird mounting an attack on the equipment. As the breeding season gets underway the effectiveness of call-back diminishes and some birds ignore it altogether. However, there are exceptions to all general statements, and buntings and pipits seem to maintain the same low level of interest throughout the breeding season.

There are large numbers of records of bird song available commercially, and it is quite easy to transfer selected songs on to a tape, but as copyright laws are rather difficult to interpret one has to be careful to avoid breaking the law. The development of light-weight battery-operated cassette recorders has removed the final problem of weight and general portability. Bird photographers with a special interest in call-back techniques are referred to the work of F. V. Blackburn listed in the Bibliography.

Lighting and backgrounds
The last two aspects of bird photography in the garden are the availability of light and the type of background suitable for this style of work. On the limited occasions when bright sunlight can be used, one often produces photographs which have a spontaneous natural look about them. For most of the time however, the sun is either masked by cloud, or coming from the wrong direction, or producing unwanted shadows, so that most photographers opt for the fixed characteristics of an electronic-flash unit. If only one unit is available it should be placed just to the side of an imaginary line from the camera to the subject and slightly above the subject. The subject to flash distance should be 1–3 m (3–10 ft) depending on the power output of the flash and the speed of the film being used. This is basically frontal lighting and it will avoid producing any deep unlit shadows. If two flash units are available they can be arranged on each side of the subject, approximately equidistant from it. This arrangement will not produce any modelling effects but is designed to achieve maximum detail with practically no shadows. A lens aperture of f16 or f22 is usually used to obtain the maximum depth of field. As it may be necessary for the flash units to be

switched on for several hours at a time, producing a heavy drain on the batteries, it is advisable to use a long mains extension lead and to operate the units from the mains electricity supply.

If the background is several metres (or yards) behind the subject it will appear almost black and rather unnatural on the final photograph. If it is close at hand but rather broken up, it might appear very distracting, and in both circumstances an artificial background would probably be the best solution. This could be a piece of card or hardboard of an appropriate colour or tone.

Photographing birds in the garden is rather like fishing, in that both involve long periods of inactivity when one sits quietly and reflects on life and its meaning, punctuated by short periods of activity and excitement, culminating hopefully, in the 'capture' of the bird on the film or the fish on the hook.

BIRDS AT THE NEST
In the early days of bird photography most photographers portrayed birds at the nest and there were at least two probable reasons for this approach to the subject. Firstly, the bird must return to the nest to incubate the eggs and to feed the young and this, therefore, guaranteed that the bird would be available for photography. Secondly a mother bird incubating her eggs and feeding her offspring made a very attractive photograph (Fig. 11.6). This approach is usually referred to as the classical style of bird photography and, although many people think it belongs to a past era, to someone new to bird photography it still has its challenge and appeal. A photograph of a robin feeding its young still makes an extremely attractive photograph.

In Britain some of the rarer birds are protected by the Protection of Birds Act 1967, which makes it an offence to disturb (including photographing) any bird included in Schedule 1 of the 1954 Act, whilst it is on or near a nest containing eggs or young fledglings (see end of Chapter). However, all birds must be treated with respect and if there appears to be even the slighest chance of the eggs or young being deserted by the parents, all photographic activities should be terminated.

Locating the nest
Finding the nest is the first problem, and this can often be a difficult task requiring a lot of patience and a good knowledge of bird ecology. Locating a swallow's nest in an old barn is very easy because

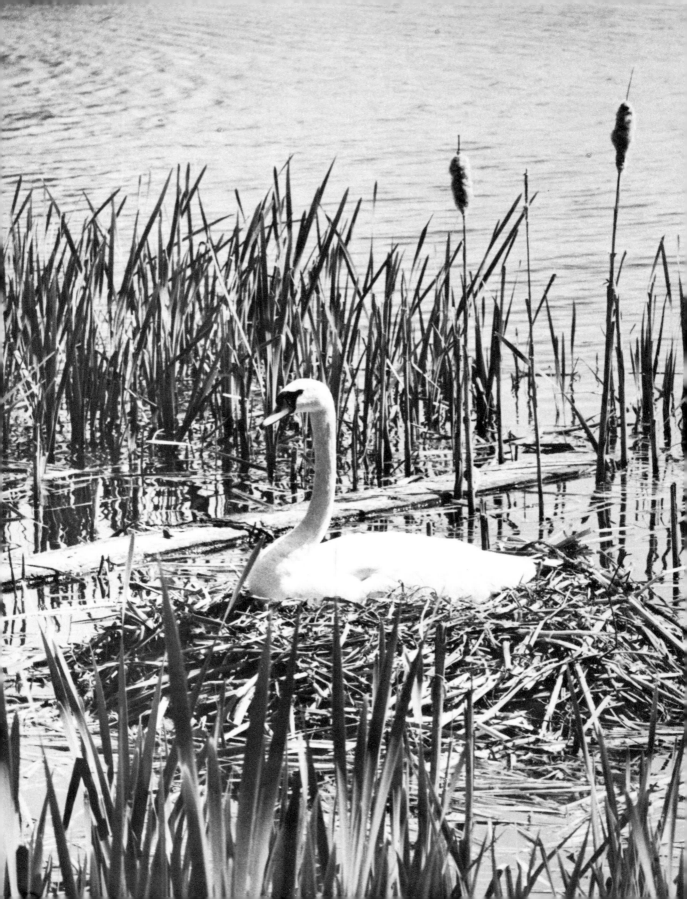

11.6 A mute swan, *Cygnus olor*, incubating its eggs. The nest is made from sticks and reeds, which are collected by the male and arranged in a huge pile by the female

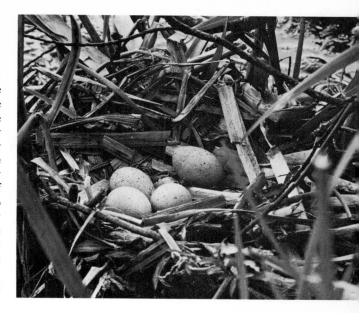

the parent birds make frequent visits to it, and the nest itself is very obvious to the eye once the nesting area has been found. Unfortunately for the photographer, most birds' nests are carefully concealed and the parent birds are often very clever in the way they enter and leave the nest. The coot makes its nest of reeds and grasses in shallow water among reeds and overhanging branches of trees. It is well camouflaged and very difficult to spot (Fig. 11.7). When a stranger is in the vicinity of the nest, the parent birds cruise about on the open water acting as decoys, and trying to draw attention away from the nest. They will not approach the nesting area while visitors are around and the longer one stays, the further they move away from the nest.

Another example is the grasshopper warbler, which builds its nest of grass on a foundation of dead leaves in an area of thick vegetation, so that the nest is virtually impossible to locate. To make life more difficult for the photographer, the nest is often approached by covered runways so that the parent bird can land several metres (yards) away from the nest and run the remaining distance through a tunnel of vegetation. If the photographer is not very knowledgeable about the lifestyle of various birds, he should either be accompanied by an experienced ornithologist or seek the advice of a local gamekeeper, otherwise many hours can be wasted in abortive searching.

Use of the hide

Having located the nest, it is then necessary to decide whether or not to erect a hide. If the area has sufficient vegetation to conceal the camera, it can be set up on a tripod, prefocused on the nest and the shutter operated from a distance by using a solenoid release or a pneumatic release. This does not allow the photographer to make any final focusing adjustments when the bird has arrived, but if a small lens aperture is used, sharp photographs can usually be obtained. The pictures of the swallow feeding its young (Fig. 11.8) were taken from a distance of about 10 m (32 ft) using a pneumatic release to operate the shutter.

If a hide is required, it must be brought gradually nearer to the nest over a few days. This is a slow process, but if the hide is immediately

11.7 The nest of a coot, *Fulica atra*, containing four buff black-spotted eggs. The nest was very well concealed amongst reeds and grasses and some temporary 'gardening' was necessary before the photograph could be taken

erected only a short distance from the nest, there is a strong possibility that the birds will desert their eggs or young. Therefore, caution is the keynote. If, when getting near to the nest, the parent birds disappear and do not return fairly soon, the hide should be dismantled and the photographer and his equipment moved out of the area.

Gardening

Often some 'gardening' will need to be done in the area between the nest and the camera, but it should be of a temporary nature. Branches should be tied out of the way, or sticks pushed into the ground to hold back unwanted foliage, but at the end of the session the area should be returned to its original state. Permanent removal of foliage by pruning should be resisted and the advice to 'leave the secateurs at home' is worth heeding. Nests left exposed are vulnerable, not only to predators, but also to draughts and direct sunlight, both of which can harm young chicks, which are not very robust during the first few days of life.

SEA BIRDS

Bird watchers in Yorkshire are very fortunate to have colonies of nesting seabirds on Bempton

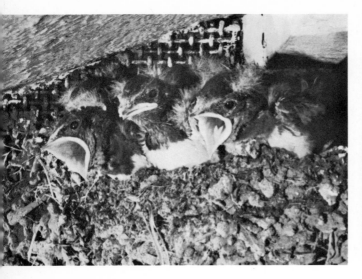
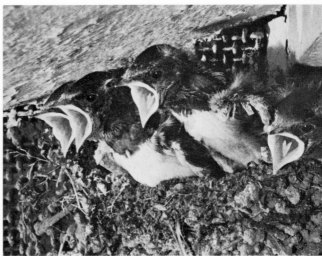

11.8 A swallow's nest, *Hirundo rustica*, containing five young. A two-flash set-up was used and the camera was operated from approximately 10 m using a pneumatic release

Cliffs (Fig. 11.9) a few miles north of Bridlington. Here the gannet has established its only mainland nesting colony in Britain and the site is shared with guillemots, razorbills, puffins and shags. Many of these birds spend most of their life at sea, coming onto land only for a short period during the breeding season (Fig. 11.10). After the eggs have hatched and the young have been reared, both the parents and their offspring head out to sea again and their nesting grounds remain deserted until the following year (Fig. 11.11).

Between April and August, these birds are too occupied with the business of nest building or feeding the hungry family to be concerned about photographers, and in this situation one can work in the open without having to erect a hide. The usual practice is to settle down on the grassy cliff top with a camera and a 300 mm (12 in) lens, observe the movements of the birds and take photographs whenever an interesting situation arises.

The movements of the birds are so vigorous that a very short exposure of 1/1,000 sec is required and as it is not possible to use flash, a fast film must be used if the lens is to be stopped down at all. This is an occasion when a film such as Ilford HP5, rated at 400 ASA, should be used rather than the usual medium-speed FP4 rated at 125 ASA.

BIRDS IN FLIGHT

As a result of the development of compact 35 mm cameras, fully automatic lenses and high-speed, good resolution films, photographers can now produce good quality photographs of birds in flight. There are some problems associated with it and the most important are the relatively small size of the moving bird, the speed of flight of the bird, and the unpredictable flight path.

Suitable lenses

The small size of the bird suggests the use of a telephoto lens and for most work a 135 mm ($5\frac{1}{4}$ in) focal length is satisfactory, although many photographers use a 200 mm (8 in) or even a 400 mm ($15\frac{3}{4}$ in) lens. The shorter focal length enables one to follow the bird fairly easily in the viewfinder, but the image will be smaller than that obtained when using a longer focal-length lens. A 135 mm – 200 mm ($5\frac{1}{4}$–8 in) lens can be handled in the normal way, whereas a 400 mm ($15\frac{3}{4}$ in) lens gives better results if used with a shoulder-pod. This consists of a support, similar to a rifle butt, which is attached to the camera so that it can be aimed like a rifle. A pistol grip and trigger are usually incorporated, the latter actuating the shutter mechanism via a cable release. A support of this

11.9 Bempton Cliffs, a few miles north of Bridlington (Yorkshire), is the summer nesting ground for thousands of sea birds including shags, razorbills, guillemots, gannets, puffins and kittiwakes

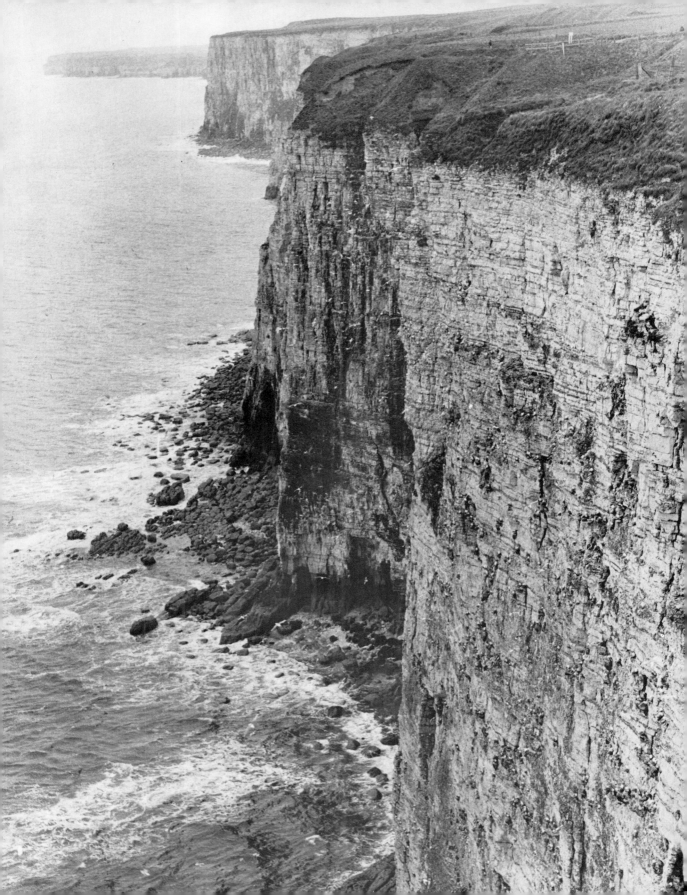

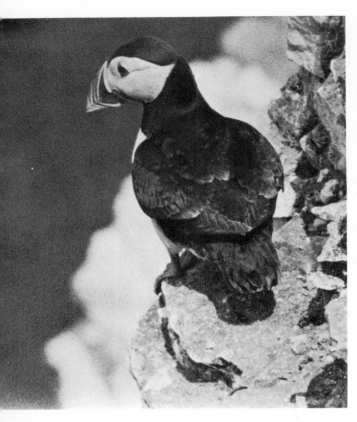

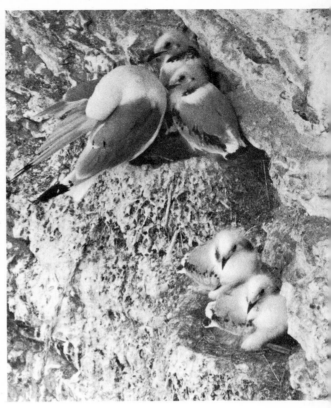

11.10 A puffin, *Fratercula arctica*, looking out to sea. Puffins spend most of their life at sea, only coming on to land for the short breeding season. A 135 mm telephoto lens and a 2× converter were used for the photograph

11.11 A kittiwake, *Rissa tridactyla*, preening its feathers. Two young birds can be seen next to the parent and nearby is another nest containing two young kittiwakes (equipment used as in previous photograph)

type is a good investment for the keen bird photographer and with it lenses up to 1000 mm (39 in) focal length can be used without incurring any obvious camera shake.

When not using a shoulder pod, camera shake can be a problem and to overcome this it is often suggested that the exposure should be the reciprocal of the focal length of the lens in use at the time. For example, a 135 mm (5¼ in) lens can be hand held at an exposure of 1/135 sec or less, whilst a 500 mm (20 in) lens would require an exposure of 1/500 sec to prevent camera shake. This is a useful general statement which refers only to camera shake and is not related in any way to the speed of movement of the object being photographed.

Photographs of birds in flight are usually taken by 'panning' the camera, ie swinging it with the movement of the bird, so that the bird remains relatively stationary in the viewfinder (Fig. 11.12). This method calls for a lot of practice, particularly for the second half of the pan, referred to as the 'follow through', but it is a very effective way of photographing birds moving rapidly across the field of view. Although the bird's body will be rendered sharp on the negative, the background will be blurred and the degree of blur decreases with the shortness of the exposure. The fastest moving parts of a bird are the wing tips and although panning will render most parts of the bird sharp on the negative, the wing tips will often be slightly blurred. An exposure of 1/1000 sec will not freeze the wing tips of small birds with a fast wing beat, but fortunately a little blur in this region is visually acceptable and quite often gives the picture a feeling of movement, which it might not otherwise possess.

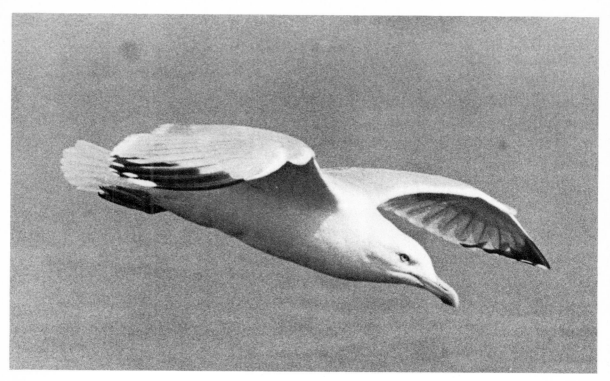

11.12 Herring gull, *Larus argentatus*, gliding on upcurrent of air near cliff face. Note the contrasting background of the sea. Photographed using the 'wait-and-see' method

Lens apertures and shutter speeds are linked for any particular light value and most photographers prefer, if possible, to stop down the lens one or two stops to obtain maximum optical performance and more depth of field. When using a 300 mm (12 in) f5.6 telephoto lens this could mean using an aperture of f8 or f11 and if an exposure of 1/500 sec is required to stop the movement of the bird, then this combination requires a lot of light and/or a fast film. Ilford HP5 and Kodak TriX are both rated at 400 ASA and are ideal for this type of work, for although they are fast films the grain is still fine enough to allow big enlargements to be made.

Focusing on a moving object is not easy and most photographers use the prefocus technique. This involves focusing the camera at a certain

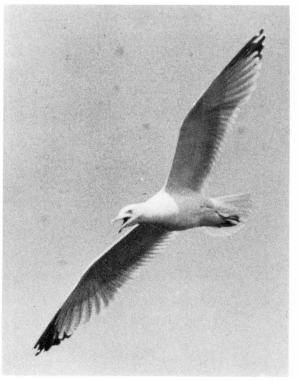

11.13 Herring gull positioned well above camera level, so that the underside of the body is clearly visible. The legs and feet are tucked away to preserve the streamlined shape

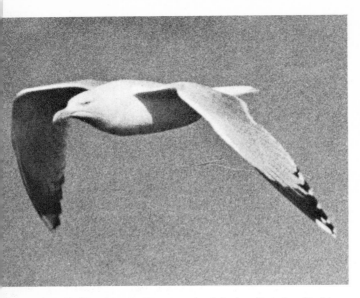

distance and following the bird in the viewfinder until it comes into the zone of focus, when the shutter-release button is pressed. This calls for a lot of practice, because the button should be pressed just as the bird is entering the zone of focus, to allow for the shutter-operation time-lag (Fig. 11.13). This method works well with a fully automatic lens, where viewing is at full aperture, but it is rather difficult to operate with a stopped-down pre-set type of lens.

Getting close to the bird

The bird must come quite close to the camera if a usefully large image is to be obtained on the negative and this requires knowledge of the bird's life-style, including its flight characteristics and its nesting habits. Sea birds such as gulls or kittiwakes can often be seen gliding along the edge of high cliffs when there is an on-shore wind blowing. The wind strikes the base of the cliffs and is deflected upwards producing a powerful vertical air current. If sea birds can find these vertical air currents, they can stay airborne without expending much energy in beating their wings. When this situation exists, the photographer has only to conceal himself near the edge of the cliff face to obtain some good inflight photographs. This requires time, much patience and a liberal supply of warm clothing to combat the often icy cold on-shore winds. Figures 11.12–11.14 were taken from this position using a 135 mm ($5\frac{1}{4}$ in) lens and a 2 × converter.

11.14 A gull photographed during flapping flight. Notice the position of the distal part of the wing which is almost at right angles to the horizontal 'forearm' region

11.15 A gull preparing for take-off. The sea in shadow makes a dark-toned background in contrast to the lighter tones of the bird

Knowledge of feeding grounds and nesting areas, and an awareness that birds land and take off into the wind can all help the photographer to be in the right place at the right time. When a bird comes in to land it employs techniques such as tilting and spreading its tail feathers to act as an air brake, extending its feet to act as air or water brakes, and using its wings to produce reverse thrust. The alula or bastard wing (a group of feathers on the second digit of the original 'hand') is used to prevent the wing from stalling as the angle of elevation is increased just prior to landing. Each species of bird has its own characteristic take-off and landing technique and a study of these can eventually result in the production of a series of very interesting photographs (Figs. 11.15–11.17). For the photographer with a motor-drive unit the possibilities in this field are almost limitless.

FLASH TECHNIQUES

In bird photography the use of flash lighting is limited to two sets of circumstances. The first is

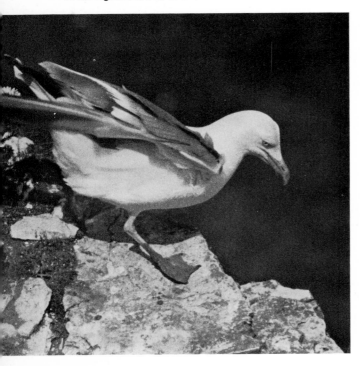

11.16 A gull just after take-off. During these early moments the wings must be flapped vigorously to keep the bird airborne

11.17 A puffin becoming airborne by throwing itself off a rocky ledge. The body is heavy and the wings are relatively small, so that the bird falls several metres before it gains sufficient speed to make the transition to controlled flight. A kittiwake watches the operation with some concern! Exposure – 1/1000 sec at f8 using a 270 mm telephoto lens

when the background is close at hand and can therefore be reasonably well lit by the flash, producing a natural-looking picture. When the background is some distance away, the flash does not penetrate, and a well-lit bird against a black background looks most unnatural, giving the impression that it is flying and feeding at night. The other circumstance in which flash can be used is, of course, when photographing birds which are nocturnal and hunt at night. The classic examples are the owls and it is almost impossible to take photographs of them without using flash.

Most SLR cameras have focal-plane shutters which are synchronised for flash at approximately 1/30–1/60 sec and this is too slow a speed for photographing moving birds. However, the flash duration of about 1/1000 sec is short enough to freeze most movements, but if the ambient light intensity is fairly high then a blur of secondary images might be present on the negative and these could spoil the photograph. This problem does not arise with a leaf-blade shutter which can be used at 1/500 sec with electronic flash.

'WAIT-AND-SEE' METHODS

This is a well-established technique for bird photography and the general principle is to find an area of known bird activity so that the 'waiting' can be minimised and the 'seeing' and photographing increased to a maximum. The places most suitable for this approach are those associated with feeding and nesting, such as mud flats, the edges of reservoirs, cliff faces and the sea-shore (Fig. 11.18). Photographs are often taken at a considerable distance from the bird and therefore a telephoto lens will be required. A 300 mm (12 in) would be a minimum useful focal length, but any focal length up to 500 mm (20 in) or even 1000 mm (39 in) could be used. A shoulder-pod would again be necessary to avoid camera shake when using the longer focal-length lenses.

Good photographs can be obtained without using a hide, if the photographer is inconspicuously dressed and partially hidden by the surrounding vegetation (Fig. 11.19). This works

11.18 A mute swan gathering speed during take-off. The photograph was taken using the 'wait-and-see' method, during an afternoon visit to Fairburn Ings in Yorkshire

11.19 A chaffinch, *Fringilla coelebs*, looking around for potential enemies during a normal feeding session. Photographed by the 'wait-and-see' method using a 135 mm lens and a 2× converter

quite well for seashore and cliff photography but there is little doubt that the likelihood of success will be greatly increased if a small inconspicuous hide can be used. This should be set up a day or two beforehand, but if this is not possible, erection on the day of shooting will have to suffice. This hide differs slightly from the one suggested for garden-bird photography, in that it should have several long horizontal openings in it, because one does not know from which direction the birds will appear.

It is now fairly common to see animals in game parks being photographed from a car, but bird photographers have been using this method for many years. Some photographers have adapted ball-and-socket heads to fit onto car windows, whilst others merely put a bean bag onto the car window frame (window fully open, of course) and rest the telephoto lens on it.

Natural daylight would normally be used for this type of work and one should be able to anticipate the changing position of the sun so as to avoid the area being plunged into deep shadow later in the day.

The background merits careful consideration as most birds are extremely well camouflaged and often merge completely into their surroundings. Two backgrounds which give useful tonal separation are the sky, which can be lightened or darkened as required by using the appropriate filter, and water, which if moving swiftly can be blurred into a smooth dark velvety backcloth in contrast to the sharp detail of the bird.

STALKING METHODS

Stalking birds has gained in popularity in recent years due to the availability of compact, light-weight equipment. The main prerequisite is to be able to locate an area where birds are likely to be present on the ground in fairly large numbers. Locations such as mud flats, swamps, woodland and the sea-shore are popular with enthusiasts in this branch of bird photography (Fig. 11.20). The stalker should enter the area inconspicuously dressed, and move about in a slow deliberate

11.20 A gull photographed by the 'stalking' method. A 135 mm lens was used and the photographer moved slowly but deliberately to within 3 m of the bird

11.21 A golden eagle, *Aquila chrysaetos*, photographed in the Highland Wildlife Park, Kingussie, Inverness-shire. A 135 mm lens and a 2× converter were used

fashion. Where possible, natural cover, such as bushes, shrubs and small hillocks, should be used and the photographer must be prepared to travel long distances on foot in return for one or two good photographs.

The most useful camera for stalking photography would be a 35 mm SLR fitted with a long-range telephoto lens (Fig. 11.21). A 300 mm (12 in) is the shortest useful length, 400 mm (15¾ in) lenses are very popular, and enthusiasts often equip themselves with 500 mm (20 in) and 1000 mm (39 in) mirror lenses. The shoulder-pod would be extremely useful for this type of work, and would be indispensable if a 500 mm (20 in) or 1000 mm (39 in) lens were being used.

BIRD PHOTOGRAPHY AND THE LAW

To protect rare breeding birds in Britain, the law forbids wilful disturbance of any species included in Schedule I of the Protection of Birds Act 1954, while it is on or near a nest containing eggs or unflown young. Photographers cannot lawfully visit such nests unless they obtain approval from The Nature Conservancy Council, 19–20 Belgrave Square, London SW1. Offenders are liable to a fine. The species are listed below.

Schedule I species

Avocet
Bee-eater
Bittern, all species
Bluethroat
Brambling
Owl, Barn
Owl, Snowy
Peregrine
Phalarope, Red-necked
Plover, Kentish

Bunting, Snow
Buzzard, Honey
Chough
Common Scoter
Corncrake
Crake, Spotted
Crossbill
Diver, all species
Dotterel
Eagle, all species
Fieldfare
Firecrest
Garganey
Godwit, Black-tailed
Goldeneye
Goshawk
Grebe, Black-necked
Greve, Slavonian
Greenshank
Harrier, all species
Hobby
Hoopoe
Kingfisher
Kite
Long-tailed Duck
Merlin
Oriole, Golden
Osprey

Plover, Little Ringed
Quail, European
Redstart, Black
Redwing
Ruff and Reeve
Sandpiper, Wood
Scaup
Serin
Shrike, Red-backed
Sparrowhawk
Spoonbill
Stilt, Black-winged
Stint, Temminck's
Stone Curlew
Swan, Whooper
Tern, Black
Tern, Little
Tern, Roseate
Tit, Bearded
Tit, Crested
Velvet Scoter
Warbler, Dartford
Warbler, Marsh
Warbler, Savi's
Whimbrel
Woodlark
Wryneck

A leaflet, entitled *Wild Birds and the Law* can be obtained from the Royal Society for the Protection of Birds, The Lodge, Sandy, Bedfordshire SG19 2DL (send a s.a.e. to cover the cost of postage).

12 Mammals_____

The mammals were the fifth and last class of vertebrates to evolve; the earliest were dog-like in size and general appearance, although some were no larger than small rats. They made their appearance in the Jurassic period (approximately 180 million years ago), at a time when the reptiles dominated the land, sea and air. The small, rather insignificant mammals were in their early tentative stages of development but they did possess certain advantages over the reptiles, in that they were developing a high fixed body temperature, and their young were born alive (except the monotremes, eg duck-billed platypus).

The former advantage, associated with the development of an insulating layer of hair or fur, enabled the mammals to withstand fluctuations in temperature and thus allowed them to spread to both polar and tropical regions. The other advantage (the young being born alive), linked to a high degree of parental care, resulted in a greater percentage of the offspring reaching maturity, giving the group as a whole a much better chance of survival. The young were suckled on milk secreted by mammary glands on the females and the milk, consisting of water, fat, sugar and protein plus many minerals and vitamins, provided all the nourishment required by the developing animals.

Finally the mammals were beginning to evolve larger, more complex brains, particularly those areas of the brain associated with movement, balance and the sense organs. There is, no doubt, some truth in the often-quoted statement that the reptiles were large, slow-moving, unintelligent animals whilst the mammals were small, agile and 'quick-witted', although it must be said that the final demise of the reptiles was probably due to changes in the climate and terrain, rather than to their inability to compete at cerebral level with the evolving mammals.

Zoologists divide mammals into smaller groups called orders, which include the Chiroptera (bats), Lagomorpha (hares, rabbits), Rodentia (rats, mice, beavers, squirrels), Cetacea (whales, dolphins, porpoises), Carnivora (dogs, cats, bears, lions, tigers), Artiodactyla (pigs, deer, giraffes, camels, cows) and the Primates (lemurs, monkeys, apes and man).

As members of the mammalian class we might not care to be reminded that the mammals are in decline like many other animal groups before them. In the world today there are approximately 4,500 species of mammals, whereas birds number approximately 8,600 species, insects 700,000 species and even the Protozoa number about 30,000 species (see *The Handbook of British Mammals* by H. N. Southern). However, it must also be remembered that one species of mammal, *Homo sapiens* (man), is rapidly increasing in number and over the last million years has made a tremendous impact on the world.

There is a general paucity of mammals in the British Isles. G. B. Corbet (in *The Identification of British Mammals*) lists 95 species of which only 40 terrestrial species are considered to be indigenous, whilst the others have either been introduced accidentally or are feral (wild) species. Most small mammals are shy and retiring; many are nocturnal; some are crepuscular (active at dusk) and a few are diurnal (active during the day). It is therefore not surprising that one rarely sees much evidence of mammal activity during a normal working day.

APPROACH

Although the range of species is not large, mammals do represent an appealing group of animals for the nature photographer to study and some ideas for photographic work are as follows.

1 A photo-study illustrating the daily routine of a selected mammal, such as a fox or a squirrel. This

would necessitate locating the animal's territory and after several periods of observation, the photography could commence. The photographs might illustrate food collecting, play, aggression, and so on.

2 A photo-study of feeding methods in selected mammals. Carnivores, rodents, insectivores and herbivores exhibit different feeding habits and each is associated with a particular type of dentition and jaw structure.

3 An illustrated study of how a particular mammal nurtures its young. One could select an animal such as a house mouse which would be unlikely to present any great problems, or tackle a species which would require rather more skill and patience, such as a fox or water vole. All mammals suckle their young and spend a considerable time feeding and protecting them until they are sufficiently strong to fend for themselves.

4 A photo-study of the social behaviour of a selected mammal. This could include courtship, mating, aggression, defence of territory, hunting and feeding.

5 Several mammals leave tracks and signs indicating their former presence in a particular area. For example, the fallow deer produces tracks in soft ground which can be identified by their size, approximately 5 cm (2 in) across the heel and 6 cm ($2\frac{1}{4}$ in) long, and general shape. Other signs left by deer are droppings approximately 2 cm ($\frac{3}{4}$ in) long which are usually in heaps called crotties, bark stripping up to a height of 1.5 m (4 ft 9 in), scrapes in the soil made by a buck's antlers during rut, and rubbing marks on branches and bark where the buck has removed velvet from his antlers. This represents fertile ground for the nature photographer interested in this aspect of mammalian ecology.

6 Many photographers want to produce clearly defined, well-composed portraits of either the whole animal or its head and shoulders. This involves trapping the animal and arranging an appropriate environment in the studio. Figure 12.1 showing the bank vole clinging to a wheat stalk, is a typical example of this approach.

EQUIPMENT

As most of the mammals likely to be photographed are not sufficiently small to necessitate special close-up facilities, almost any good-quality camera would be capable of tackling this type of work. The TLR camera has the advantage of a large negative but the disadvantage of a fixed lens (the Mamiya

12.1 A bank vole, *Clethrionomys glareolus*, clinging to an ear of wheat. Photographed indoors using two electronic-flash units

C2–C330 series being a notable exception), and the problem of parallax when working close to the specimen. Once again the SLR camera (either 35 mm or 6 × 6 cm) is the obvious choice as there are no parallax problems, and a wide range of telephoto lenses is available, producing a usefully large image on the negative without getting too close to the subject. The lenses used to produce the illustrations in this chapter range from the standard 50 mm (2 in) lens mounted on a No. 1 (11 mm/$\frac{3}{8}$ in) extension tube for the bank-vole photograph, to a 135 mm ($5\frac{1}{4}$ in) telephoto lens coupled to a 2 × converter for the photograph of the roe deer. Other useful equipment would include a tripod, an electronic-flash unit and, depending on one's interests, various switching and tripping devices of the type described in Chapter 2. Working indoors, one would require some form of artificial lighting (preferably electronic flash), and a range of props and backgrounds appropriate to the animals being photographed.

PHOTOGRAPHING MAMMALS IN THE FIELD

This probably represents the most difficult area of mammal photography because, as mentioned earlier, most British mammals are small, secretive, and often nocturnal, so that even finding them can present a problem, in addition to having to work in poor light or occasionally in total darkness. Their hearing, within a certain frequency range, is very acute and a clumsy approach is usually doomed to failure. Even the slightest sound, such as the rustling of a leaf or the snapping of a twig, is often sufficient to send the small mammal scurrying off to find protective cover. Finally, most mammals have a very highly developed sense of smell and unless one is constantly aware of this, human scent carried on the wind is sufficient to keep the animal at a very safe distance. This is particularly important when stalking woodland deer, such as the fallow and roe deer, which have both an acute sense of smell and well-developed hearing.

Fortunately for the photographer, most mammals, particularly small ones, have rather poor eyesight. Their visual acuity (ie the ability to produce a sharp image of an object) is very low, but they are sensitive to changes in light intensity and can therefore detect gross movements. The fox illustrated in Fig. 12.2 was discovered by chance in a woodland clearing. Fortunately I was downwind and, after remaining motionless for a few moments, was able to slowly raise the camera and take the photograph. The noise of the camera shutter precipitated its immediate departure.

The wood mouse is one of the most abundant of the small vertebrates; it lives underground and is strictly nocturnal. It can be readily observed using the red-light technique described by H. N. Southern, J. S. Watson and D. Chitty in 'Watching Nocturnal Animals by Infra-red Radiation', *Journal of Animal Ecology* 15, pp 198–202 (1946). He suggested that nocturnally adapted eyes are probably almost blind to red light and on this assumption he covered the lens of a powerful focusing electric torch with a disc of red celluloid. The beam of red light seemed to have no adverse effect on the animals and they could be readily observed on the darkest night using this method. A useful technique is to set up the camera and flash unit overlooking the hole from which the wood mouse is likely to emerge and to observe events from a distance using the red light. As the mouse leaves the hole the camera shutter and flash can be operated via one of the remote-release systems

12.2 A common fox, *Vulpes vulpes*, discovered by chance in a woodland clearing. A 135 mm telephoto lens, coupled to a 2× converter, was used in normal daylight

described in Chapter 2. In this situation it would seem appropriate to use either the pneumatic release or the solenoid release, both of which can be operated manually from a safe distance.

Southern described how he set up a bait point in woodland cover and illuminated it from the overhead position, using a red light focused on the area around the bait. A camera and flash were also focused on the bait and during the night not only were many photographs taken, but much was learned about the nocturnal habits of the wood mouse.

The European badger is found in practically all the countries of Europe and is very widely distributed in the British Isles, yet because of its nocturnal habits it is rarely seen. Badgers make their setts in a variety of places, but typically in woods on sloping ground. They often take over old rabbit warrens. The sett is a complex labyrinth of tunnels and chambers usually containing many

exits and only by continual nightly study with a red light can one determine which are in regular use.

Thomas McGinley of Oxford, who has a long-standing interest in badgers, told me recently that in his experience the adults are often rather wary of the red light, whereas the cubs take to it quite readily and can, in fact, be brought up to accept increasing strengths of white light. Badgers have a very keen sense of smell and should always be approached downwind. Any human scent carried by the wind to the sett is picked up by the boar, who is usually first out, and the others then remain in the sett until the air has cleared. Badgers are very short-sighted but apparently they can pick out large areas of dark tone, and as the boar emerges he surveys the area looking for unfamiliar silhouettes. Badgers are omnivorous and will feed on mice, rats, voles, slugs, snails, earthworms, fruits of all kinds, acorns, beech mast and sweet chestnuts. McGinley related how he often uses raisins and nuts as bait for adults and that cubs are very partial to honey.

When photographing badgers, it is normal practice to arrange one or preferably two flash units to illuminate the feeding area and to operate the camera remotely, although it is possible, when using a telephoto lens, to stay with the camera and operate it manually. Figure 12.3, showing 12 to 15-week-old cubs, was taken in early June between 8 and 10 pm using a 135 mm (5¼ in) lens and a flash unit.

Cine films of badger activity have been made, using both available and artificial light, by H. R. Hewer and E. G. Neal ('Filming Badgers at Night', *Discovery* 15, pp 121–4 (1954). A milestone in the study and photography of badgers was reached in June 1977 when BBC 2 visited an established badger sett and, using remotely operated cameras, brought pictures of badger activities to millions of viewers in Britain. Exciting close-ups were filmed by remotely controlled zoom lenses, showing badgers leaving the sett and going in search of food.

Squirrels are not difficult animals to observe and photograph, because they exhibit diurnal activity and live above ground level. The red squirrel has been replaced in most areas of Europe by the grey squirrel and, although classed as vermin and closely allied to the rat family, there is something very attractive about this animal. Is it the bright alert eyes, the large bushy tail, or the almost human way it holds food between its 'hands', which makes it so appealing?

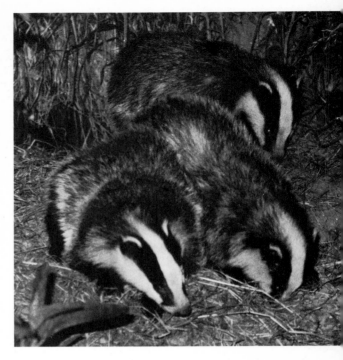

12.3 Three badger cubs, *Meles meles*, feeding near to their sett. The photograph was taken at approximately 9.00 pm in early June using a 135 mm lens and one flash unit

Squirrels are found chiefly in woodland areas and it is possible to photograph them in the trees using the 'wait-and-see' approach. However, only rarely can an uninterrupted view be obtained, as the intervening distance is often partially obstructed by twigs of branches, and one has no control over the direction and quality of the sunlight. A more successful method is to put down bait in an area which is frequented by squirrels, particularly during the winter months, when food supply is at a premium. The food could include acorns, sweet chestnuts, beech mast, pieces of apple, and cereals such as wheat and sunflower seeds. During hot summer weather squirrels drink frequently, and a pool or trough of water will soon be spotted. Once regular visits to the food or water have become established, the camera and flash units can be set up and triggered from a safe distance.

Deer and other larger mammals are often found in Forestry Commission areas, and contact with the warden would be very useful, because, although primarily interested in the timber, most wardens are also very knowledgeable about the

animal life in their reserves. They can often indicate trails regularly used by deer on their way to a particular feeding or drinking area.

In this situation the trip wire and mousetrap release mechanism (see Chapter 2) are worth trying. This would necessitate fixing the camera to a suitable tree, using the screw attachment from the camera clamp table tripod (also described in Chapter 2). The camera should be roughly parallel to the animal track and at least 2 m (6 ft) above ground level, so that it is not too obvious to inquisitive passers-by or roaming mammals. Two flash units should be attached in appropriate positions to other trees and linked to the camera with extension leads. The mousetrap release can be attached to either the camera itself or, if the cable length permits, to the trunk just below the camera, and a fine nylon line run down the tree, through a curtain hook screwed into the tree, and across the track to a fixed point at the other side.

The height of the trip wire will depend on the size of the animal being photographed; about 1 m (3 ft) seems to be ideal for deer. The nylon line is attached to the mousetrap as described in Chapter 2, so that when the release is tripped the line falls away − thus preventing possible damage to the trap and camera. If the weather is likely to be wet, the camera (with the exception of the lens) and the flash units should be protected in polythene bags. One can then retire to a safe distance and observe events through a pair of binoculars. A flash discharge will be a visible sign that the camera has been tripped and an exposure made.

A similar technique is to use the trip wire to operate a simple switch which is linked to the solenoid release unit described in Chapter 2. A third method is to replace the trip wire with a switch-mat (see List of Suppliers) laid on the trail and covered with leaves and dead grass. As the animal walks over the mat, the circuit is closed and the solenoid release actuates the camera.

The release mechanisms described so far must be re-set after each exposure and this necessitates moving into the area and probably disturbing the animal being photographed. A useful outfit which is self re-setting would consist of a camera equipped with a motor drive and operated by a pneumatic release mechanism. Using this set-up a complete film could be exposed from a distance of up to 11 m (34 ft), using a Kagra 34, although of course the focusing and exposure could not be altered without going to the camera and changing

it manually. The motor drive is worth mentioning, because it is now being manufactured in a less sophisticated form for several 'amateur' SLR cameras, such as the Yashica, Canon and Pentax, at a price which is quite reasonable.

PHOTOGRAPHING MAMMALS IN ZOOS AND WILDLIFE PARKS
Zoos
Most modern zoos, although covering a rather restricted ground area compared with wildlife parks, do allow the animals much greater freedom than was possible in the older type of zoo, and from the photographer's viewpoint this does make the task much easier. The basic requirements are that the animal should be suitably illuminated and located in a background which is fairly typical of the species. The photographer should therefore move around so that the direction of the sunlight is acceptable, and any obvious man-made structures, such as posts and fencing, are not too obtrusive on the photograph. Figure 12.4, showing two elephants is a typical example of this type of approach and was taken using a 135 mm ($5\frac{1}{4}$ in) telephoto lens.

Photographing animals behind wire fencing can present some difficulties, depending mainly on the type of mesh and how close one can get to it. If one can touch it, and the size of the mesh is sufficiently large to allow the camera lens an unrestricted view, there should not be any problems. The camera should not touch the wire, which might be vibrating due to the wind or to animals inside rubbing against it, but should be held a centimetre or so from it. Figure 12.5 of the Arctic fox cub was taken through such wire from a viewpoint which did not include any fencing in the background. The dull overcast weather and the rather low contrast of a 135 mm ($5\frac{1}{4}$ in) lens coupled to a 2 × converter resulted in a rather flat negative which had to be printed on a very hard grade of paper to increase the tone range.

The most difficult situation arises when the photographer cannot get close enough to the wire mesh and this is only too common when the 'big cats' are involved. It is normal practice to have a high wire fence around the lion and tiger enclosure, surrounded by a low 1 m (3 ft) high fence set back 1−2 m (4 ft) from the main fence. For the best results the photographer should be as near to the main fence as possible and the animal being photographed as far away from it as possible. A standard 50 mm (2 in) lens is quite unsuitable for

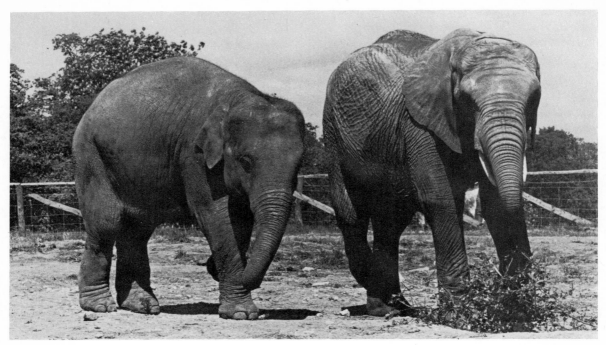

this work, and should be replaced by a 135 mm (5¼ in) or a 200 mm (8 in) telephoto lens. The depth of field must be kept small by using a fairly large aperture, and the results of applying this technique are shown in Fig. 12.6. Both photographs were taken from exactly the same position at an aperture of f4 but the first exposure was made with a standard 50 mm (2 in) lens, whilst for the second, a 135 mm (5¼ in) telephoto lens was used.

An animal actively involved in some activity, such as hunting, playing or feeding provides a more interesting photograph than an animal simply staring at the camera, or even worse, falling asleep in front of it. Lions and tigers are not usually very co-operative, spending much of their time in what appears to be a deep coma, but the old trick of photographing one of them in the act of yawning is is worth mentioning because the final photograph is often quite impressive. It appears to show a ferocious snarling lion in a typical 'king of the jungle' pose! Feeding at the zoo is obviously a good occasion for photography and one should always check the meal times of the animals which are to be photographed.

Wildlife parks
Wildlife parks tend to be much larger than traditional zoos and the animals can roam over a much greater area. Two types of park seem to exist

12.4 These two elephants were photographed without difficulty through the wide-mesh wire fencing. A 135 mm telephoto lens was used

12.5 An Arctic fox cub, *Alopex lagopus*, photographed in the Highland Wildlife Park. A viewpoint was selected so that none of the wire fence appeared in the background. A 135 mm lens coupled to a 2× converter produced a large but rather flat image, which had to be printed on a very hard grade of paper

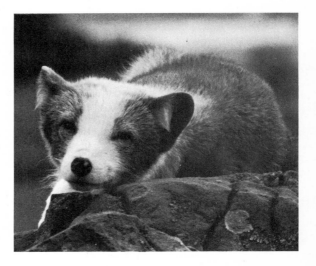

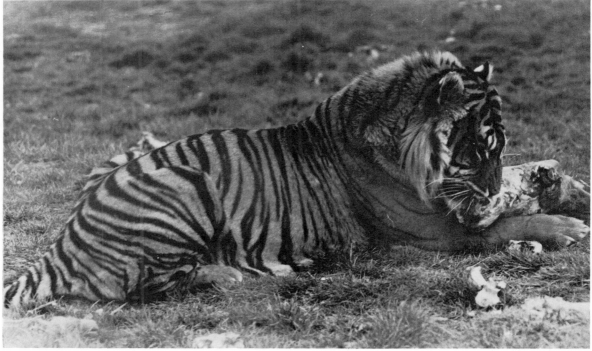

12.6 A tiger at feeding time. The first photograph was taken at f4 using a standard 50 mm lens – the wire fencing is clearly visible. The second photograph was taken from exactly the same position using a 135 mm lens also set at f4 – the wire fence is no longer visible

12.7 Two fawns lying motionless against a 'protective' background. The high frontal lighting gives little tone separation between the animals and the background and makes them more difficult to spot

— the first, containing lions and other dangerous carnivores, and the second, which usually covers a much greater acreage, houses fairly harmless mammals such as bison, wild goats, deer and antelope. The lion parks allow cars to travel round a fixed circuit with the occupants firmly entrenched in their cars behind closed windows. A telephoto lens is usually required and although photographs can be taken through car windows, this should be restricted to the flat side windows rather than the front and rear, which are curved. The camera should be placed at right angles to the window glass, so that the latter is acting as a plain glass filter and causing minimum distortion. A finger-end wedged between the glass and the lens mount will help to steady the camera if the car is moving. The problem of photographing through glass can be solved by opening the window slightly but this does introduce the small risk of having the camera wrenched out of the window by a belligerent tiger!

The more open parks housing the less dangerous animals represent a much better prospect for the photographer. If one is restricted to the car but allowed to open the windows, the camera can be supported on the window ledge (window wound right down) using a bean bag between the camera and the ledge. Usually the photographer is allowed to get out of the car but must stay on the road. Equipped with a medium-length lens, 135–200 mm ($5\frac{1}{4}$–8 in) and a 2 × converter, one can cover most of the subjects likely to arise.

It is worth remembering that an f5.6 200 mm (8 in) lens, coupled to a 2 × converter, would give a working aperture of f11 (ie 2 stops less) and a focal length of 400 mm ($15\frac{3}{4}$ in). The latter would necessitate a shutter speed of 1/400 sec or less if possible camera shake were to be avoided, and this exposure, linked to a maximum aperture of f11 would indicate the use of a medium-fast film and a firm tripod (for longer exposures) if the weather were dull.

The direction of the sunlight is important and worth considering for a moment. If the sun is high in the sky and producing frontal illumination, this is likely to result in high-intensity, but rather flat lighting, which will give little separation of the animal from its background. Figure 12.7 was taken under these conditions, making the fawns rather difficult to spot. This is of course an advantage to the animals in that it offers some protection from would-be predators. If the photograph is to illustrate animal camouflage, this type of lighting is ideal. Compare the photograph of the fawns with that of the buck roe deer sniffing the wind (Fig. 12.8), and notice how the back lighting has isolated

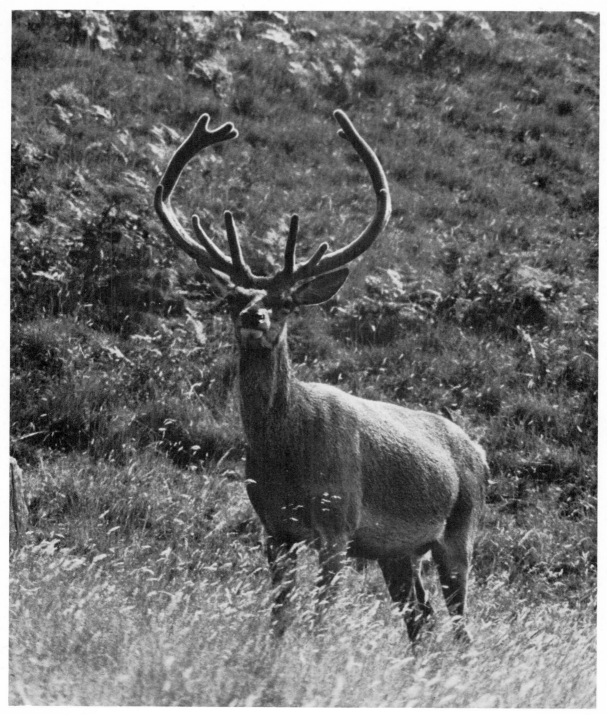

12.8 A buck roe deer, *Capreolus capreolus*, sniffing the wind. The photograph was taken at the same time as the previous one but from a different position. The near back lighting helps to separate the deer from its background. A 135 mm telephoto lens was used

the deer from its background. The two photographs were taken within 50 m (160 ft) of each other and illustrate the profound effect the direction of the lighting can have on a scene.

PHOTOGRAPHING SMALL MAMMALS INDOORS
Collecting the specimens
If small mammals are to be photographed indoors, some efficient means of catching them alive must be available. The common mousetrap is a break-back trap and quite unsuitable for doing anything other than killing its catch. In Britain the Longworth trap has gained universal acceptance over the years as an easy-to-operate and extremely reliable piece of equipment. The original trap was designed by D. H. Chitty and D. A. Kempson of the Bureau of Animal Population in Oxford, and it is manufactured by the Longworth Scientific Instruments Company (see the List of Suppliers).

The basic design consists of two parts – a tunnel trap and a nest box. The former, which is approximately 5 cm (2 in) square and 13 cm ($5\frac{1}{8}$ in) long, has a flap-door at the entrance released by a trip-bar at the other end. The nest box is rather larger, measuring $7 \times 9 \times 14$ cm ($2\frac{3}{4} \times 3\frac{1}{2} \times 5\frac{1}{2}$ in), and houses the bedding material and food. The tunnel is clipped onto the nest box and, with the flap-door raised, the trap is placed in a suitable collecting area. The animal enters the tunnel in search of food and accidentally depresses the trip-bar, which closes the flap-door. The animal, now trapped in the unit, finds its way into the warm nest box, where it remains during its enforced stay.

It is normal practice to check the traps at least every 12 hours, because small mammals such as voles, mice and shrews have a large surface-area-to-volume ratio and tend to lose heat rapidly. They are however, very well protected in the nest box, kept warm by the bedding, and liberally supplied with food. Cereals such as oats and wheat or sunflower seeds are a good all-purpose bait, supplemented with carrot or apple for short-tailed voles, and pieces of earthworm for shrews. New traps of polished aluminium are rather conspicuous and should be sprayed dark green or khaki and then given a 'mousey' odour by leaving them in a cage of tame mice for a day or so.

There is a wide range of live traps available for catching medium-sized mammals such as squirrels and hedgehogs. Most work on the principle of attracting the mammal into a wire cage to retrieve bait, and in doing so a non-return door is closed behind them. Although most of these traps were originally designed for rats and squirrels, they can be used to trap water voles, stoats, weasels and hedgehogs. Interested readers are directed to a Forestry Commission leaflet entitled *Traps for Grey Squirrels* in which several types are discussed in some detail.

Housing small mammals
If the live trapped mammals are to be kept for only 24 hours for the purpose of photography, some temporary housing, such as a ventilated metal container, containing suitable bedding and a supply of food and water, would be adequate. If, however, the animals are to be long-term residents more suitable accommodation must be provided. It is worth remembering that many of these animals are likely to be gnawing rodents and will quickly escape from most wooden structures. Cages for mice and hamsters are readily available from pet shops and can either be set up to replicate the natural environment, using moss, dead leaves, dry grass and twigs, or be furnished with straw, wood shavings or some other natural insulating material. The former arrangement will allow the animals to be photographed in natural surroundings, whereas the latter will simply house the animals, which should then be moved to another setting to be photographed.

These small mammals have their own particular characteristics. For example, gerbils tend to designate one corner of the cage as the toilet, keeping the remainder of the floor free from waste; mice produce a smell out of all proportion to their size; hamsters take all their food to bed with them! Having decided to keep a small mammal, it is a good policy to visit the local pet shop and purchase a booklet on its housing and general care.

Photography
The larger of the small mammals, such as rats, guinea pigs and rabbits, can be photographed using a standard 50 mm (2 in) lens on a 35 mm SLR camera. Close-up facilities are not normally required for this size of animal. A 135 mm ($5\frac{1}{4}$ in) telephoto lens has the advantage of allowing the camera and photographer to be further away from the animal, thereby causing less disturbance. When smaller mammals, such as mice, gerbils and voles are being photographed, some close-up equipment will be required. This could include a bellows unit, close-up lenses, or extension tubes. The photographs of the vole and young mice (Figs.

12.1 and 12.9) were taken using a standard 50 mm (2 in) lens mounted on a No. 1 (11 mm/⅜ in) automatic extension tube. As in all close-up work, a small lens aperture (f16–22) should be used to produce the maximum depth of field.

The lighting can be either continuous half-watt lighting (photofloods) or short duration electronic flash. Since small mammals tend to exhibit rather erratic nervous movements, the electronic flash with its short (approximately 1/1,000 sec) movement-freezing flash and its high light output is preferable. If a modelling light can be incorporated into the flash set up, so much the better, otherwise the flash units will have to be used 'blind'. The Courtnay Colour Flash 100 and Sola II units produce a wide spread of light and are not really designed for close-up work, but they do function quite effectively if moved to within 1 m (3 ft) of the animal. If only one unit is available, it is probably best used to produce fairly high frontal lighting so that details of the fur can be clearly seen. However, if one has access to two units, one of them could be positioned high up and slightly behind the animal, to produce a backlit effect, and the second could be used as a quite powerful frontal light. As an alternative one could arrange the lights as for human portraiture by having a main 45° frontal light and a low intensity fill-in light at the height of the animal.

Finally some thought must be given to the use of 'props' and backgrounds. Typical requirements for a normal environment would include pieces of bark, dead leaves, moss and, in the autumn, sprays of fruits and berries. Whilst such 'props' are satisfactory for wood mice, voles and shrews, they are not quite appropriate for hamsters and gerbils, which are really desert dwellers and require a more sandy environment. For close-up portraits of small mammals the 'props' can be reduced to a minimum or dispensed with altogether. Both approaches are valid and merely reflect the interest and enthusiasm of the photographer.

When working indoors, special attention should be given to the background: if it is ignored, it is highly probable that the final photograph will be unacceptable, or at best less attractive than it might otherwise have been. When working in colour, the background should harmonise with the subject matter. For example, when the camera is

12.9 Three young mice photographed indoors using two electronic-flash units. A standard 50 mm lens coupled to an 11 mm extension tube was required to produce a reasonably large image on the negative

pointing up at the animal, a blue background, simulating the sky, looks very effective and seems to add a third dimension to the photograph. If a high viewpoint is selected, a green or brown background might be more appropriate. For black-and-white work have three backgrounds of black, grey and white sheets of cartridge paper available (see Chapter 8); try each in turn and select the one which is most suitable for the subject and lighting being used.

The distance of the background from the animal is important for two reasons. Firstly, if the background is fairly close, there is a great possibility of unwanted shadows falling on it, and secondly, the amount of light on the background will depend on its proximity to the main light (unless the background is lit separately). For example, a white background, if moved well away from the specimen being photographed, could appear almost black on the final print. The position of the background also depends to a large degree on whether the animal is being photographed inside or outside its cage. Some animals, such as voles, hamsters and guinea pigs, can be arranged outside their normal closure, whereas the wood mouse, being an active jumper, must be kept in a box covered with a sheet of glass.

Appendices

1 Geological periods

Era and duration	Period and epoch; estimated years since each began	Life	Important geological events
CENOZOIC (age of mammals; approx. 70 million years)	*Quaternary* Recent 20,000	Modern species and subspecies; dominance of man	Post-glacial; warm
	Pleistocene 1 million	Modern species of mammals or their forerunners; decimation of large mammals	Glacial conditions
	Tertiary Pliocene	Appearance of many modern types of mammals	Warm climates, gradually cooling. Continental areas mainly free of seas. Continued growth of mountains, including Alps and Himalayas
	Miocene	Rise of modern sub-families of mammals; spread of grassy plains; evolution of grazing mammals	
	Oligocene	Rise of modern families of mammals	
	Eocene	Rise of modern orders and suborders of mammals	
	Paleocene 70 million	Dominance of archaic mammals	
	Cretaceous Upper Lower 135 million	Dominance of flowering plants commences; extinction of large reptiles by end of period	Initially great swamp deposits; followed by birth of Rocky Mountain and Andes, and cooling of climates

Era and duration	Period and epoch; estimated years since each began	Life	Important geological events
MESOZOIC (age of reptiles; duration 155 million years)	*Jurassic* Upper Middle Lower 180 million	Reptiles dominant on land, sea, and in air; first birds; archaic mammals emerging	Many of continental lowlands near sea level
	Triassic Rhaetic Upper Middle Lower 225 million	First dinosaurs, turtles, ichthyosaurs, plesiosaurs; cycads and conifers dominant	Widespread desert conditions
PALEOZOIC (duration approx. 375 million years)	*Permian* Upper Lower 270 million	Radiation of reptiles, which displaced amphibians as dominant group	Continued mountain-building, variable climates including aridity and glaciation
	Carboniferous Upper Lower 350 million	Fern forests; sharks abundant; radiation of amphibians; first reptiles	Land low with sea over much of continents at the beginning; warm. Coal swamps, from which the greatest of our coal deposits come. Mountain-building towards end
	Devonian Upper 400 million	Age of fishes (mostly freshwater); first trees, forests and amphibians	Still considerable portions of land below water; evidence of aridity in continental areas
	Silurian Upper Middle Lower 440 million	Invasion of the land by plants and arthropods; archaic fishes	Much of land below the sea at first, followed by mountain-building at the end
	Ordovician Upper Lower 500 million	Appearance of primitive fish-like vertebrates	Great submergence of lands
	Cambrian 600 million	Appearance of all major invertebrate phyla	Mild climates. Much lowland. First abundantly fossiliferous rocks

2 Classification of Animals (main phyla)

Phylum	Characteristic features
PROTOZOA	Microscopic; one-celled or colonies of cells, live in a fluid environment (water, blood)
PORIFERA	Sponges; body wall perforated by pores and canals, found in both fresh water and the sea; group includes the glass sponges which can be up to 1 m (3 ft) long, and the common bath sponge
COELENTERATA	Usually cylindrical or bell-like individuals, or sometimes in colonies; includes well-known examples such as Hydra, jellyfish, sea anemones and corals
PLATYHELMINTHES	Flat worms; body thin, compressed, and leaf or ribbon like; common examples include liver flukes and tapeworms
NEMERTINEA	Ribbon worms; body slender, soft and elastic; free living, mainly marine
ECHINODERMATA	Echinoderms; symmetry radial, usually five-pointed; all are marine and abundant on lower shore; common examples include starfish, brittle stars, sea lilies, sea urchins and sea cucumbers
MOLLUSCA	Molluscs; soft body usually covered with hard limy shell; locomotion by large muscular feet; widespread in marine, freshwater and terrestrial environments; common examples include snails, slugs, limpets, clams, oysters, squids and mussels
ANNELIDA	Segmented worms; long, slender, usually with fine bristle-like chetae for locomotion; common examples include sandworms, tubeworms, earthworms and leeches
ARTHROPODA	Jointed-legged animals; hard exoskeleton covers all regions, and is moulted at intervals; four or more pairs of jointed appendages; examples include lobsters, crabs, barnacles, all insects and spiders, scorpions, mites and ticks, centipedes and millipedes
CHORDATA	All animals which have a backbone or some other central supporting rod
Group A. ACRANIA	No cranium, jaws or backbone; usually possess a central notocord for support; examples include acorn worms, tunicates, and lancelets
Group B. CRANIATA	True vertebrates with cranium (skull) and backbone; group includes some jawless vertebrates such as lampreys, hagfish, and many extinct species *Class 1 Chondrichthyes* – cartilaginous fish; skeleton of cartilage, skin usually covered with rough hard scales; examples include sharks, skate and dogfish *Class 2 Osteichthyes* – bony fish; skeleton more or less bony; gills covered by a flap or operculum; most of the common fish, eg cod, haddock, trout, perch and carp are included in this class *Class 3 Amphibia* – amphibians; body covered with soft delicate skin used for breathing; all must return to water during reproductive cycle; common examples include frogs, newts, toads, and salamanders

Phylum	Characteristic features
	Class 4 *Reptilia* – reptiles; body covered with dry horny skin, usually with scales; mostly terrestrial, some aquatic, examples include turtles, lizards, snakes, alligators and tortoises Class 5 *Aves* – birds; body covered with feathers; forelimbs modified for flight; flightless birds include ostriches, rheas, emus and kiwis Class 6 *Mammalia* – mammals; body usually covered with hair; young suckled on milk from female mammary glands; examples include duck-billed platypus, opossums, and kangaroos (Australia and New Zealand), bats, moles shrews, rabbits, whales, dolphins, seals, horses, cows, camels, monkeys, apes and man

3 Classification of Plants (main groups)

Division	Class and distinctive features
THALLOPHYTA	1 Algae – simple green plants; many microscopic but class also includes seaweeds and filamentous pondweeds 2 Fungi – simple non-green plants; includes mushrooms, toadstools, yeasts, moulds, blights and smuts 3 Lichens – algae and fungi growing together for mutual benefit; small and inconspicuous; sensitive to air pollution
BRYOPHYTA	1 Musci – mosses; small, common plants with stem and leaves but no true roots; examples include the hair mosses, cord mosses and bog mosses 2 Hepaticae – liverworts; both thalloid and leafy types exist; tend to prefer damp environments; examples include the common liverwort, the great scented liverwort and the spleenwort scale moss
PTERIDOPHYTA	1 Filicales – ferns; green plants with stem, roots and leaves; the conspicuous fern plant is the spore-bearing generation; the gametophyte is the small and inconspicuous generation; examples include the common bracken, the male fern and the polypody 2 Equisetales – horsetails; an ancient group fast dying out; they attained tree-like proportions in the Carboniferous period 3 Lycopodiales – clubmosses; also a dominant feature during the Carboniferous, but few remain today
GYMNOSPERMS	1 Coniferales – mostly cone-bearing plants with naked seeds; examples include the pines, spruces and larches 2 Gnetales 3 Cycadales } Tropical plants 4 Ginkgoales
ANGIOSPERMS	1 Monocotyledons – flowering plants with seeds enclosed in a case (fruit); one cotyledon per seed; typical monocots include grasses, cereals, lilies, tulips and orchids 2 Dicotyledons – flowering plants with seeds enclosed in a fruit; two cotyledons per seed; typical dicots include most wild flowers, shrubs and trees

Bibliography

Equipment

Kinne, R., *The Complete Book of Nature Photography*, Barnes & Co, New York, 1962

Tölke, A. and I., *Macro Photo and Cine Methods*, Focal Press, London 1971

Close-up Techniques

Blaker, A. A., *Handbook for Scientific Photography*, W. H. Freeman & Co., San Francisco, 1977

Bomback, E., *Close-ups*, Fountain Press, Kings Langley, 1962

Engel, C. E., *Photography for the Scientist*, Academic Press, London 1968

Photomicrography

Barer, R., *Lecture Notes on the Use of the Microscope*, Blackwell, Oxford, 1968

Beeler, N. and Branley, F., *Experiments with a Microscope*, Faber & Faber, London, 1958

Brain, E. B., *Techniques in Photomicrography*, Oliver & Boyd, Edinburgh, 1969

Life Library of Photography, *Photography as a Tool*, Time-Life International, 1973

Tupholme, C. H. S., *Colour Photomicrography*, Faber & Faber, London, 1961

Walcott, C., *Small Things – An Introduction to the Microscopic World*, McGraw-Hill, New York & London, 1967

Walker, M. I., *Amateur Photomicrography*, Focal Press, London, 1971

Non-flowering Plants

Brightman, F. H. and Nicholson, B. E., *The Oxford Book of Flowerless Plants*, Oxford University Press, 1966

Duncan, U. K., *Introduction to British Lichens*, Buncle, Arbroath, 1970

Jewell, L., *The Observer's Book of Mosses and Liverworts*, Frederick Warne & Co, London, 1955

Ramsbottom, R., *A Handbook of the Larger British Fungi*, British Museum, London, 1965

Tribe, I., *The Plant Kingdom*, Hamlyn, 1972

Flowering Plants

Lewis, P., *British Wild Flowers*, Kew Series, Eyre & Spottiswoode, 1958

McClintock, D., and Fitter, R. S. R., *Pocket Guide to Wild Flowers*, Collins, London, 1955

Martin, W. Keble, *The Concise British Flora in Colour*, Ebury Press, London, 1965

Insects

Angel, H., *Photographing Nature: Insects*, Fountain Press, Kings Langley, 1975

Blaker, A. A., *Field Photography – Beginning and Advanced Techniques*, W. H. Freeman & Co., San Francisco, 1977

Burton, J., *The Oxford Book of Insects*, Oxford University Press, 1968

Dalton, S., *Borne on the Wind*, Chatto & Windus, London, 1975

Imms, S. D., *Insect Natural History*, Collins, London, 1956

Nuridsany, C. and Pérennou, M., *Photographing Nature*, Kaye & Ward, London, 1976

Oldroyd, H., *Insects and Their World*, British Museum (Natural History), 1966

Sandars, E., *An Insect Book for the Pocket*, Oxford University Press, London, 1966

Turner-Ettlinger, D. M., *Natural History Photography*, Academic Press, London, 1974

Aquatic Organisms

Barrett, J. H. and Yonge, C. M., *Collins Pocket*

Guide to the Sea Shore, Collins, London, 1964

Clegg, J., *The Freshwater Life of the British Isles*, Frederick Warne Co, London, 1965

Cruise, J., and Newman, A. A., *Photographic Techniques in Scientific Research, Vol 1*, Academic Press, London, 1973

Engelhardt, W., *The Young Specialist Looks at Pond Life*, Burke, London, 1964

Macan, T. T., *A Guide to Freshwater Invertebrate Animals*, Longman, London, 1964

Amphibians and Reptiles

Hellmich, W., *Reptiles and Amphibians of Europe*, Blandford, London, 1962

Smith, M., *British Amphibians and Reptiles*, Collins, 1951

Steward, J. W., *The Snakes of Europe*, David & Charles, Newton Abbott, 1971

Hardstaff, M. (ed) *Animals and Plants*, (Nuffield Junior Plants), Collins, London, 1967

Birds

Blackburn, F. V., *Natural History Photography*, (Ch 7, 'The Use of Play-back Tape'), Academic Press, London, 1974

Brown, B., *The Hamlyn Guide to Birds of Britain and Europe*, Hamlyn, London, 1970

Campbell, B., *The Oxford Book of Birds*, Oxford

University Press, 1964

Gooders, J., *Wildlife Photography – A Field Guide*, Hutchinson, London, 1973

Hosking, E., *An Eye for a Bird*, Hutchinson, London, 1970

Reader's Digest, *The Book of British Birds*, Drive Publications, London, 1969

Urry, K. and D., *Flying Birds*, Vernon & Yates, London, 1970

Warham, J., *The Technique of Bird Photography*, Focal Press, London, 1973

Yapp, W. B., *The Life and Organization of Birds*, Arnold, London, 1970

Wild Birds and the Law, and *Bird Photography and the Law*, RSPB Publications, The Lodge, Sandy, Bedfordshire SG19 2DL

Mammals

Brink, F. H., *A Field Guide to the Mammals of Britain and Europe*, Collins, London, 1962

Corbett, G. B., *The Identification of British Mammals*, British Museum (Natural History), London, 1969

Leutscher, A., *Tracks and Signs of British Animals*, Cleaver-Hume Press, London, 1960

Southern, H. N., *The Handbook of British Mammals*, Blackwell, Oxford, 1964

List of Suppliers

Photomicrography

Bausch & Lomb Incorporated
635 St Paul Street
Rochester, New York 14602, USA
Microprojectors, microscopes, and other optical scientific instruments

Carolina Biological Supply Company
2700 York Road, Burlington, North Carolina, USA
and
Box 7, Gladstone, Oregon, USA
Biological models, microscopes, plast-o-mounts, and laboratory equipment

Brunnings Ltd
133 High Holborn, London WC1
New and secondhand microscopes, polaroid

sheet, prepared and blank slides, mounting materials, advice on use of equipment

H W English
469 Rayleigh Road, Hutton, Brentwood, Essex CM13 1SU
New and ex-government microscopes, lamps, prepared slides and accessories, catalogue on request

Philip Harris Ltd
Hazelwell Lane, Birmingham 30
Microprojection illuminating base

E. Leitz, Inc.
468 Park Avenue South, New York N.Y. 10016, USA
Microscopes and microprojectors

Queckett Microscopical Club
c/o British Museum (Natural History)
Cromwell Road, London SW7 5BD
Club for amateur enthusiasts

Scientific Instruments Ltd
Hemel Hempstead, Herts
Microprojectors

Swift Instruments, Inc.
P.O. Box 562, San Jose, California 95106, USA
Microscopes and accessories

Living cultures of micro-organisms

Commonwealth Mycological Institute
Kew, Surrey
Moulds, yeast, etc

Culture Centre
36 Storey's Way, Cambridge
Algae and protozoa

Philip Harris Biological Ltd
Oldmixon Industrial Estate
Weston-super-Mare, Somerset
Moulds, yeasts, bacteria, algae, protozoa
(educational and private suppliers)

Oxoid Division, OXO Ltd
Southwark Bridge Road, London SE1
Agar tablets and powder, all types of nutritive
media, both liquid and solid

Insects

Griffin Gerrard
Worthing Road
East Preston, West Sussex
Locusts, stick insects, Large White butterflies
and Hawkmoths

Watkins & Doncaster
Park View Road
Welling, Kent
Moth traps and insect nets

Worldwide Butterflies Ltd
Over Compton
Sherborne, Dorset
British and tropical butterflies and moths

Amphibians and reptiles

Jewel Aquarium Company, Inc.
5005 West Armitage Avenue, Chicago,
Illinois 60639, USA
Aquariums, terrariums, germinating beds, and
modular units

Philip Harris Biological Ltd
Oldmixon Industrial Estate
Weston-super-Mare, Somerset
Toads, frogs, grass snakes, lizards etc

Xenopus Ltd
151 Frenches Road
Redhill, Surrey
African toad (Xenopus), salamanders, tree-frogs
etc

Birds

Jamie Wood Products Ltd
Cross Street
Polegate, Sussex
Fensman hide, King Fensman hide, range of
nesting boxes

Mammals

Longworth Scientific Instruments Co
Radley Road, Abingdon, Berks
Longworth traps

Proops Brothers Ltd
Hyde Industrial Estate,
Edgware Road, Hendon, London NW9 6JS
Switch mats

General

Ward's Natural Science Establishment, Inc.
P.O. Box 1712, Rochester 3, New York, USA
and
P.O. Box 1749, Monterey, California, USA

General Biological Supply House, Inc. (Turtox)
8200 South Hoyne Avenue, Chicago 20, Illinois,
USA

Index